PRINTMAKING
IN THE SUN

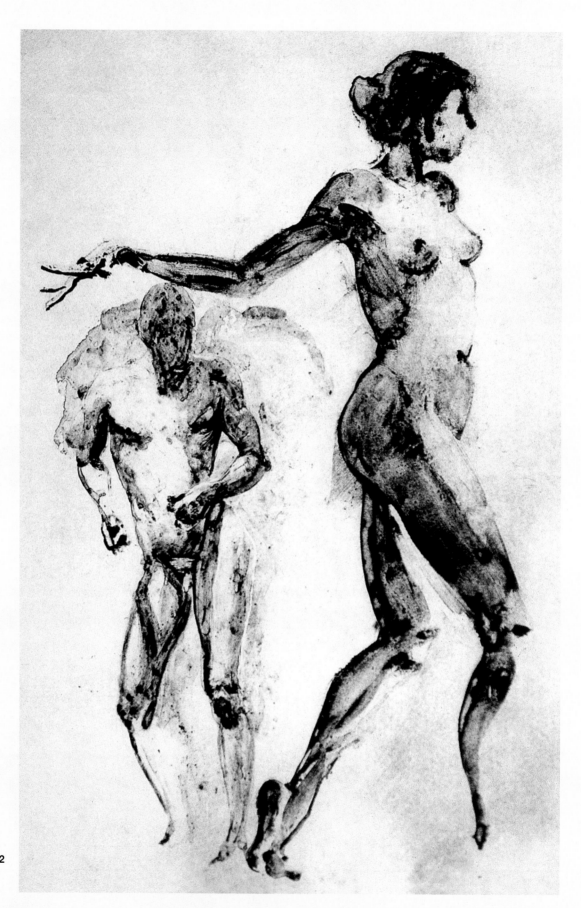

Eric Fischl, *Dancers*, 1992
Intaglio print, 24 x 18 in
(61 x 45.7 cm)

PRINTMAKING IN THE SUN

*An Artist's Guide to Making Professional-Quality Prints
Using the Solarplate Method*

DAN WELDEN AND PAULINE MUIR

WATSON-GUPTILL PUBLICATIONS
NEW YORK

For Andrew and Kryn

Cover
Dan Welden, *Sheep Tracks*, 1997

Senior Editor: Candace Raney
Editor: Audrey Walen
Designer: Abigail Sturges
Production Manager: Ellen Greene

First published in 2001 by
Watson-Guptill Publications,
a division of BPI Communications, Inc.
770 Broadway
New York, N.Y. 10003
http://www.watsonguptill.com

Library of Congress Cataloging-in-Publication Data

Welden, Dan
Printmaking in the sun: an artist's guide to making
professional-quality prints using the solarplate
method/Dan Welden and Pauline Muir.
 p. cm.
 Includes bibliographical references.

ISBN 0-8230-4292-8
Prints—Technique. I. Muir, Pauline. II. Title.

Manufactured in Malaysia
First printing, 2001

Acknowledgments

No book succeeds without the help and support of others. Our special thanks to all the artists who have so kindly contributed their artwork for this book; health and safety expert, Monona Rossol, of Arts, Crafts & Theatre Safety, who co-wrote the chapter on safety and is renowned for her dedication to health and safety in the arts; Bernice Ficek-Swenson, Associate Professor of Printmaking at the University of Wisconsin, River Falls, who shared her special expertise in photogravure techniques and researched and wrote the details for making photographic positives; and well-known South Australian artist, Janet Ayliffe, who drew the delightful diagrams.

There are many others to thank: Adele Boag, for her constant support; Arts SA for a grant which assisted in research; Anthea Boesenberg; Judy Bourke who has been pivotal in promoting solarplate in Australia; Alex Castles; Audrey Dickenson; Jan Harvey; Roger Hyndman and Jessica Bayer; Denise Kasof; Elaine Le Vasseur; Lorna Logan and Dick Mello; Kurt Lohwasser, mentor to Dan Welden; Laurel McKenzie; Don Messic; the Morrisseys at Henley Graphics; Node Computers, South Australia, for unparalleled technical advice; Dennis Olsen; Strange Ross, for many interesting discussions; Shelley Ryde; Paul Verbeeck and Mary Jo Van Mechelen; Judith Kaufman Weiner, former director of the East End Arts Council, Riverhead, New York, who was instrumental in the New York State Council of the Arts grant in 1987 for the research, development, and exhibition of "Solarplate Prints;" and Jeffrey and Carl Welden.

The authors would also like to thank the team at Watson-Guptill, particularly Candace Raney and Audrey Walen, and the designer Abigail Sturges, who helped us realize this book.

CONTENTS

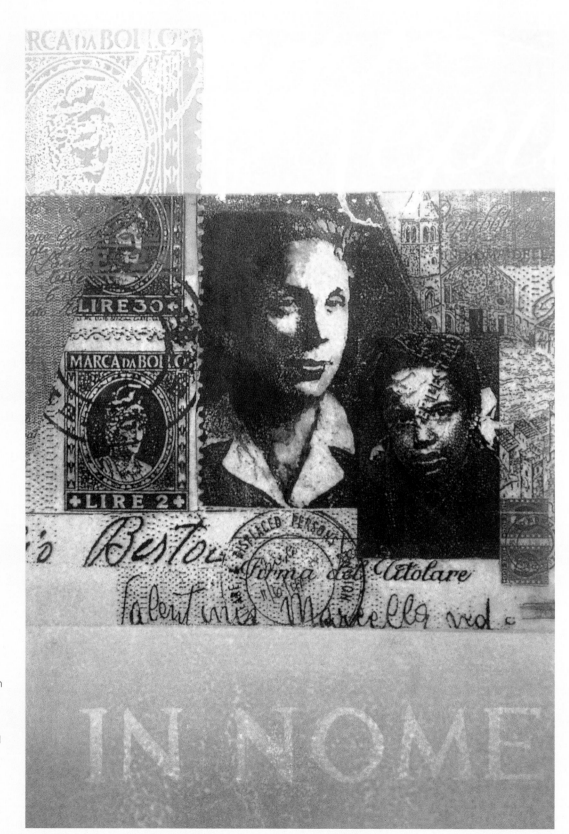

Laura Stark, *Passport Series IV*, 1995
Two-plate intaglio print with relief embossment, 24 x 18 in (61 x 45.7 cm)
Laura Stark has collaged text and images using a photocopier and transferred this to a solarplate to form the key plate. The background is a collagraph, an impression printed from a plate built from cardboard and other materials.

INTRODUCTION

Ever since ancient cave people used stenciling to produce impressions of their hands there have been printmakers. The earliest known relief prints are woodcuts dating from almost 2000 years ago in China, and from the medieval period onward many innovative printmaking techniques have appeared, such as engraving, etching, drypoint, lithography, mezzotint, photogravure, screen printing and others, all of which have become part of the rich tradition of printmaking. This book is about a revolutionary new technique, solarplate printmaking, which Master Printmaker, Dan Welden, first developed in 1972.

Traditional relief printmaking

1. A printmaker carves away part of the surface layer of a block of wood or linoleum.

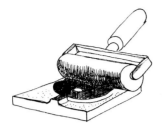

2. Ink is rolled on to the remaining raised surface.

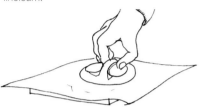

3. Paper is laid on to the block and pressure is applied either by hand or with a printing press.

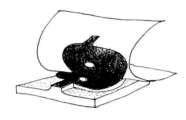

4. The image is printed on to the paper. *Note that the printed image appears in reverse.*

Traditional intaglio printmaking

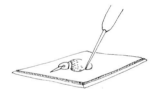

1. A printmaker draws through ground on a metal plate.

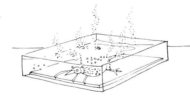

2. The plate is immersed in an acid bath.

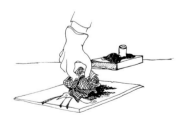

3. Ink is applied to the plate and the excess is wiped away, leaving ink in the etched grooves.

4. Dampened paper is laid on to the plate and the plate and paper are run through a printing press. *Note that the printed image appears in reverse.*

TRADITIONAL PRINTMAKING

print is an image most commonly created by transferring ink to paper using pressure. Making a print can be as simple as rolling ink on a fingertip or a leaf and pressing this on to paper. But in most forms of traditional printmaking an artist works on a matrix, and, whether carved in wood, etched in metal, drawn on stone, or stencilled from silk, the matrix provides a sensitive surface from which the printed image is drawn.

Before printing an edition, an artist makes a succession of impressions, often working on the plate or block further to modify the image and experimenting with different colored inks and inking techniques. This process is called proofing. For the artist it is an important stage for revising and evaluating the image, and the culmination of all the creative and physical energy invested. Once the image is fully resolved, it can be printed in multiples to make an edition. Printmakers vary a good deal in their approach to editioning: for some, making each impression as similar as possible is a sacred discipline in itself, while for others, employing more painterly techniques allows the creation of variable impressions. The artist uses the matrix as a tool for creativity, and whether the prints from one edition are identical or variable, each print is an original.

Woodcut, stone lithography, and intaglio processes are the oldest and most traditional techniques, and still widely practiced by artists today. Many of these same artists also make use of modern manufactured materials, such as linoleum, glass, plaster, and plastics, and incorporate technological innovations in photography and computer technology, sometimes combined with more traditional

methods. The solarplate method described in this book deals primarily with relief and intaglio printing, thus we do not discuss the other main print techniques, lithography and screen printing, which are covered in other specialist books.

The most ancient print technique is relief printing, traditionally worked on wood, but now more commonly on linoleum. A printmaker first carves or scores an image into the flat surface of a wood or linoleum block using special tools. The raised part that has not been carved away is called the relief surface. Ink is rolled on to the relief surface, paper is laid on the inked block, and the ink is transferred either by rubbing the back of the paper with a baren or by means of a press. Only the relief parts of the block print to form the image.

Intaglio is the inverse of relief printing: the inked image originates in the grooves just below the surface of the plate. Drypoint, engraving, and etching are common intaglio processes, with etching being the most favored. For a simple line etching, a printmaker draws with a sharply pointed tool through a coating of acid-resistant ground previously laid on to a metal plate. This exposes the metal beneath the ground, and when the plate is immersed in an acid bath, lines and grooves are etched into the exposed metal. The ground is cleaned off, ink is applied to the plate so that it sits in the etched lines, and the excess ink is wiped off the surface. Dampened paper is laid on the plate, covered with felt blankets, and rolled through a press with sufficient pressure to force the flexible, damp paper into the grooves, thus picking up the ink and transferring the design to the paper. In both traditional relief and intaglio techniques you always work directly on the plate, and must compose the image in reverse.

WHAT IS SOLARPLATE?

tching is a long and involved process and Dan Welden, in a search to find a simpler alternative, began experimenting with light sensitive polymer plates used in letterpress printing. In the 1960s these polymer plates started to replace traditional metal plates, effectively freeing industrial printers from the hazards of poisonous lead fumes generated when making lead type on composing machines. Dan found that by exposing a plate in the sun, he could make a high quality intaglio plate very simply and quickly, thus the name "solarplate." Now the technique is widely known as "solarplate printmaking," or "solar etching," a term that describes so well the way many printmakers are working—exposing plates in sunny backyards and spending more time in the fresh air.

What is so special about solarplate printmaking that a book should be written about it? Firstly, to make a solarplate print you create a piece of artwork on a transparent or translucent film, overlay it on a solarplate, and expose the film and plate together to the sun. The surface layer of the plate is composed of a light sensitive polymer, which is also soluble in water. Wherever ultraviolet light strikes the surface of the plate, the polymer hardens, while the parts of the polymer blocked from the light by the opaque lines and marks of the drawing remain soluble. By scrubbing the plate gently in tap water, the soluble residue washes away, leaving a plate with lines and grooves seemingly etched in the polymer. Effectively you are transferring the drawn image to the plate, and the plate can then be used to print either in relief or in intaglio. A further benefit of solarplate is that, unlike traditional relief and intaglio methods, with solarplate printmaking there is no need to compose an image in reverse—the printed

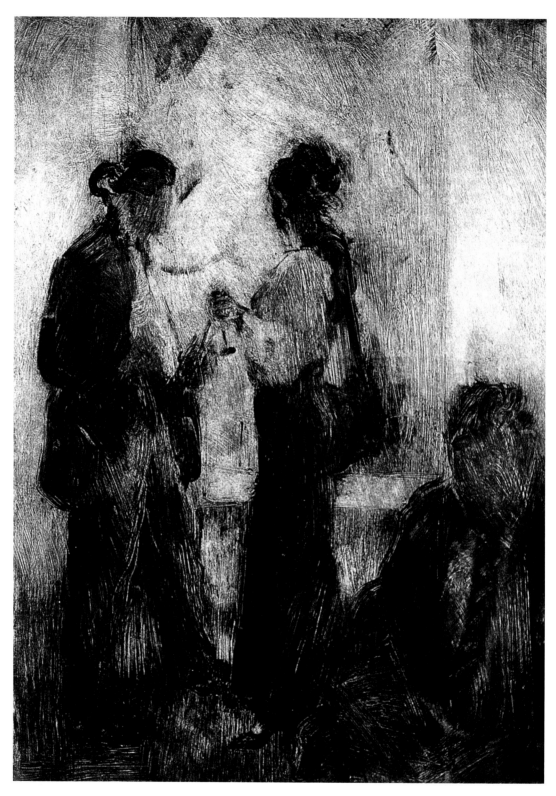

Joe Peller, *Gallery Opening,* **1997**
Intaglio print, 12 x 9 in (30.5 x 23 cm)
You can work directly on a solarplate. This Degas-like
image was created by painting with etching ink on the
polymer. The plate was exposed in the sun and printed
using the a la poupée inking technique.

image appears with the same orientation as the original drawing.

One of the most exciting characteristics of solarplate is its flexibility, which allows printmakers to generate a wide range of printed effects. Depending on the materials used to create a transparency, prints can resemble etchings, lithographs, screenprints, linocuts or exhibit photographic effects. Because of this special property, solarplate printmaking offers a very attractive alternative to traditional etching and lithography. You can also make a solarplate in a matter of minutes and the process is highly predictable, while etching and lithography are lengthy and chemically complex, and, therefore, prone to error and disappointment. In addition, there is no need to buy expensive equipment and chemicals for different processes, since with access to a basic printing press and a sunny, or even a cloudy day, you can achieve a great variety of effects with one simple technique.

There are many other advantages: printing is less arduous because you require much less pressure to print an intaglio solarplate; the plates are very durable and will print many impressions; when planning a color image with multiple plates you can work on a number of transparencies, laying them one over the other for ease of registration; and, unlike the color changes that appear in prints when inking different metals, you can apply any ink to the polymer and the color will remain true.

There is a whole range of opaque drawing materials and films to work with and many exciting ways to create an image. For example, you can draw with ink, pencils, graphite sticks, crayons or felt tip pens on drafting film, grained glass or textured or smooth transparencies. As well as drawings, you can use photocopies, photographs, found objects, digital images, or photographic positives made in the darkroom as the basis for a print.

You will find this technique simple, maybe even addictive, and it will be a revelation to

Solarplate printmaking

1. A printmaker draws on a transparency.

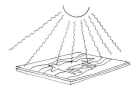

2. The transparency is placed face-to-face with the solarplate and exposed in the sun. UV light penetrates clear areas of the transparency and hardens the polymer, while areas beneath the opaque lines of the drawing remain soluble.

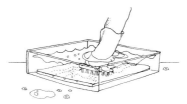

3. The plate is scrubbed in tap water and the soluble areas are washed away.

4. The plate has grooves and lines similar to an etched metal plate.

5. The printmaker inks the grooves and wipes the surface to create an intaglio print, or . . .

6. the printmaker rolls ink on to the surface and creates a relief print.

experienced printmakers to find they can make plates with only the sun and water. Solarplate printmaking has attracted a diverse range of talented art practitioners, artists, photographers, and serious printmakers, many of whom have generously contributed images for this book. We hope their work will inspire readers to try this technique for themselves, and experience this highly versatile and expressive new art medium.

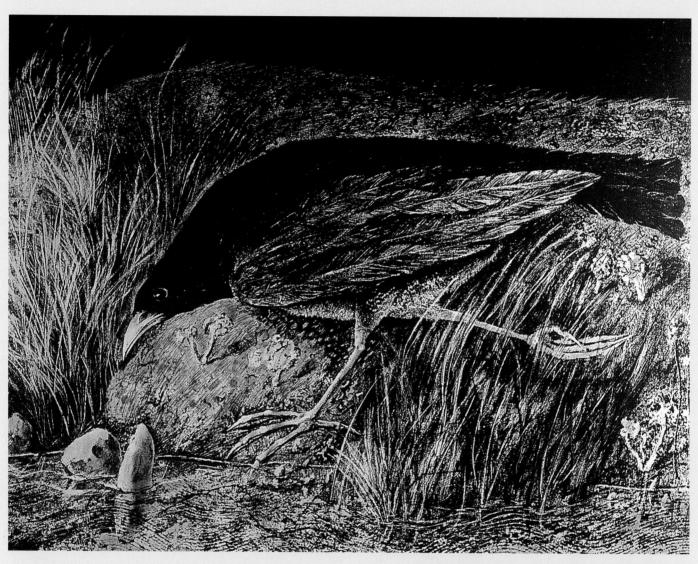

Kelly Fearing, *Dark Bird in Passage Searching*, 1996
Intaglio print with hand coloring, 18 x 24 in (45.7 x 61 cm)
Made from an original drawing, enlarged on to a photocopy
transparency and reworked with lithographic crayons, ink,
and scraping back techniques. The plate was printed by
Jerry Manson with a special mixture of Charbonnel and
Graphic Chemical & Ink Co intense black, to achieve a rich,
deep black color.

EQUIPMENT AND MATERIALS FOR MAKING SOLARPLATES

One of the many wonderful things about solarplate printmaking is the ease of setting up. Many of the materials required for exposing and developing solarplates, such as brushes, trays, a timer, talc, oven thermometer, and hair dryer, are household items, which you may already have around the studio or can easily find at the local supermarket or hardware store. A contact frame for exposing plates is a basic piece of equipment easily constructed from board, foam, duct tape, glass, and spring clamps. You need opaque drawing media and transparency films and most reputable art suppliers stock a wide range to choose from. Solarplate can be found at printmaking suppliers and direct through specialist agencies (see p.142), while a guillotine or paper trimmer is a very useful addition to your studio for cutting and trimming plates and other materials.

ABOUT SOLARPLATE

Soledad Salamé, *Invisible World*, 1998
Intaglio print and gold leaf, 24 x 18 in (61 x 45.7 cm)
Originally drawn on acetate, this print shows how
solarplate can capture subtle tones and fine brush work.
The artist added gold leaf after printing the image.

Solarplate is tough and resilient. It is ideal for working with in the sun since exposure times are rarely affected by extremes of winter and summer temperatures. The residue washes out in water very easily during developing, and, although it is best to control the temperature of the water, the temperature can vary quite a bit without adversely affecting the process.

Solarplate has what is called a "wide latitude of exposure," which means the polymer is resistant to small variations in the intensity of UV light. This makes it an ideal plate for exposing outside in varying seasonal and weather conditions. When printing, you will find it very durable: when printing editions from intaglio solarplates you can obtain seventy-five, and sometimes a hundred or more impressions, using gentle wiping techniques, and many more impressions are possible from a relief plate.

EXAMINING SOLARPLATE

If you hold a solarplate in your hand you will see that it is made of a thin steel base coated with a thin layer of green plastic. The green plastic layer is the light sensitive polymer which, in turn, is protected from dust and damage by a translucent cover film. You must remove the protective film before an exposure so that when you lay the transparency on the plate it is in close contact with the polymer surface. Poor contact is one of the commonest problems encountered when first learning to make plates, and can lead to disappointing images that look faded or patchy. Another barely visible, fine matte film sealed to the surface of the polymer promotes good contact between the transparency and

the plate surface during an exposure. It is this film that tends to retain ink during wiping and creates the light plate tone characteristic of intaglio prints.

"Polymer" is a generic term describing a huge range of natural and synthetic substances. Natural polymers are ubiquitous in living organisms and make up many of the substances essential to life; for example, fats, proteins, and carbohydrates are all polymers. Many of the properties of synthetic polymers mimic natural processes, and the hardening of the polymer layer of a solarplate in UV light is much like the formation of the hard chitinous outer skeleton of a newly emerged insect as it basks in the sun.

The light sensitive layer of an unexposed solarplate, although frequently called a polymer, is not a true polymer until transformed into a hard plastic by UV light. It is largely made up of chemicals consisting of small, water-soluble molecules, or "monomers." When the plate is exposed to UV light, the light, aided by a catalyst, triggers a chemical reaction called "photopolymerization" where monomers link in repeating units to form long molecules or polymers of plastic. You can compare the process to popping many identical beads together to make a bead necklace. These long molecular chains then cross-link, creating a strong three-dimensional network, which appears as the hardened polymer to the naked eye. Between the steel base and the polymer is an antihalation chemical that prevents light from reflecting uncontrollably off the shiny steel base, and, in turn, prevents errors in the polymerisation process and distortions in the final structure of the polymer. Once hardened the polymer is very strong and resistant to many chemicals, but it is still soluble in water, and if left soaking in water or stored in a humid environment, it will start to erode and deteriorate rapidly.

Author's note

We have tested many brands of polymer plates and found that they all require different exposure and development conditions. These characteristics significantly affect the handling of plates and the look of the final print, particularly the intaglio print. Of all the plates tested we found Torelief plates made by Toray were the best for printmaking, and when referring to solarplate we mean the brand Torelief.

HANDLING SOLARPLATE

Solarplates are firm and light and easy to handle. The plates most suitable for printmaking are coded according to their overall thickness: plate numbers 95, 83, 73, and 43 indicate an overall plate thickness of 0.95 mm, 0.83 mm, 0.73 mm, and 0.43 mm, respectively. It is better to avoid plates thicker than 0.95 mm because they have a very tough steel backing which is difficult to cut without warping the plate. The 95 plate is more readily available in Australia and New Zealand, while the 83, 73, and 43 are more popular in the U.S.

Any of these plates are suitable for intaglio work, but thinner plates are preferable. With thinner plates the lines and grooves that form in the polymer are often shallower and hold less ink; consequently there is less chance of ink bleeding on to the paper during printing. Generally, the thinner the plate, the thinner the polymer layer, and the shorter the exposure and washout time required.

It is better to use the thicker plates for relief printing since it is much easier to roll ink on to a thick plate. Also, blind embossing is more attractive with the thicker plate which can provide a deep relief structure, and by washing away the residue down to the steel backing, you will be able to exploit the full depth of the polymer layer.

Basic equipment:

Solarplate

Guillotine/Paper trimmer

Lightproof paper

Baby oil

Tissue paper

Plastic bags

Cardboard

Another characteristic is the sponginess, or compressibility, of the hardened polymer, referred to by industrial printers as the *shore hardness*, or *shore D*, measured in degrees from 0° to 100°. All the plates we recommend using are of a medium shore hardness of between 55° and 65°, which is the best for printing on a manual press.

BUYING SOLARPLATE

If you are new to the technique and want to try it out first, you can purchase a single plate. Some suppliers also have a guillotine service and will cut plates to any size for a small fee, although you can cut them yourself. The most economical way to buy plates is in bulk and agents will package plates appropriately. Always wrap plates in lightproof paper if you are transporting them, otherwise UV light can harden the polymer prematurely, rendering the plate useless. Never transport plates in very hot or humid weather, even when the plates have been processed.

STORING SOLARPLATE

While the manufacturer guarantees solarplate for twelve months, most commercial platemakers and agents estimate that plates will last at least two years and perhaps for as long as four or five years if stored correctly. As plates age, the polymer becomes less sensitive to UV light and may require longer exposures to obtain a result. Some solarplate samples we tested were three or four years old and required the same exposure time as new plates, and we believe the life span of these plates is many years.

Prior to storage, apply a thin film of light oil, such as baby oil, to the back and front surfaces of plates after printing to help preserve the polymer. Then wrap them individually in tissue paper, and pack and seal them in plastic bags. If left in the open air for a long time the polymer may become brittle and start to separate from the steel base.

Keep plates in a cool, dry, dark place well away from your workroom. Solarplate gives off a slight odor, which can permeate your workspace very quickly. Try to store plates flat; the thin steel backing may bend if you leave the plates in an upright position or lean them against a wall. It is also important not to put anything heavy on top of the plates because weighty objects may leave an impression on the surface of the polymer that can reappear later as a dark shape in intaglio prints. If you are storing many plates on top of one another, interleave them with cardboard to avoid indentations.

WORKING WITH THE PLATE

It is good practice to keep plates wrapped in lightproof paper as much as possible and, when handling plates in the studio, to keep them away from sunlight streaming through windows and any other sources of daylight. We have found that it is quite safe to work on a solarplate under normal room lighting conditions for up to two hours, although much depends on how much daylight penetrates the room. Keep in mind that if plates are left out on a bench unprotected and exposed to light for many hours, even the very small amount of UV light in fluorescent or incandescent lights can prematurely harden the polymer.

CUTTING PLATES

It is important to cut plates so they are completely flat without a warped edge, a bent corner, or a lip along the cutting edge. This is not always easy to do because the steel backing is flexible and designed to wrap around the large cylinders of commercial rotary presses. To avoid these problems use good cutting equipment and always cut the plate with the polymer surface facing upward. One of the most frequent causes of poor contact and consequent patchiness in the final print is a badly cut plate; a cleanly cut plate will ensure

close contact between the transparency film and the polymer during an exposure.

Before cutting you should mark out on the protective film how you will cut the plate. You will need a number of small pieces for test exposures as well as a plate for the complete image. The plate destined for the entire image should always be slightly larger than the size of your transparency, approximately $1/8$ to $1/4$ inches (.3 to .6 cm) larger all round; this border is trimmed away before printing.

For test exposures, cut strips approximately 1 to $1 1/2$ inches (2.5 to 3.8 cm) wide by 4 to 6 inches (10 to 15.2 cm) long, or small rectangular pieces 2 by 3 inches (5 by 7.6 cm), depending on the shape and size of your image. You may need several test pieces for an image, and even two or three test pieces per exposure for a large image, particularly when starting off. Once you have gained sufficient experience, you may not find it necessary to make test exposures and may be able to proceed directly with platemaking.

METAL GUILLOTINE: One of the most effective cutting machines is a metal guillotine, often located in art schools and well equipped print workshops. Check that the blade is sharp, otherwise it can bend the solarplate or leave a lip along the cut edge. Take great care when you use these powerful machines; they are quite capable of removing fingers.

PAPER TRIMMERS: A substantial paper guillotine or trimmer is a great investment for your studio. They can cut a solarplate with a single sweep of the blade, slice away warped edges, and are useful for trimming the plate accurately in preparation for printing. Kutrimmer, a German guillotine, is one of the best; it cuts cleanly leaving no lip along the cut edge, and in our experience the blade requires no sharpening even with constant use over several years. Paper trimmers designed for cutting twenty-five or more sheets of paper at a time are also strong enough for cutting solarplates, and often come with a self-

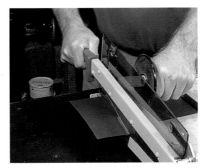

Using a paper cutter to cut and trim plates.

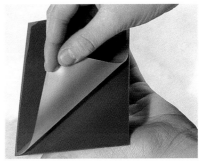

Solarplate comes with a protective plastic film that must be peeled off and disposed of before an exposure. Note that the cover film does not protect the plate from light.

sharpening blade. One author has used an Ideal machine for several years without needing to sharpen the blade. Try to test a particular guillotine or trimmer on solarplate before you purchase it, since some will warp a plate badly. It is also a good idea to buy guillotines and trimmers that have a shield or clamp to prevent cut fingers. If the clamp has a cushion, you can hold the clamp down on the plate without damaging the surface. But if it has no cushion, simply cover the polymer layer with a piece of cardboard, plastic or heavy paper, hold the clamp down, and cut.

DISK DRIVE CUTTER: This is another good machine: it causes virtually no warping of the plate and is very accurate. In place of a blade there is a small sliding disk with a very sharp edge. Clip the solarplate into place, and slide the disk along the cutting line several times, pressing down as you do so. Remove the plate from the cutter, and, by gently bending the two parts of the plate, the steel should break apart easily. When the small disk is blunted, you will need to replace it with a new one.

KNIVES: It is common for commercial platemakers to cut their plates with a scalpel and, similarly, printmakers can use a scalpel, a snap-off design knife, or a utility knife. Make sure you insert a fresh blade before cutting, then, with the polymer surface facing upward and holding a metal ruler firmly on the plate, drag the knife along the cutting line several times until you can feel the grating resistance

of the steel. You can tell if you are making sufficient headway by looking at the back of the plate for a raised impression on the steel. Gently bend the two parts up and down until the steel snaps, or use the edge of a bench, securing one half of the plate on the table with the cutting line near the edge and moving the other part up and down until it snaps.

OTHER TOOLS: A draw tool with a very fine replaceable blade can cut through the steel backing with just a few strokes. Some are available from hardware stores, while professional draw tools are available through picture framing suppliers. In Australia the Olfa P-cutter 450 is ideal. Always mark the plate with a pen before cutting with a draw tool.

If you want to shape a plate, always cut it after it has been exposed and developed. Although difficult and time consuming, a scroll saw or jewelers saw is the best tool for this job. Tin snips or scissors are also useful for shaping plates, but need care since it is easy to warp the plate.

Using a draw tool

Setup for cutting the plate with a draw tool.

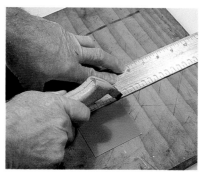

Using a T-square and board, repeatedly score the plate with the draw tool.

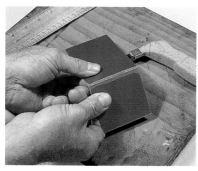

Bend the plate back and forth gently until it snaps in two.

The cut plate.

MATERIAL FOR PREPARING IMAGES

The most immediate way to create both relief and intaglio prints is to draw with opaque and semiopaque media on a transparent film, or transfer images to a film using a photocopier. Working with images on film is an indirect way of working, but you can also work directly by painting and drawing or arranging found objects on the polymer. (More sophisticated approaches to transferring digital images and photographic images to film are described on pp.101–114.)

The list of drawing media you can use is extensive, and experimenting with different ways of applying materials to a variety of transparencies, using brushes, pens, and other tools will yield a great range of printed effects. Many of the drawing methods can be used to create either a relief or an intaglio print, and any plate you make can be printed in either relief or intaglio.

DRAWING MATERIALS

Choose opaque or semiopaque materials when selecting drawing media. Black is preferable to colored inks and pencils that frequently let light through, although some colored media can be used to create light, subtle tones. Exceptions are liquid opaque pens or paste that are dark red or metallic, and perform more like black materials. If you plan to work in the sun, first test your drawing media to make sure they will not liquefy in the heat, since this can ruin your original drawing.

Relief prints are normally high contrast black-and-white images and it is common to create an image for a relief plate by scratching through an opaque film, such as Scriberite or photographic film, using a variety of tools. Assemble a range of scratching materials and tools, such as sandpaper, scalpels, safety razor

blades, a drypoint needle, linocut tools and a design knife or utility knife. These are ideal for scratching and altering all kinds of drawings and photocopies, and also for reworking the plate.

When working with intaglio images, you will find solarplate has the exciting potential to capture light pencil marks and subtle marks and tones drawn on a transparency. Also, with careful preparation it is possible to create intaglio prints with deep, rich, velvet blacks and an attractive light plate tone, both highly valued qualities in traditional printmaking. The kind of drawing materials you choose and how you apply them will affect the aesthetic quality of the printed image.

DRAWING FILMS AND OTHER TRANSPARENT MATERIAL

For drawings it is a good idea to select good quality transparencies which do not distort in the heat or buckle with washes, and remain flat after being worked on. Thin, flexible transparencies are preferable since they will give good surface contact with the polymer during an exposure. The surface of the film, whether it is smooth or textured, also influences the aesthetic quality of your drawing. Single and double matte drafting films, good quality tracing papers, and vellum are excellent for drawing and painting, and best for creating smooth lines and wash effects in prints. There are versatile, textured films

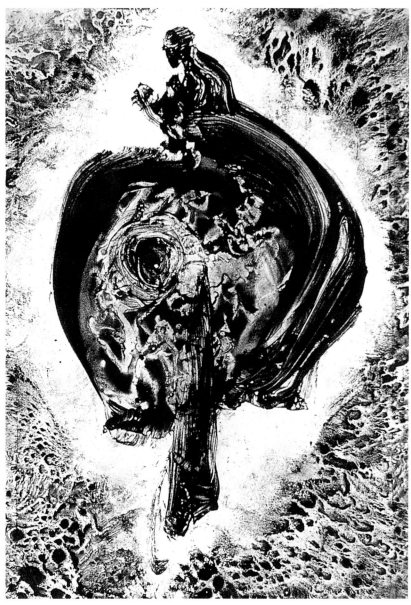

Nik Semenoff, *Contemplation*, 1999
Intaglio print, 15 x 11 in (38 x 28 cm)
Nik Semenoff used photocopy toner dissolved in solvent to paint on clear acetate, and then heat set the resulting image before creating the solarplate.

Results obtainable with drawing materials

Texture and tone	Soft B and E pencils, Stabilo pencils, lithographic pencils, lithographic crayons, charcoal, graphite sticks and pencils, oil crayons.
Smooth lines and marks	Opaque and semiopaque felt tip pens, rapidiographs, pen and India ink, liquid opaque pens, soft B and E pencils.
Painterly marks and tonal washes	Dissolve tusche, lamp black powder, gouache, or drawing ink in water; apply black oil-based paints and inks with brushes and dilute with baby or vegetable oil.

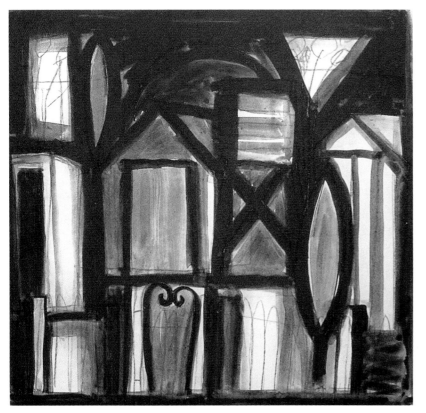

Dieter Engler, *Glencoe Farm V*, 1998
Two-plate intaglio print, 5.5 x 10.75 in (39.5 x 27 cm)
Dieter Engler created the transparencies for this
solarplate print by painting with gouache on drafting film
in an expressive manner.

**Brad Cushman,
*Cubism: Work Done
by Cuban Artists*,
1994**
Intaglio print, 4.75 x
3.75 in (12 x 9.5 cm)
To create this image,
Brad Cushman collaged
a photocopy of Fidel
Castro's head on to the
body of Pablo Picasso.

called True-Grain, also known as Autotex, and translucent textured acetate, which tend to endow prints with grainy, textured qualities. Acetate and other plastic transparencies also provide interesting surfaces to work on. However, you will be limited in the range of media that can be applied to shiny plastic surfaces, as many media will not adhere or leave smudges; only special markers, like the Finepoint series, and some permanent and overhead markers work well.

Many of the above transparencies are fairly substantial and will withstand more vigorous drawing techniques like scratching, rubbing, and erasing. It is a matter of choosing the medium and transparency that will give you the desired effect. We offer a word of warning about Plexiglas, Perspex, and polycarbonate plastics: some of these are UV resistant and completely block out UV light, so always test a sample piece or check with the supplier before buying in larger quantities.

An exciting way to work is to draw directly on plate glass, either clear or glass that has been sandblasted or grained. You can learn to grain glass yourself. It requires some fine carborundum powder, water, and a graining tool, such as a levigator, a glass muller, a lithography stone, or a small, thick piece of plate glass. (There is more about working on glass on pp.67–69.)

In addition to experimenting with a wide range of drawing methods, you can also photocopy images and drawings on to transparent film. Some photocopy services will allow you to use your own transparency films, which is usually cheaper than buying them from the photocopy service. If so, you must buy photocopy or overhead transparency films made of a special heat resistant plastic, which will not melt in the photocopying machine. Color photocopiers also require special transparency films usually supplied by the photocopy service.

EQUIPMENT FOR EXPOSING

For a low-tech approach you can build a contact frame for exposing small plates in the sun or in a simple UV light box. A UV light box is versatile and very handy if your lifestyle does not allow you to use the sun. For large plates and expensive photographic film it is better to use a commercial exposure unit with a good vacuum frame to avoid contact problems and damaging delicate film. (There is more about exposing in the sun, how to make a UV light box, and using commercial exposure units on pp.93–99.)

CONTACT FRAME

When making a contact frame always construct it is so that it has a border at least 1 to 2 inches (2.5 to 5 cm) larger all around than the size of the solarplate. We recommend not exceeding a plate size of 16 x 20 inches (40.6 x 51 cm) for exposures in a contact frame; for larger plates you will require a vacuum frame.

To construct a contact frame for a plate that is 4 x 6 inches (10 x 15 cm):

1. Cut a plywood base 6 x 8 inches (15 x 20 cm).

2. Cut a piece of foam at least ¼ inch (0.6 cm) thick the same size as the base and secure it to the wooden base with duct tape. If the foam is too thin it will not give the plate sufficient support to ensure good contact between the plate and the transparency film.

3. Cover it with a piece of glass the same size as the base. Only use glass that is free of scratches and make sure it is spotless, cleaning it thoroughly with window cleaner if necessary.

4. Finally, to keep the layers together reasonably tightly, clip spring clamps on each of the four sides. Make sure the clamps do not overlap the solarplate, otherwise they will block out UV light and any polymer under the clips will

wash away. You can use thin glass for the cover, but thicker plate glass helps to weigh down the film against the polymer and improve contact.

An alternative to a contact frame is the specialized frame which photographers use in the darkroom for contact printing. Some are simple glass frames with removable backs and spring clips. Others have a hinged glass frame attached to a rigid support. Either type works well providing you arrange a cushion support, like foam, on the rigid backing to ensure good contact during exposure.

TALC

Dusting the polymer surface with a light coating of talc is an old platemaker's trick designed to prevent films from sticking to the polymer during an exposure. It is useful to apply it with a soft wide brush, such as a hake brush. Use baby powder or cosmetic talc since commercial talc, also called French chalk, sometimes contains a small percentage of asbestos that may be harmful.

Making a contact frame

Many materials can be employed to cushion the plate. Foam and bubblewrap are highly effective.

To make your own contact frame you need a plate glass cover, foam backing, rigid support board, and clamps.

Using duct tape to adhere the cushioning material on to the back of the flat board.

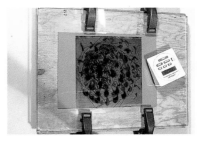

A completed contact frame with a solarplate, positive transparency, and a timer, ready for exposure.

23

Making test strips

 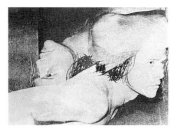

A series of test strips; the backs of the plates are marked with exposure times.

Proofs of the test strips may be taken for closer examination. They are also a useful means of keeping records of the different exposure times.

Happy accidents and unpredictable results are part of the solarplate adventure. Shown is the same image inadvertently exposed twice on the same plate.

Talc has many other applications in the printmaker's studio. You can apply it to a drawing to increase its opaqueness, dip fingertips into talc when printing to prevent inky fingerprints appearing on your printing papers, and, when you clean oil-based ink off relief rollers with solvent, dust the roller with talc to absorb excess solvent and preserve the rubber.

TIMER

When you start platemaking you first expose a transparency on test strips of solarplate using different exposure times. This allows you to estimate the correct exposure time before exposing the final plate, and avoids the expense of wasted plates. Exposures can vary from less than 1 minute up to 30 minutes, and any kind of timer which records minutes and seconds accurately will suffice.

PROTECTIVE GEAR

Wear protective clothing such as an impermeable apron and nitrile gloves during platemaking. And it is especially important when developing plates to put on chemical splash goggles. Contact safety suppliers to buy this equipment (see pp.142–143).

Tom Wasik, *Self Portrait,* 1999
Photopolymer gravure print, 11 x 15 in (28 x 38 cm) This plate was printed in blue/black, demonstrating that testing pays off.

EQUIPMENT FOR DEVELOPING

Developing a solarplate takes a matter of minutes, but it is essential to work well away from sunlight, which can re-harden the soluble polymer. If you work inside make sure you have good ventilation. Many printmakers work outside in the shade, or keep the exposed plates in a drawer or wrapped in lightproof paper, and develop them outside in the evening.

TRAYS AND SINKS

Buy some shallow, flat-bottomed plastic trays or photographic trays for developing solarplates if you do not have access to a sink. The trays should be large enough to comfortably hold your plates and leave room for scrubbing. A great trick is to stick a piece of magnetic vinyl to the bottom of a tray with waterproof glue, or place it in the bottom of a sink, arranging it with the magnetic surface face up. Then the solarplate, which is lighter than a zinc plate or wood block, will stick to the vinyl and not slide around when you are scrubbing it. Alternatively, simply glue the magnetic vinyl to a flat piece of board and put it in the tray or sink when washing out plates. You can buy magnetic vinyl from plastic or sign suppliers, or ask for an old sign no longer in use, which would serve the purpose equally well.

BRUSHES

You need some kind of bristled brush, such as a soft nailbrush, to scrub away the soluble polymer. A body brush, the type used in the shower, is ideal for larger plates. Solarplate is quite tough and the bristles need to be reasonably stiff. If the residue seems difficult to wash out, then your brush may be too soft, while if printed images have ragged lines and edges, the brush could be too stiff. After developing a number of plates you may find the bristles stiffen and become harsh from accumulation of hardened polymer. To preserve your brushes, soak them in some water and a little detergent until the bristles soften and rinse in clean water before using again.

BLOTTING CLOTHS

You need a clean, lint-free towel, newsprint, or damp chamois leather to blot the plate after developing. Avoid materials like cheap sponges or paper , as they are not as absorbent and tend to disintegrate, leaving bits of sponge and paper sticking to the plate. Lithographic sponges are not suitable, either since they spread excess polymer over the plate and can transfer unwanted marks to the final image.

THERMOMETER

An oven thermometer or photographic dark-room thermometer is suitable for monitoring the temperature of the washout water.

DRYERS

A simple hair dryer is sufficient to dry plates in a few seconds. But it is worth noting that watermarks and spots on the plate will print large and interesting blotches for several impressions, and may be worth experimenting with in some instances.

Equipment for developing:

Developing tray

Soft brush

Lint-free towel

Oven thermometer

Hair dryer

Impermeable apron

Chemical splash goggles

Nitrile gloves

Before exposing plates, have the necessary materials at hand: water, magnetic vinyl tray, nitrile gloves, thermometer, hair dryer, tweezers, metal file, newsprint or blotting cloth.

Brushes used to wash the plate.

Dan Welden, *Canyon 41*, **1987**
Intaglio monoprint, 18 x 24 in (45.7 x 61 cm)
Dan Welden painted on to a processed plate with water-based Createx monoprinting inks and printed the plate in intaglio, achieving a very painterly effect. You can work solely with water-based inks if you wish, although the polymer will erode more quickly with water-based inks.

EQUIPMENT AND MATERIALS FOR PRINTING

You will achieve the best results if you work in a room or studio with plenty of space, good lighting and good ventilation. If you are new to printmaking and setting up a studio for the first time, make sure to allocate places for the press, an inking area, drying prints, and storage space for papers, inks, and other equipment. It is important not to contaminate any clean paper or prints, so it is a good idea to designate a clean area for storing paper and drying prints well away from inks, printing, and press work.

For printing solarplates you will need relief and etching inks, ink modifiers, a variety of inking tools and equipment, and good printing paper. Access to an etching press will allow you to print both relief and intaglio plates. Local art suppliers stock many of these items, but it is better to select and order materials and equipment from the informative catalogues published by specialized printmaking suppliers, who often sell presses as well. (Many of these are listed in the supplier section on pp.142–143.)

GENERAL EQUIPMENT

Setting up your work room with some basic equipment for inking either relief or intaglio plates will make printing easier and more systematic.

PROTECTIVE GEAR

Always work in protective clothing. Wearing an impermeable apron and nitrile gloves will minimize exposure to the pigments and solvents in ink. Use thin, disposable nitrile gloves, similar to surgical gloves, which will make handling and wiping of plates quite easy. You can obtain suitable safety equipment from most safety suppliers. (See Safety and the Working Environment, pp.129–137.)

TWEEZERS AND METAL FILE

The polymer of solarplate has electrostatic properties and will attract fine hairs and particles. Prior to printing, examine a plate carefully and remove any debris from the surface with tweezers.

You also need a metal file for removing burrs from the steel plate and rounding off the sharp corners of plates prior to printing.

NEWSPRINT

Ample supplies of clean newsprint laid out on benches in readiness for printing will help keep your work area clean. Art suppliers sell newsprint in sheets, but it is much cheaper to buy it in rolls from bulk paper suppliers.

INK SLAB

A good-sized piece of plate glass or marble provides an ideal surface for rolling out and mixing ink. You may need two or three slabs if you intend to use colored inks. It is a good idea to place a sheet of white paper or newsprint under the glass, so that you can see the colors accurately. When ordering glass, ask the supplier to sand away any sharp, cutting edges and make sure it is large enough for your widest roller.

INKING KNIVES AND SPATULAS

Spatulas, putty knives, and cheap paint scrapers are available from hardware stores and are useful for removing ink from tins. Many professional workshops prefer inking knives with square blades that are better for mixing ink on the slab and allow even removal of ink from tins. They are also very effective for scraping off remnants of ink when you clean the slab after a printing session. Assemble several inking knives if you are using colored inks; you will need one knife for each color so there is no risk of contaminating colors.

INKING BOARD

Inking and wiping intaglio plates or rolling ink on to relief plates is almost effortless with an inking board with a magnetic surface. Take a piece of board, about 18 x 24 inches (45.7 x 61 cm) in size and 1/4 to 1/2 inch (.63 x 1.27 cm) thick, and with contact cement or super glue adhere a similar sized piece of magnetic vinyl on to the board with the magnetic surface facing upward. Smooth the vinyl with the flat of your hand to remove any air bubbles, put a board over it, pile on some weights, and let the glue dry for a few hours. When inking, you can locate the solarplate near the edge of the inking board, jutting out over the edge slightly; this allows you to lever the plate up easily when you have finished inking and facilitates wiping the edges of the plate prior to printing.

Printmaker Bill Negron wearing nitrile gloves, apron, and mask.

General equipment:

Tweezers

Metal file

Newsprint

Ink slab

Inking knives and spatulas

Inking board

Impermeable apron

Nitrile gloves

MATERIAL FOR RELIEF PRINTING

The two basic items you need for relief printing are relief inks and rollers. Rollers, sometimes called brayers, are designed to roll ink on to flat printmaking surfaces.

RELIEF INKS

Relief inks, often referred to as block printing inks, are available in oil- or water-based dispersions. For relief printing of solarplates the best ink to use is an oil-based relief ink which will give a crisp image and allow you to print a large number of impressions. Graphic Chemical & Ink Co and Van Son Holland make good oil-based relief inks.

You can buy ink in tins or tubes, but for a long-term commitment to printmaking the most economical way of buying ink is in $^1/_2$ lb and 1 lb tins. You need to take good care of ink in tins and keep the lids on as much as possible because when left to the air, the ink will dry out and lose its smooth consistency. It often forms a crusty skin, which can then break up into unmanageable lumps and become useless. When removing ink from a tin, do not dig into the solid mass of ink but scrape it from the top. Then replace the paper cover that prevents skinning and replace the lid tightly. Once the paper cover wears out, you can apply anti-skinning sprays or special papers to protect the ink. One trick for oil-based inks is to coat the inside lip of a can with petroleum jelly, rotating it as you apply the jelly for even coverage; this will allow you easier access to the ink.

Oil-based relief inks consist of pigment, linseed oil, and additives. Pigments give inks their brilliant colors, while burnt linseed oil, sometimes combined with resin, is the vehicle and determines the flow of the ink, its drying properties, and promotes the binding of pigment to paper. The additives include solvents, anti-oxidants, driers, and plasticizers: solvents thin the ink to a manageable consistency, anti-oxidants stabilize ink, driers speed up drying, and plasticizers determine the thickness of inks. Relief inks tend to be stiff and tacky and may need the addition of a small amount of light plate oil to loosen them and make printing easier (see section on ink modifiers, p.31).

Due to health and safety considerations, water-based inks are manufactured at an ever-increasing rate. They are composed of pigment and either gum arabic or acrylic polymer to bind the pigment to paper. They may also contain water, preservatives, and dispersing agents, which improve the life span of the ink and the flow of the inks on paper.

Water-based inks perform well on relief solarplates, but they do have limitations compared to oil-based inks and should be considered as an experimental method of printing. They are not as easy to apply as oil-based inks, they dry faster, which can cause problems when editioning, the polymer often becomes permanently stained with color, and, although the polymer does not deteriorate in the short term, eventually it is eroded by the water in the ink.

ROLLERS

Rollers vary a good deal in price, but, generally, the more expensive the roller, the better

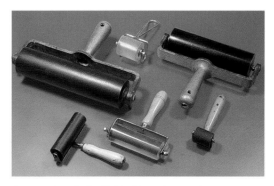

An assortment of rollers or brayers.

Inking the relief plate

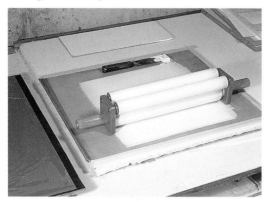

The ink-charged Semenoff Roller for large areas.

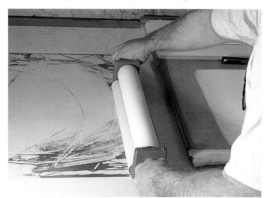

Inking the relief plate.

Pulling the print.

the quality; beware of cheaper brands that do not always apply ink evenly. Smaller rollers consist of a handle, a frame, and most commonly a cylinder of rubber or polyurethane, which is also called a roller. This cylinder can also be made of PVC, neoprene, or other synthetic materials. You can use other types of rollers, which contain fiber and are primarily used in lithography, but they do not always give the best results.

Some brands have removable rollers to make cleaning easier. These can be easily reground or replaced when they become worn out or damaged. Rollers are easily damaged. Never leave a roller sitting with the rubber resting on the ink slab since it can flatten on one side. A well-designed roller may have a frame with a "foot," so that when it is at rest on a bench the rubber cylinder rotates freely and will not become deformed by resting on a hard surface.

Large rollers, often called spindle rollers, have a handle at each end and look like rolling pins. The handles and central cylinder are sometimes made of aluminum with a hollow core to make the tool lighter. The best way to look after large rollers is to buy or make a special storage box with two notches to support the handles; this will keep the rubber roller off the bench and free of pressure.

To obtain even ink coverage the circumference of the rubber roller should be slightly greater than the length of the plate, and the roller wider than the width of the plate. If you are likely to be making different sized plates then you may need a variety of different sized rollers. Rollers vary according to the hardness or durometer of the rubber or polyurethane: 20 to 25 is soft, 30 is medium, and 40 and above is hard. Using a hard roller leads to a printed image with more contrast, while softer rollers transfer more ink to the plate and a softer image results.

MATERIAL FOR INTAGLIO PRINTING

Intaglio printing requires plenty of practice before good impressions start appearing. The basic items you need are etching inks, ink modifiers, ink applicators, and tarlatan and paper for wiping the plate surface.

INTAGLIO INKS

Many of the major brands of etching inks work well with solarplate. These are oil-based and have a similar composition to oil-based relief inks, but have a softer, more buttery consistency. As far as we know there are no water-based etching inks on the market yet, although manufacturers are trying to develop such inks. Try inks made by Faust, Charbonnel, Gamblin, or Graphic Chemical & Ink Co. Some heavily pigmented inks, like the Charbonnel and Gamblin brands, tend to give images a heavier plate tone, although you can reduce plate tone by blending the ink with an ink modifier. Less pigmented inks can often be applied without any modifiers at all. In particular, Graphic Chemical's 514 Black is an ideal printing ink.

If you are a beginner, it is best to buy ink in small tubes until you learn more about color and different types of ink. One advantage of ink in tubes is it cannot skin. You can also buy etching ink more economically in tins. (The recommendations for looking after inks in tins described on p.29 also apply to intaglio inks.) Another way of buying ink is in cartridges, which can be installed in a caulking gun. Graphic Chemical & Ink Co supply ink in cartridges. This arrangement minimizes wastage and avoids the skinning problem. If you have ink left over after a printing session, store it in empty photographic film cannisters or wrap it in greaseproof paper and seal in a small bottle.

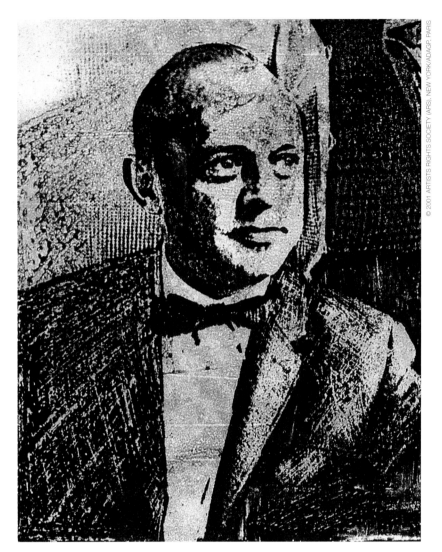

Amy Ernst, *Blue Professor*, 1997
Intaglio print, 15 x 11 in (38 x 28 cm)
You can combine relief and intaglio inking methods on one plate. Here, Amy Ernst inked up the plate with black intaglio ink straight from the can. Then using an ink modifier, she created a transparent blue ink which she rolled on to the surface of the plate.

INK MODIFIERS

Etching inks may be stiff or loose, depending on the brand or age of the stock, and you often need to add an ink modifier to alter the consistency so it is suitable for printing. Use light or medium plate oil to loosen stiff inks. Other modifiers such as Easywipe Compound, tack reducer, miracle gel, and Setswell Compound are frequently added to loosen etching inks and make the wiping of surface ink on intaglio plates much easier.

Equipment for intaglio printing:

Etching ink

Light plate oil

Easywipe Compound

Scraps of mountboard

Tarlatan

Old telephone books

Using intaglio ink

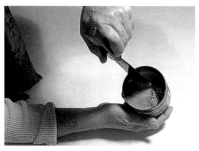

When removing ink from a can, always scrape the top layer of ink, leaving a smooth surface; this will prevent the ink in the can from drying out and becoming lumpy.

After removing the skin from a can of ink, the remaining ink can be strained through tarlatan to refine it and improve the consistency.

Softening tarlatan

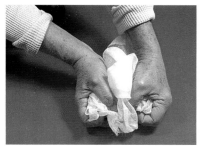

Softening tarlatan by rubbing it against itself.

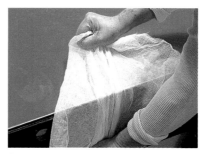

Softening tarlatan by drawing it back and forth against the edge of a table.

Meredith Dean, *Whispering*, **1999**
Intaglio print on handmade paper, 13 x 9.5 in (33 x 24 cm)

Both Handschy and Daniel Smith make good quality Setswell Compounds. Although rarely employed, the white powder, magnesium carbonate, can be mixed with ink to stiffen it and is useful for viscosity printing. If you decide to use magnesium carbonate, buy the refined type with a fluffy, white texture.

CARDBOARD SCRAPERS AND APPLICATORS

Printmakers often apply ink to intaglio plates with cardboard scrapers cut from scraps of mount board; you can cut these to suit the size of the plate you are working with. Another cheap and effective tool for applying ink to an intaglio plate is a plastic paint applicator or autobody fiberglass applicator available from hardware stores.

TARLATAN AND TELEPHONE BOOKS

Printmakers wipe intaglio plates with a pad of softened tarlatan to remove excess ink. Tarlatan is starched cheesecloth and is sold in different weaves: fine, medium, and coarse, with the finest best for wiping solarplate. Tarlatan that hasn't been softened can scratch the plate. To soften the fabric, cut a piece about 18 inches (45.7 cm) long and rub it against the edge of a table to remove some of the starch, or rub the material against itself until it feels soft. Then fold it to form a pad that sits comfortably in the palm of your hand. Constantly refold the tarlatan as you wipe plates. Do not throw the tarlatan out after a printing session, throw it out only after it becomes saturated and will no longer absorb ink.

Many printmakers use pages from old telephone books for the final wiping of the plate. However, be aware that sometimes the ink in the telephone book can contaminate lighter colored inks. If you encounter this problem, try wiping with tissue paper or newsprint. You can also wipe with greaseproof paper, or Tableau, an inexpensive block printing paper.

PRINTING PAPERS

Out of the great range of beautiful printing papers available, the main task is to choose a paper that will enhance your image. It is worthwhile taking some time to explore different types, for each has its own unique characteristics of grain, texture, weight, color, and size. If you hold a sheet up to the light you will find a design or name forming a subtle impression, usually at the edge and near a corner of the sheet. This is a watermark and is like a signature identifying the maker of the paper.

ORIGINS

Although papermaking originated in China over 2000 years ago, it spread west to Europe where the first European papers were made in Cordoba, Spain, about 1036 AD. The art of papermaking has evolved in different ways to produce two distinctive types of paper, Western and Oriental. Art suppliers sell both European and American made papers which are considered "Western," while papers from Japan, Nepal, and India are called "Oriental." Japanese papers are especially renowned and highly prized for their unique delicacy and strength.

COMPOSITION

All paper is made from the cellulose in plant fibers. Japanese papers, often mistakenly called rice paper, are not made from rice plants, but from the bark and plant fibers of gampi, mitsumata, and kozo. The fibers from these plants are characteristically long and this is what gives the paper great strength. The beautiful colors of Japanese papers derive from vegetable dyes extracted from certain flowers, insects, berries, and leaves that are added to the paper pulp during manufacture. The more

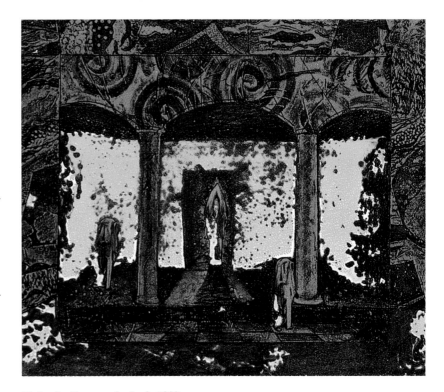

Elaine Le Vasseur, *Le Lark*, 1999
Intaglio print, 7 x 8 in (18 x 20.5 cm)
This image was printed using the viscosity technique.

decorative papers combine swirling patterns of fibers, bits of bark, flower petals, and leaves.

In the past, cotton and linen rags were the main source of Western papers and were collected by rag pickers from the discarded clothing of the wealthy. Clothes left stately homes by the back door and re-entered by the front door, transformed into fine books, works of art, and writing paper. Although some manufacturers, like the Whatman Mill in England, still use pure cotton rag, today most Western papers are made from cotton linters. Linters are the fibers attached to cotton seeds and are technically not rag, but artists still refer to paper composed of linters as "cotton rag." Cotton releases cellulose easily, and a high cotton content gives stronger, better quality paper. Sometimes wood pulp, or sulphite, as well as other plant fibers like flax, jute, or hemp, are added, all of which still

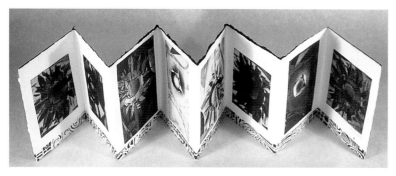

Ruth Leaf, *The Landscape of My Mind*, 1998
7 x 5.5 in (18 x 14 cm)
This book is made of digital images printed
in intaglio on to Somerset paper.

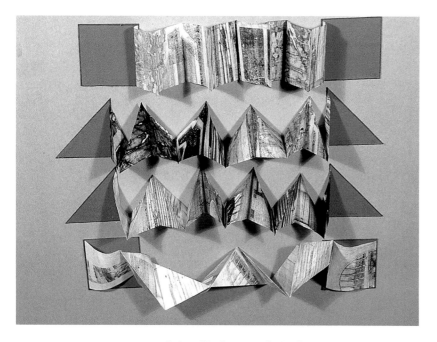

Robyn Waghorn, *44 Smith Street*, 1994
Set of 4 handmade books with intaglio print images,
4 x 4 in (10 x 10 cm) each
Oriental papers are ideal for making books because they
are strong yet delicate. Robyn Waghorn printed digital
intaglio images on rice paper and fashioned them into
these handmade books with concertina style pages.

make good paper. A recent development is the extraction of high alpha cellulose, also called synthetic cotton, from wood, which is used to make high quality papers like the German Hahnemühle range.

In the nineteenth century commercial papermakers began to use wood pulp, resulting in a much weaker and inferior paper that could not withstand the damaging effects of environmental pollution. Many books and artworks from this period have deteriorated badly. As a conservation measure, most paper is now acid free or has a neutral pH of no less than 6.5, and many are buffered with calcium carbonate to maintain an alkaline pH to counteract the ravages of modern pollution. It is essential to use acid-free paper if you want your works of art to last.

All Western and Oriental papers come in three types: handmade, moldmade, and machine-made. Handmade and moldmade papers are stronger and of higher quality, while machine-made is cheaper and varies in quality, yet is still a good choice for printmaking. Handmade paper is the most expensive, with fibers that are randomly distributed, making each sheet slightly different. Handmade paper can be identified by the slightly ragged deckle edge on all four sides. Moldmade paper has two true deckle edges and two simulated deckle edges, while machine-made paper is absolutely uniform and normally has no deckle edges.

CHARACTERISTICS
Another quality of paper to consider is the surface. The smoothness or texture of the surface is created by a pressing process in the manufacture: sheets can be hot pressed to give a smooth surface, cold pressed for a slight texture, or left to dry naturally leaving a rougher surface.

Papers also vary in their absorbency, which is dependent on how much size they

contain. Size is a kind of glue, and for a long time rosin or gelatin was added to stiffen or glaze paper, but because rosin and gelatin are slightly acidic, papermakers are slowly replacing them with Aquapel, glue, casein, or starch. Very absorbent paper is called waterleaf and is unsized, slightly sized papers are slightly less absorbent, while, at the other end of the continuum, ink tends to sit on the surface of heavily sized sheets. Dampening the paper prior to printing dispels the size and increases the receptivity of the paper for ink.

Paper comes in a variety of weights, but the most popular Western papers weigh between 250 and 350 gsm. "Gsm" is weight measured in grams per square meter, and this measure allows you to compare the density of each type of paper directly with another. It is fast replacing the traditional American way of weighing paper by 500 sheets in pounds weight. In this scheme, the sheets can be of any dimension so the figure does not give an accurate notion of the density of an individual sheet, nor can you compare papers with one another. Most Japanese papers are lighter than Western papers, the lightest tissue thin sheets weigh as little as 30 gsm, while some Arches papers reach over 800 gsm. The dimensions of paper are more discernible, but can vary a great deal between types, and choosing a certain dimension will depend much on the format of the image you are working with. Fortunately suppliers issue very informative catalogues describing rag content, mode of manufacture, specific pH, sizing, whether hot pressed, cold pressed, or rough, weight, color, and size, and other details of the printing papers they sell. These are worth careful consultation.

Many artists make their own paper, working with a great variety of plant species, fabrics, and recycled paper. For these artists, papermaking, sculpting, molding forms, and creating

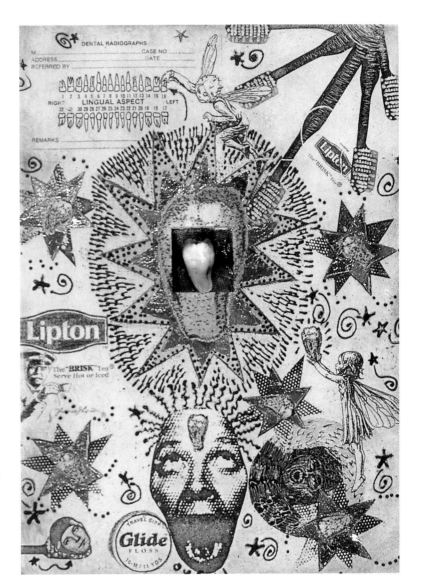

Marisha Simons, *Open Wide,* 1997
Intaglio print with metal foil and tooth, 9 x 8 in (23 x 18 cm)
High quality printing paper is strong enough to decorate and create into three-dimensional works, like this intaglio print to which foil and a tooth has been added.

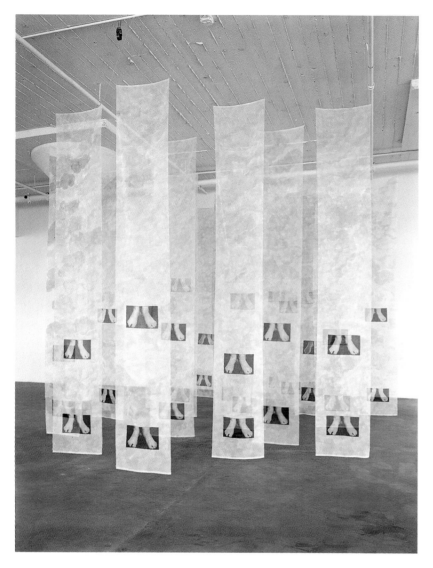

Ellen Brous, *How Do We Get There?*, 1997
Installation view
This installation consists of multiple muslin hangings, each of which has been printed with the solarplate method. It shows how versatile solarplate printmaking can be.

carefully, away from extremes of humidity, dust, chemicals, and dryness that can cause deterioration. Unused paper should be protected by wrapping in acid-free tissue paper and stored flat in drawers; plan or mapping drawers are ideal. Proofs and editions of prints should be stored interleaved with acid-free tissue paper and wrapped in acid-free paper also.

TYPES

Use newsprint for proofing relief plates. Editioning beginners could experiment with Japanese papers, such as Hosho, Nishinouchi, Kitakata, and Masa dosa, or a versatile Japanese buff-colored machine-made paper called Awa. Experienced printmakers should experiment with their favorite papers. Any Western intaglio papers that are 100 percent cotton and moldmade are excellent for relief printing; use them dampened as for intaglio printing.

For intaglio printing the paper will be dampened and printed under sufficient pressure that the paper is pushed into the grooves of a plate to pick up ink. A paper that is at least 250 gsm is ideal, while newsprint and other flimsy papers will simply tear. Try BFK Rives, Velin Arches, Magnani, Hahnemühle Etching, or any of the printmaking papers made by Lana or Somerset. If you want to explore further, experiment with high quality handmade papers made by individual paper mills like Twin Rocker, Richard de Bas, or Quire.

Commercial printers use solarplates to print on a huge variety of materials, including cardboard, paper, plastics, and metal surfaces. Although we have not tested all kinds of paper, it is likely that solarplates will print well on any good quality printing paper. This versatility suggests there is scope for innovative printmakers to experiment with materials other than paper. However, if you plan to explore such media, you may need special types of inks and presses.

interesting surfaces is an art in itself, and experimenting by printing solarplates on handmade paper can add another dimension to this art.

Buying paper in single sheets is expensive, but as a beginner you may like to work this way until you understand the impact of the subtle qualities of paper on a printed image. Many printmakers buy in packs of 25 called a quire, or in millpacks of 50 or 100. The price will fall the more sheets you buy, and you can buy as many as 500 to 1000 sheets at a time.

STORAGE

Printmakers work under very varied conditions, and it is important to store your paper

EQUIPMENT FOR PRINTING

You may already own a press, but if you are new to printmaking and are contemplating buying a new press then it is likely to be your most prized possession and it is essential to try out quite a few before deciding on one. Another alternative is to join a community access print workshop which will have a variety of presses and good facilities for hire. Such print workshops frequently run printmaking courses, and as well as sharing a love of printmaking with others, you can learn much by working alongside practising printmakers.

HAND PRINTING

Use a baren or a wooden spoon for hand-printing relief plates. The traditional baren is made of bamboo, while the modern baren made by Speedball is composed of cast metal with a strong wooden handle and a Teflon pad. To print an impression, ink the plate, lay the paper on the plate, and rub a baren or spoon across the back of the paper.

PRESSES

An etching press will allow you to print both relief and intaglio solarplates. Etching presses are cylinder presses and comprise a stand with two steel cylinders or rollers and a heavy steel or hard composition plate that sits on the bottom roller creating the bed of the press. The dimensions of the press bed are also how the press size is described.

To print, an inked plate is laid on the bed of the press, paper is laid on the plate and together they are rolled through the press by turning a wheel. For reliable and even printing of impressions, the printmaker can control the pressure of the top roller as evenly as possible by adjusting the screws above the top

Hand printing barens

Using the "palm press" designed by Nik Semenoff is a very effective way of hand burnishing. It incorporates many roller bearings that produce greater pressure than the traditional Oriental baren.

A homemade baren created from a door knob and a large wooden dowel.

Different Presses

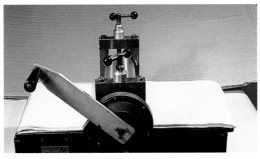

This small Conrad table top press is portable, excellent quality, and has produced over 30,000 impressions in art schools, universities, and workshops. Its relative light weight allows shipment all over the world.

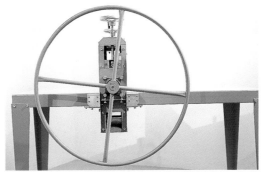

The Whelan press is a new design where the rollers move over the stationary bed of the press. This allows printing of variable thicknesses more easily with less wear on the press.

A registration sheet under the mylar or plastic sheeting will help with accurate placement of paper and plate during printing.

roller; larger presses frequently have a micrometer on either side to give a more accurate measurement of pressure. To keep parts protected and moving freely, periodically lubricate the screws and other moving parts with a few drops of light machine oil.

PRESS BED

To protect the bed of the press cover it with a sheet of strong, rigid plastic, like mylar, Plexiglas, Perspex, or thick acetate, which should be cut to about the same size as the bed of the press. This plastic cover keeps the registration sheet in place during printing and is easily kept clean with a dry rag. For stubborn ink marks rub the protective cover with denatured alcohol, or apply a stronger solvent for heavier ink deposits. Never use acetone or harsh solvents that melt plastics. Never use razor blades or sharp objects to remove marks on the plastic; a scratched surface will only hold ink and eventually transfer inky marks to the printing paper.

BLANKETS

Blankets, also called etching felts, are made of felted or woven wool. They are essential for intaglio printing, but many printmakers also print relief plates with blankets. Woven blankets are more expensive than felted blankets, but can be washed and last much longer. Wash them by hand in warm water with soap flakes, rinse in warm water and lay out flat on a towel to dry.

You require at least two or three blankets for intaglio printing. The blanket closest to the plate is called the sizing catcher; it is the thinnest felt and prevents the other blankets from becoming saturated with the size in paper. Most professional workshops have two, which are rotated when one becomes too wet. The second and thickest blanket is the cushion, which provides the necessary flexibility for the blankets to force the paper into the grooves of the plate. The top blanket, the pusher, is the toughest blanket and withstands the constant rolling action of the press.

TISSUE PAPER

Tissue paper has many uses around the studio, mainly for storing plates and drying prints. In addition, many printmakers lay a piece of tissue paper or newsprint between the dampened printing paper and blankets during printing to prevent the blankets from absorbing too much size; blankets become stiff and ineffective if they absorb too much size from the printing paper.

DRYING STATION

Open access studios and print workshops often have wire drying racks on which large numbers of prints be can stored. If you do not have access to one of these, you can make a simple homemade rack from blotters or homosote softboard which is light enough for laying prints between to flatten the paper and will not smudge the surface ink. Several printmaking workshops use sheetrock or wallboard, a

Tip

Always release the pressure on the press at the end of a printing session by winding up the roller, otherwise the blankets will become deformed.

$^1/_2$-inch (1.27-cm) -thick plasterboard ideal for absorbing moisture and flattening prints, while Australian printmakers can use caneite, a light board made from sugar cane. Interleaving each print with newsprint or tissue paper will prevent offsetting of the image and keep boards clean. Whichever material you choose, seal the edges with masking tape or duct tape to prevent any particles from flaking off and sticking to your prints.

CLEANING UP

Water-based inks are easily cleaned off rollers, the inking slab, and other tools with water. You need to take special care when cleaning water-based inks off a solarplate to minimize erosion of the polymer: scrub the plates in water with a soft nailbrush as quickly as possible, dry for 5 minutes with a hair dryer and expose in the sun for 5 minutes. Graphic Chemical & Ink Co makes one of the best water-based inks; it has a shellac base and can be cleaned up with household ammonia, which removes all traces of ink from the plate.

You will need a store of clean, lint-free towels or chamois leather for wiping the edges of inked intaglio plates prior to printing and for cleaning up at the end of a printing session. It is important to use lint-free towels so that no fibers are left on surfaces where ink is mixed; these can contaminate prints later. Use vegetable oil or baby oil to wipe ink off tools, plates, hands, and other surfaces; this is much safer than using solvents. A stiff brush or an old toothbrush is useful for scrubbing oil into the crevices of solarplates to dislodge ink and thoroughly clean plates. Clean rollers with odorless mineral spirits, as vegetable oil may erode the rubber, but always wear nitrile gloves to protect your hands, and work either outside or in a well ventilated space with an exhaust system (see Safety and the Working Environment, pp. 129–137).

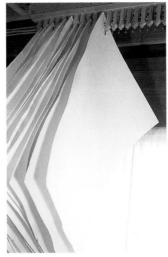

Damp blotters suspended from a rack.

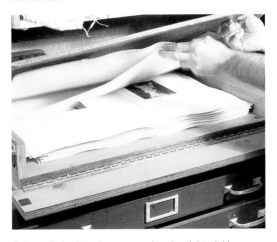

Prints will dry flat when covered and weighted. Here they are weighted with a lithographic stone. When dry prints should be stored away from dust in flat files, or print drawers.

You can dry prints in drying boxes by interleaving them with newsprint and clean blotters. Alternatively, you can dry prints on wire racks.

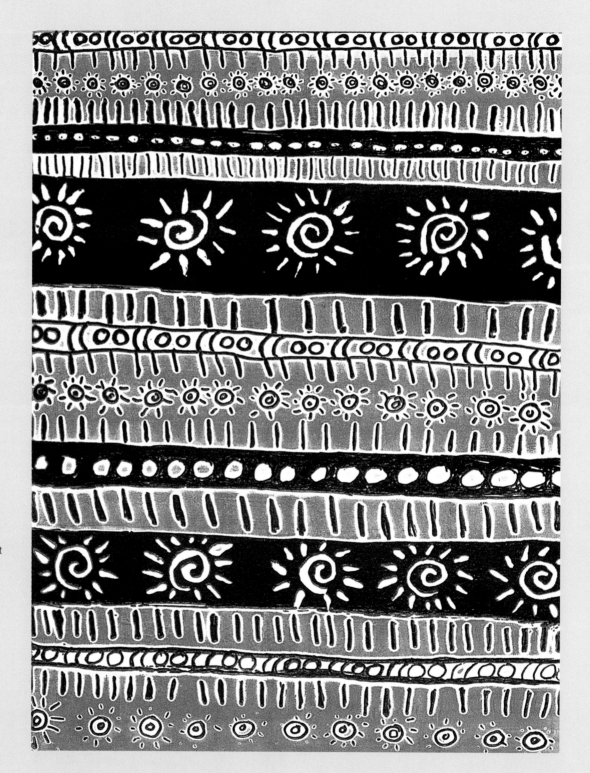

Jodie Watson, *Untitled*, 1999
12 x 9 in (30.5 x 23 cm)
The inspiration for this print comes from traditional Aboriginal body painting. The original drawing was created by rolling a thin layer of etching ink on to plate glass, dusting with talc, and drawing into the ink with a stick to create a negative transparency. Adding talc to the ink increases the opacity and helps retain the integrity of the drawing during an exposure.

PREPARING A RELIEF IMAGE

A relief print normally requires a negative transparency, similar in appearance to the negatives used for making photographs: the image is clear or translucent and the background is opaque. A traditional relief print is normally a high contrast black and white image. To achieve this effect with solarplate the best way of working is to draw and scratch through an opaque film of ink or paint, or draw with opaque materials on a transparent film or glass. Always compose your image the way it will appear in the final print. One great advantage of working on film is that you still have the original image at the end of the process. This means that if you make an error in platemaking or wish to develop your image further you can make another plate.

You can use other methods, such as painting or drawing directly on the polymer itself, arranging found objects on the plate, or photocopying images. Keep in mind that any plate you make can be printed in relief or intaglio, though you are more likely to achieve a successful print if you decide beforehand which kind of print you are going to make.

DRAWING METHODS

Before preparing a full-scale image it is a good idea to make a sampler to test drawing materials and to explore the range of marks possible for a relief print. This approach will allow you to eliminate drawing materials which will not dry properly or stick to the polymer during an exposure and ruin the plate. You may also occasionally encounter polycarbonate or Plexiglas UV-resistant films which need to be avoided. You can identify these if, after exposing a test transparency on a piece of solarplate for several minutes, all the polymer completely washes away during development; this signifies that no UV light has reached the polymer.

Creating a glass negative for a relief plate

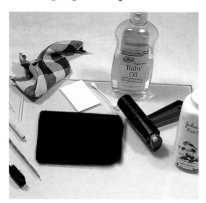

1. A piece of clear glass is inked in preparation for drawing on in order to create a negative for a relief image.

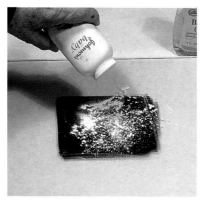

2. Dust the inked glass with talc or baby powder.

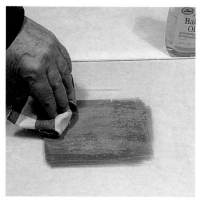

3. Gently wipe the dust over the ink and remove excess powder.

4. Draw through the wet ink with a variety of mark-making tools.

For a sampler apply some of the drawing techniques described below by inscribing strips of opaque photographic film or inked film, or by drawing with a variety of opaque media. Make and print a plate following the directions in the relief platemaking chapter. Compare the print with the sampler and examine the corresponding grooves in the solarplate. From this you can determine how image making relates to the shape and quality of marks in the final print.

OPAQUE FILM

You can buy or acquire a transparency already coated with paint or emulsion that can be inscribed and scratched into. One ideal source of opaque film is exposed photographic film from commercial printers, and you may be able to collect scrap film from graphic design houses or offset printers.

First, hold the film up to the light and block out any pin holes with liquid opaque or an opaque felt tip pen. Cut the film to the size of your image and position it with the emulsion or non-glossy surface side up on a light table. This way you can see your image clearly as you work. Extremely fine lines and marks can be created with chisel-pointed etching needles, sandpaper, razor blades, utility knives, dental tools, or any sharp, mark making instruments. As you scratch and work through the emulsion, the light will reveal the design and the result will be a negative transparency that can be exposed on a solarplate.

INKED FILM

You can make your own opaque transparency by rolling or brushing printing ink on to a piece of clear acetate or plate glass; avoid any flimsy films which will warp during drying. When using this method, cut one piece of film for your image and some smaller pieces to test the exposure time; even when dry inked films are fragile and ink may lift off during an exposure.

Tape the film to a large piece of clear plate glass. Roll very thin layers of any black oil-based or water-based ink on to the film, covering the whole surface with it. You can use many kinds of ink, but the ink must remain wet long enough for the time you want to draw. An excellent water-based ink is Graphic Chemical & Ink Co. relief ink, which is very sensitive and can hold fluent lines and fine textures.

Make sure the transparency is completely coated by holding it up to the light. If there are pinholes of light, either continue rolling to distribute the ink more evenly or apply more ink. You can also increase the opaqueness by dusting talc or red iron oxide on the wet ink. Then, while the ink is still wet, draw very fine marks and textures using pencils, brushes, calligraphic pens, old felt tip pens, or even sticks.

Adding water will disperse the ink as particles, while drawing with a cotton bud or a brush soaked in denatured alcohol will create subtle strokes and washes. For textures and more painterly effects paint with brushes and scrapers or press pieces of material, found objects, or crushed aluminum foil into the ink. Work your test strips the same way as the finished drawing to give accurate exposure times prior to printing.

If you have dusted the ink with talc you can expose the transparency immediately. If you have not applied talc, dry the transparency with a hair drier on a warm setting, or leave it covered in a cardboard box to air dry. Once dry, you can add finer lines by carving, scratching, or scraping the ink.

To create some unpredictable effects, paint large bold brushstrokes on plate glass, removing and wiping the ink and impressing textures to form an exciting transparency. Dusting the image with talc will increase its opacity, but the main advantage is that during an exposure the talc preserves the integrity of the image.

TRANSPARENT FILM

You can create a negative transparency by drawing with opaque media on acetate or drafting film; textured film often used for intaglio image making is normally not suitable because you cannot achieve dense, even lines. Painting and drawing with gouache, liquid opaque pens, opaque felt tip pens and markers often makes marks that stop out the UV light very well. If any drawn marks or lines appear semiopaque, apply more media so when you develop develop the plate the polymer washes out very easily under these marks. If marks are not dense enough, light can penetrate and harden the polymer and no grooves will form. With this approach you can also create a positive transparency. The resulting relief print will appear as white lines on a dark background and resemble a woodcut or linocut.

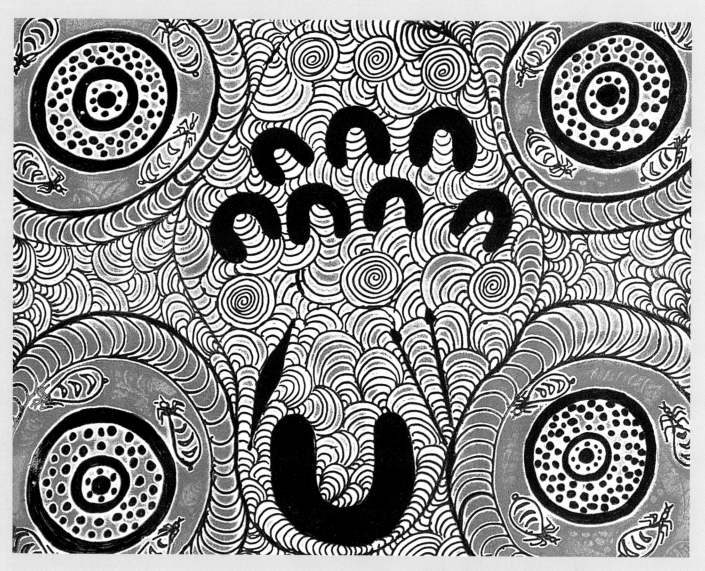

Tjungkara Ken, *Seven Sister,* **1999**
Relief print, 12 x 9 in (30.5 x 23 cm)
Tjungkara Ken drew with a stick through ink on glass to
create a negative transparency. She made this plate in
October, near her home in central Australia, where there
was so much sunshine that the plate needed only 3
minutes exposure in the sun. Two colors were applied to
the plate by using two rollers and varying the pressure when
inking. The first color was applied under strong pressure,
covering almost all the plate with ink except those portions
next to the shoulder of the relief "bite" that remained
uninked. The second color was applied with very light
pressure, kissing only the uppermost surfaces of the plate.
When printed, both colors were transferred to the paper,
generating a rich and painterly effect.

MAKING AND PRINTING
A RELIEF PLATE

In most traditional printmaking techniques, a printmaker works on a plate or block and then proofs it periodically to see how the image is developing. Making a solarplate is more akin to photography. The key to understanding and refining the platemaking process is to perform a series of test exposures, processing and printing small test strips of solarplate before you make the final plate, much like a photographer works in the dark room testing exposure and development times with strips of photographic paper. As you work through these chapters, there are troubleshooting tables you can refer to to solve any printmaking and platemaking problems.

Platemaking techniques vary according to whether you are making a relief plate or an intaglio plate. Making a relief solarplate is the simplest technique and entails only a single exposure, while an intaglio plate normally requires two exposures. However, whether you are working with relief or intaglio images, you will find that the whole process of making a plate is very rapid. Exposing, developing, drying, and post-exposing a plate takes only a matter of minutes, and once the whole sequence is completed, you can print immediately.

For a relief solarplate that will print with good contrast you need to make a plate with deep grooves in the polymer layer. You can achieve this by working with opaque drawing media, exposing the plate for as long as possible in the sun and washing the plate for 3 minutes or more to remove as much polymer as possible. The end result will be a strong relief plate with all the fine detail preserved. With deep grooves in the polymer, ink can be rolled in thin layers on to the remaining relief surface without clogging up the grooves, and the plate will print with good contrast.

Since most printmakers will prefer to draw on transparent film, this chapter has been designed for the indirect approach.

Equipment for making a relief plate:

Drafting film or textured acetate

Scratching tools

Opaque drawing media

Solarplate

Talc

Contact frame

Developing tray

Oven thermometer

Nail brush

Soft wide brush

Lint-free fabric towel

Hair dryer

Magnetic vinyl

Lightproof paper or black plastic

Window cleaner

Cardboard

Impermeable apron

Chemical splash goggles

Nitrile gloves

Making a relief solarplate from opaque film

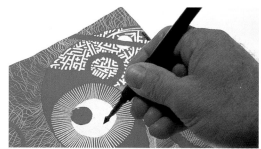
1. Scratching through opaque film.

2. Peeling the plastic coating from the solarplate.

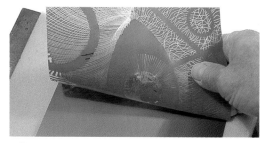
3. Placing the image face down on the plate.

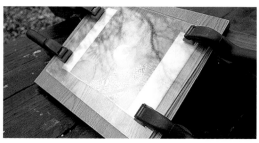
4. Exposing the plate to the sun in a contact frame.

5. Pouring water on the plate.

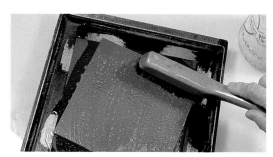
6. Scrubbing the plate. Observe that the water has removed the polymer in the unexposed areas.

7. Blotting the plate after rinsing.

8. Using a hair dryer to dry the plate.

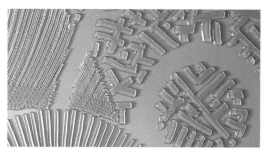
9. The relief depth is apparent in raking light.

10. Inking the plate with two different colors using rollers of different durometers.

46

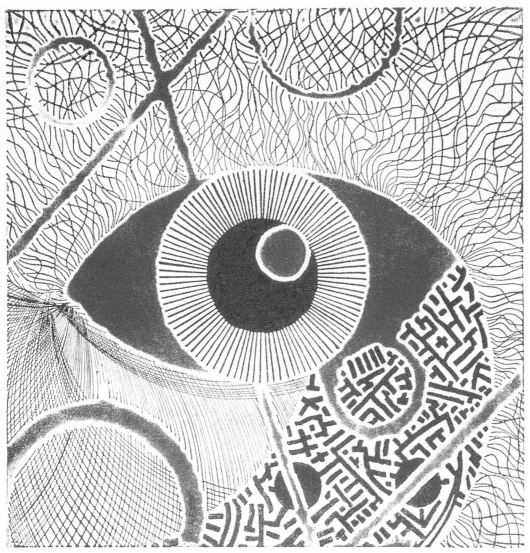

Carl Welden, *Beholder*, **1999**
Relief print, 10 x 10 in (25.5 x 25.5 cm)
The plate for this print was made from an image scratched in opaque film.

MAKING A TEST STRIP

To solve any printing or platemaking problems before making the final plate, cut test pieces from a solarplate and process and print these. Learning to refine and control the technique requires an understanding of the interaction of several variables: the opaqueness of the image, the density of the drawing media, the exposure time, the intensity of UV light, and the length of the washout during the development stage. All these factors have an impact on the final image, and making prints from test strips as you change and fine-tune all these parameters allows you to monitor the technique and work toward creating high quality prints.

With test strips you can experiment with different exposure times, test the darkest and lightest parts of your image, or examine a significant part of the image and envisage the look of the print with much greater accuracy. If you process and print test strips and eliminate any problems by working through the trouble-shooting tables, you will also avoid wasting plates. You may need to modify printing techniques, increase or decrease the exposure time, alter the opaqueness of your original drawing, or shorten or lengthen the washout time.

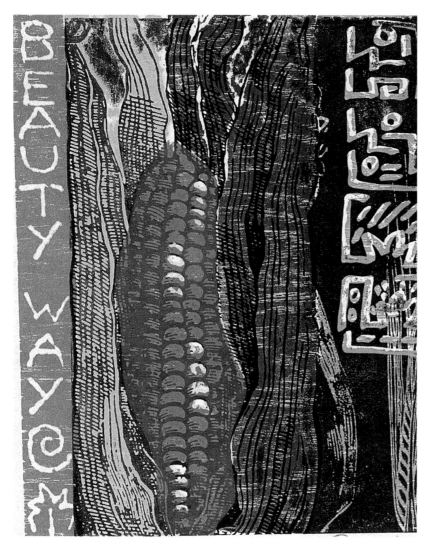

Melanie Yazzie, *Beauty Way*, 1999
Mixed relief print, 10 x 8 in (25.5 x 20 cm)
Melanie Yazzie combined a woodcut with a relief
solarplate. The solarplate was made from a drawing
on acetate.

PREPARING

To prepare your test strip:

1. First draw on the transparency with opaque drawing media, for example, gouache, opaque felt tip pens, lithographic crayons, or charcoal, and draw the image the way it will appear in the final print. Opaque media block the light very effectively keeping the polymer soluble so that it washes out thoroughly, contributing to the formation of deep grooves. You can determine the opaqueness of your image by holding it up to the light. If necessary, add more drawing media to the transparency.

2. Once the drawing is complete, trim the edges of the transparency to remove any excess film.

3. Cut some test pieces of solarplate approximately 2 x 3 inches (5 x 7.6 cm) in size, or strips large enough to cover a significant part of your image.

4. Cut a piece of solarplate slightly larger than your completed transparency, at least $^1/_8$ to $^1/_4$ inches (.32 to .63 cm) larger all round. If the transparency film overhangs the plate during an exposure it can cause incomplete contact and faded edges will appear in the printed image. You can then trim the plate to the correct size before you start editioning.

The transparency must sit in close contact with the surface of the plate during an exposure, so check the test strips and plate for any warped edges and trim these away or gently straighten any bent corners. Re-wrap any unexposed solarplate pieces in lightproof paper or a black plastic bag for future use.

EXPOSING

Before exposing any plates, prepare a developing tray by lining it with magnetic vinyl. Fill a small jug with tepid tap water, put an oven thermometer in the container, and adjust the water temperature to between 68°F–78°F. If the temperature falls below 68°F, add more hot water. We have found that temperatures lower than 68°F do not affect the washout process very much, but if the

temperature is too high, parts of the hardened polymer can melt and start to dissolve away.

1. Remove the cover film from the test strip and lightly dust the polymer with talc applied with a soft, wide brush; this prevents the polymer from sticking to the transparency and damaging the drawing.

2. Position the plate on the base of your contact frame with the polymer face up and arrange the transparency with the worked surface face to face with the plate. Check the cover glass for marks and clean off any spots and stains with window cleaner; any dirt left on the glass can add unwanted marks to your image.

3. Place the glass over the transparency and sandwich the layers together with spring clamps, checking that the clamps do not cover any part of the film or plate.

4. Cover the frame with a piece of lightproof material, such as cardboard, and carry the frame outside.

5. Remove the cardboard and expose in full sunlight for an initial testing time of 3 minutes (summer), holding the frame at right angles to the sun so the polymer receives the direct rays of the sun.

6. At the end of the exposure, cover the frame with the cardboard and take the contact frame to the developing tray.

For a solar exposure, choose a sunny day with no clouds and expose from midday to

Author's note

We have designed the platemaking chapters for impatient artists and printmakers who are longing to make a solarplate without spending too much time on preliminary reading of the book. Often putting a technique into practice, then studying the text to discover more about a process is an ideal way to learn a new skill. (Before starting any practical work, however, it is important to read Safety and the Working Environment on pp.129–137 and follow the guidelines recommended for your health and safety.)

early afternoon. The intensity of UV light varies a great deal depending on where you live and what season it is, but the density and opaqueness of your image also determines the exposure time. During an exposure each translucent area lets UV light through, hardening these specific areas of the polymer which in turn form the raised structure of the final plate. The greatest risk is that with too short an exposure the polymer will not harden enough and subtle and delicate parts of the image will wash away during development. There are two principles you can follow: you can produce stronger relief plates by exposing for as long as possible; and the more opaque the image the longer you can expose it in the sun.

Processing times for relief transparencies

TYPE OF IMAGE	EXPOSURE TIME	WASHOUT TIME	POST-EXPOSURE
Scratching through Scriberite or opaque film. Drawing through ink	15–30 min	5–10 min	5–10 min+
Drawing with opaque materials on drafting film. Inkjet or laser transparencies.	3–10 min	3–5 min	5–10 min+

This table provides a range of exposure times for summer to winter. Shorter exposures are required for summer, and longer exposures for winter.

Analyzing the test strip: Inking and printing problems

PROBLEM	CAUSE	SOLUTION
Flat, raised relief areas of the polymer do not print as solid areas of black	Insufficient pressure from the press	To increase the pressure wind the roller down a little or lay more sheets of newsprint over the printing paper
	Insufficient inking	Re-apply ink rolling on additional layers of ink
	The ink may be too stiff	Modify the ink with varnish or light plate oil
	The ink may be too thin	Add heavy plate oil or mix with a little magnesium carbonate. Alternatively, start with a new batch of ink
	The rubber roller may be hard, warped or damaged	Use a softer roller and reject warped rollers
	The press bed may be warped	Move the plate to a different place on the bed of the press
The image shows a gradation from dark to light	The press roller is unevenly aligned and printing unevenly	Wind down one screw on the press a little more, ink and print until your image prints evenly
	Continuously inking from the same end of the plate	Change inking directions for each impression
Ink is in unwanted areas	The press pressure is too great	Unwind both screws to lift the roller and decrease the pressure
	You have rolled too much ink on to the roller and inked the plate too heavily	Clean the plate and re-apply ink using thinner layers of ink
	The ink may be too thin	Add heavy plate oil, or mix with a little magnesium carbonate, or start with a new batch of ink
	The inking roller is too soft	Use a harder roller
	The diameter of the roller is too small	Use a roller with a larger diameter
Excess ink on leading edge of the plate	Press pressure is causing plate slippage	Adjust plate to pass under roller at a slight angle

Once you have eliminated any problems caused by inking or printing and your print is still not as you hoped, then work through the next table on platemaking to correct the problem.

Platemaking problems

PROBLEM	CAUSE	SOLUTION
Non-printing parts of the image are inked in	Drawing materials are not opaque enough	Add more opaque marks to the original transparency to block UV rays
	You have not developed the plate for long enough	Scrub longer, wash down to the steel backing
	You have overexposed the plate	Expose another test strip for less time, ink, and print
Parts of the relief structure have washed away and do not print	You have underexposed the plate	Expose a test strip for a longer time and print. Repeat until the relief structure is retained
	The washout water is more than 78°F	Check the temperature and adjust to between 68–78°F
Plate surface shows ragged edges	You are scrubbing the plate too vigorously	Scrub more gently or use a softer brush during development

Keep adjusting these variables and processing test strips until you achieve a good quality print. Then you can proceed to make your final plate under the optimum conditions of exposure, development, and printing.

DEVELOPING

If you are developing the plate outside, work in a shaded area. Do not wash plates in direct sunlight since this can completely harden the soluble parts of the plate.

1. Remove the transparency and examine the plate surface. Sometimes you can see a ghost of the image indicating that the exposure has worked. However, the absence of this ghost does not signify that the plate will not work.

2. Put the solarplate on the magnetic vinyl in the developing tray and put on the recommended safety gear.

3. Pour a little water on to the plate and gently scrub with a soft brush as evenly as possible over the entire surface. Occasionally add more water and continue to scrub. Although at this stage you are unlikely to see much, periodically lift and examine the plate for signs of grooves forming. Learning to "read" the plate and judging how far to go with this step will only come with experience.

4. Keep scrubbing for 3 to 5 minutes, since washing away as much of the soluble polymer as possible creates deeper grooves, and when printed this type of plate will give a distinct relief image.

5. Give the plate a final rinse before drying. Keep in mind that wherever light has reached the unprotected polymer, these areas will have

hardened, and wherever opaque marks have blocked the light sufficiently, these areas will have washed away.

6. Lay the plate face up on a clean, lint-free towel and blot the surface. For each blotting action use a fresh part of the towel, since tacky polymer can be transferred to another part of the plate.

7. With a hair dryer on a warm setting, dry the surface for about 1 minute, or until there are no more droplets of water. Dry in an area that is relatively free of dust because the polymer tends to attract particles and hairs that stick to the surface. If there are any particles adhering to the polymer, put the plate back in the developing tray and scrub briefly with water, rinse, and dry again. If you examine the test strip, you should now see the grooves and channels clearly and how they correspond to your drawing.

8. To give the polymer a final hardening, post-expose the plate in the sun for 5 minutes or longer. If the plate surface or washed out areas are still tacky after post-exposure, leave it in the sun until the polymer is no longer tacky. The timing of this stage is not critical; you can put the plate on a sunny window ledge or leave it out in the sun to bake for 1 to 2 hours without any adverse effects.

Solarplate is a tough, resilient plate, but the polymer can be damaged by scrubbing too vigorously, creating ragged lines, dislodging printing elements, and resulting in loss of detail in the final print. Too little pressure will make little impression on the surface of the plate.

PRINTING

Establishing order and cleanliness is paramount when printing. First, check that the ink slab, bench, and press are clean, especially the acetate on the bed of the press. Lay out clean newsprint on your workbench, set up the magnetic inking board and establish a clean area for preparing paper well away from the bench where you ink your plates.

You can proof test strips and the final plate with newsprint; it is preferable to proof with a black oil-based relief ink before using color. Printing in black gives a more accurate idea of the quality of a plate, despite the esthetic appeal of colored inks. You also need two or three rubber rollers of different hardness for rolling ink on to the plate. To allow even coverage of ink, the circumference of the roller should be greater than the length of the plate you are printing, and the roller must be wider than the plate.

To set the pressure of the press:

1. Place the uninked test strip on the bed of the press and position it under the roller.

2. Place a small sheet of newsprint on the strip and cover with two larger sheets of newsprint.

3. Wind down the roller as evenly as possible by turning the screws on either side of the top roller, and set the pressure to just "kiss" the surface of the plate; presses with properly adjusted micrometers should give identical readings on either side.

4. Roll the test strip through and place it on the magnetic inking board ready for inking.

5. Roll out a thin layer of ink on the ink slab (much less than for linoblock printing), and roll three layers of ink on to the test strip. Take care not to overink because solarplate can print very fine detail and it is easy to fill in fine grooves and lines with too much ink.

6. Position the inked test strip on the bed of the press and cover with a sheet of newsprint slightly larger than the piece of solarplate.

7. Cover with two sheets of newsprint and roll through the press.

8. Lift the paper off the solarplate and examine your test print. You may not need to make any adjustments, but if your print does not turn out as you hoped, the first thing to check is your inking and printing technique by referring to the troubleshooting tables on pp.50, 51.

You need fairly stiff ink for relief printing and often ink straight from the tin is stiff enough. But if the ink is difficult to roll out, add one or two drops of thin plate oil, blending it into the ink with an ink knife until it is smooth.

Author's note

Before scrubbing the plate, rinse and clean any residual polymer from the brush, otherwise you may scratch the surface.

Relief inks dry out quickly. If you have to suspend printing for 15 minutes or more, seal the surface of the ink with plastic wrap and rub your hand over it to make sure there are no air pockets; this prevents the ink from drying out. When you return and remove the plastic, the ink is still open and usable.

MAKING
THE FINAL PLATE

There are some factors to consider when making larger plates. You will need to scrub for longer and using a larger brush will make it easier. If the plate is larger than 9 x 12 inches (22.8 x 30.5 cm), then it is better to expose the plate at midday, store it in lightproof paper, and develop it in the evening. We have observed that with the longer developing time, reflected UV light in shaded areas can slightly re-harden soluble parts of a larger plate. Dan Welden has even left an exposed plate for twenty-four hours before developing without any adverse effects.

Especially if a plate is large, dry the plate by rotating it two or three times to ensure even drying. Drying for longer will not harm the plate, and in industry platemakers dry for up to 25 minutes. But take care not to use a high heat setting since the polymer can overheat and melt.

PREPARING THE PLATE

Before commencing to proof a plate, trim it to the final size with a guillotine or paper trimmer. If a plate has a slight lip on one edge, you can put it through the press under pressure a couple of times to flatten it; this way the first impressions will print evenly. Examine the polymer for any particles and fine hairs and remove these with a pair of tweezers. Finally, round off the sharp corners of the plate with a metal file and file away any burrs along the edges, which can trap ink and transfer unwanted marks to the printing paper.

MAKING
A REGISTRATION SHEET

To accurately print your plate on paper make a registration sheet from newsprint which will sit on the bed of the press. Cut a piece of newsprint slightly larger than your printing paper, place a piece of printing paper on the newsprint and draw around the edge of the paper leaving a paper outline on the newsprint. Then position the plate within this outline where you would like your print to sit on the printing paper. Draw around the edge of the plate in pencil so that you have a second outline in which you place the inked plate. We shall refer to this as the plate outline. It is useful to write "top" above the plate outline where you want the top of your plate to sit. Arrange the registration sheet on the bed of the press under the piece of acetate.

PREPARING PAPER

First proof a full-sized plate with newsprint and, once you are happy with the result, continue proofing and editioning with high quality paper. There are many types of Oriental and Western papers that give excellent results and we can recommend Hosho (heavy) or Awa.

Good printing papers usually have either soft tapered deckled edges or some soft torn edges. For aesthetic considerations it is better to preserve the look of the soft torn edges when cutting paper to smaller sizes. On a clean sheet of newsprint, cut Oriental paper by folding it and tear along the crease with a blunt knife. Another method is to fold a sheet and dampen along the fold with a clean brush or sponge. As you open out the sheet and tear, the two parts will separate along the fold. Alternatively, many printmakers will lay a metal straightedge on a sheet of paper and tear the paper upwards using the

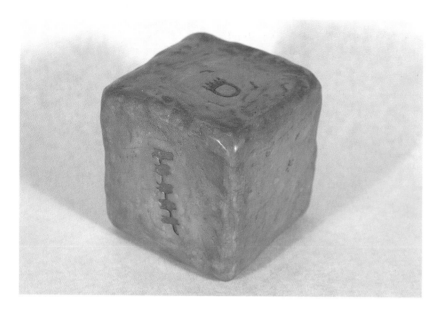

Mary Maynor, *Rocks*, 1997
Fimo clay with embossing,
3.25 x 3.25 x 3.25 in
(8 x 8 x 8 cm)
Maynor used inked
solarplates to emboss
the surfaces of this totem.

EXPERIMENTING

xperimentation is an important part of becoming adept at printmaking. Apart from varying the color of the ink, you can create variations in your images by experimenting with the washout time, or using dampened paper or different rollers when printing. Another interesting variation is blind embossing where an uninked relief plate is printed under pressure to give a beautiful and subtle impression.

ALTERING THE WASHOUT TIME

Experiment by increasing the washout time up to 5 or 10 minutes, or even as long as 20 minutes. Washing away more polymer will create a deeper relief structure and may result in a print with more contrast. Take care not to scrub or brush too vigorously or for too long in case you lose important details. Alternatively, you can reduce the time to as little as 30 seconds or 1 minute when more polymer will remain in the grooves and lines and a greater surface area will print. After a short washout, the plate is likely to be quite tacky and can stick to the paper during printing. Post-expose for up to 30 minutes or more to reduce the tackiness and achieve a smooth surface.

USING DAMP PAPER

You can vary the look of a print by using damp paper. Dampened paper improves the transfer of ink from plate to paper and gives a softer impression. For the Japanese method cut pieces of newsprint slightly larger than the printing paper you intend to use, and dampen half of the newsprint sheets with a wet brush. If you can, use rainwater, distilled water or spring water. Then arrange pieces of paper in the following order: 1 damp newsprint, 1 dry newsprint, 1 sheet of

ruler as the cutting edge. You can print with damp or dry paper, but for the first impression we recommend you try printing with dry Japanese paper.

PRINTING THE PLATE

Roll the required number of layers of ink on to the solarplate. Position the inked plate on the bed of the press in the plate outline of the registration sheet and place a sheet of printing paper carefully on top of the plate. Use the paper outline of the registration sheet to accurately align the paper to the plate. Cover the printing paper with two sheets of newsprint and roll through the press. Lift the paper off the solarplate and examine your first relief solarplate image.

To complete the process, place the print on a clean blotter or board of a drying rack. Cover with clean newsprint or tissue paper and cover with another board. Especially with damp paper the boards prevent the sheet from twisting as it dries. Keep interleaving boards, prints, and tissue paper until you finish printing. An entire edition may be stacked, weighted with a board and heavy objects to dry overnight. It is important to stack prints neatly with sheets lined up so as to keep the pile uniform. If the ink is still wet in the morning exchange the newsprint for fresh sheets or rotate any blotters.

Japanese paper, 1 dry newsprint, 1 wet newsprint, 1 dry newsprint, 1 Japanese paper, and so on. You can experiment with different ratios, inserting 2 or 3 sheets of Japanese paper instead of 1 sheet. Wrap the stacked sheets in a plastic bag and leave for as little as 5 minutes or longer to obtain evenly dampened paper with no shiny areas of excess water. Normally thin paper requires shorter times and much thicker paper needs to be left overnight.

You can also use dampened intaglio papers for relief printing and you can print a relief plate in intaglio; some images work well with both print techniques. (Techniques for dampening intaglio paper are described on p.84.)

EXPERIMENTING WITH ROLLERS

Applying ink with rollers of different hardness will create different printed effects. Harder rollers tend to distribute ink on the upper-

Experimenting with solarplate exposures

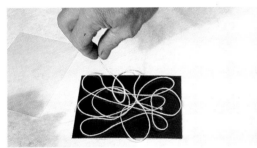

1. This simple exercise will help you understand the principles of exposure with solarplate. Place a piece of string on two different pieces of solarplate.

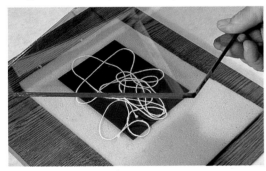

2. Place the two pieces of solarplate in a contact frame, and expose one piece for 2 minutes, and the other piece for 15 minutes. Then wash out the image.

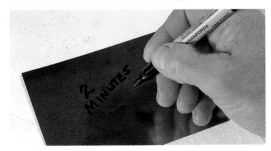

3. Mark the length of the exposure on the back of each piece of solarplate.

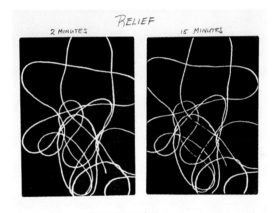

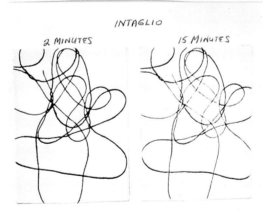

Ink and print the test plates as both relief and intaglio images. The shorter exposure of 2 minutes results in deeper and wider grooves in the plate. The intaglio print has a strong dark line, and the relief print has a strong white line. The longer exposure of 15 minutes results in shallower grooves and less well-defined relief and intaglio images.

most parts of the relief structure of the plate, so the impression will have more contrast. Softer rollers tend to distribute ink on a greater surface area, and impressions will look softer.

There are limitations to how fine a relief plate you can print on a manual press. The finer the relief structure the more care you need to take in printing. This particularly applies to plates made from exposing photographic film. The general rule for printing fine detail is to use as little press pressure as possible, use a hard roller and apply a minimal amount of ink. This will minimize the problems of the plate filling in with ink.

BLIND EMBOSSING

You can roll ink on to a relief plate and print it with dampened intaglio paper, etching felts, and increased pressure of the press to create subtle embossing. Blind embossing is a technique for creating an impression without ink. Using solarplate, found objects or drawings can be embossed on to paper in either positive or negative form. If you make a plate with a negative transparency then the subject will print as a recessed impression, while a positive transparency will print as a raised form.

For good blind embossing use very opaque drawing media, like gouache, acrylic, or liquid opaque, and paint or draw the media densely on to drafting film. Very opaque media will block the light very effectively and with sufficient scrubbing wash away completely down to the shiny steel backing to form a deep "etch" ideal for greater embossing. For finer work transfer images and text to photocopies or computer film, and, if necessary, double the films to make it as opaque as possible. Dense materials and three-dimensional objects that have some height will cast a shadow and form interesting and more indefinite shapes.

Expose a transparency keeping in mind it is the opaque marks applied to the transparency that will correspond to the raised surface of the embossing. Expose for 15 minutes or for as long possible to preserve fine detail. If you are using a less opaque transparency, like a photocopy darkened with ink, then shorten the exposure to between 1 minute 30 seconds to 3 minutes. Develop by scrubbing all the polymer away until you can see the shiny steel backing, taking care not to wash away any fine raised lines. This may take 5 to 10 minutes or longer, depending on the size of the plate. Post-expose for up to 30 minutes to reduce any stickiness.

In contrast to relief printing with ink, the plate is printed under sufficient pressure to push the dampened paper deep into the grooves of the plate. You can use blankets, but because there is a lot of pressure the plate can leave a permanent impression on felt blankets which, in turn, transfers to other impressions. To save expensive blankets substitute a thick rubber blanket, at least $1/2$ inch (1.27 cm) thick. Increase the pressure of the press as much as possible and print using any well-dampened intaglio paper. The greater the pressure, the deeper the grooves, the more distinct the blind embossing. The embossing can be sharpened by rolling the plate and paper through the press twice, but do not lift the paper off in between each printing.

Tip

One tip for blind embossing: if you are using a plate that has already been inked, often ink remains deep in the grooves and will transfer to clean paper. First clean the plate thoroughly by scrubbing odorless mineral spirits into all the crevices with a soft toothbrush to obtain pristine, ink-free embossing.

Make only a few impressions at a time to prevent the polymer from absorbing water from the paper; too much water will eventually erode the polymer surface. Dry the plate with a hair dryer and leave the plate in the sun for 30 minutes to keep the surface hardened, then continue printing. If the polymer is tacky, the paper can stick to the plate. To avoid this problem, you can ink up the plate with white ink, use dry paper, or cover the plate with cling film.

HAND PRINTING

Hand printing of linoleum is still practiced by many printmakers, and for specialists of the Japanese woodcut technique this is the only method of printing relief woodblocks to obtain a sensitive, truly "handmade" print. Traditionally water-based ink is applied to a woodblock with a brush, vegetable fiber paper is placed on top, and the back of the paper is rubbed with a bamboo baren to transfer the image to paper. Gauguin printed many of his Tahitian woodcuts using this technique, creating a sensitive, primitive quality not possible with a press.

After making a relief solarplate, dampen some Japanese paper; thin, delicate Japanese papers are easiest to print by hand. Use a good oil-based relief ink such as the Graphic Chemical & Ink Co line of Perfection Palate and block printing inks which roll up and release ink easily. Roll thin layers of ink on to the plate with a roller, cover with a sheet of dampened Japanese paper, and rub the back of the paper with a wooden spoon or baren. You can use a traditional bamboo baren or the ball bearing baren with a Teflon pad made by Speedball. If the paper you are using is very delicate, cover it with tissue paper during rubbing to prevent any tears. The more pressure you apply the darker the print, while varying the pressure on different parts of the plate will introduce subtle printed effects.

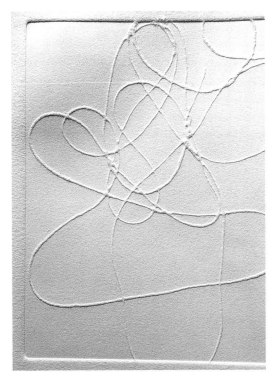

Blind embossing of string test plate.

Newsprint is used to cushion the rubbing action of the homemade baren.

Unveiling the print, showing both intaglio and relief areas have printed. It is worth noting that the sensitivity of hand printing allows a greater variety of effects, although a press will achieve more consistent results.

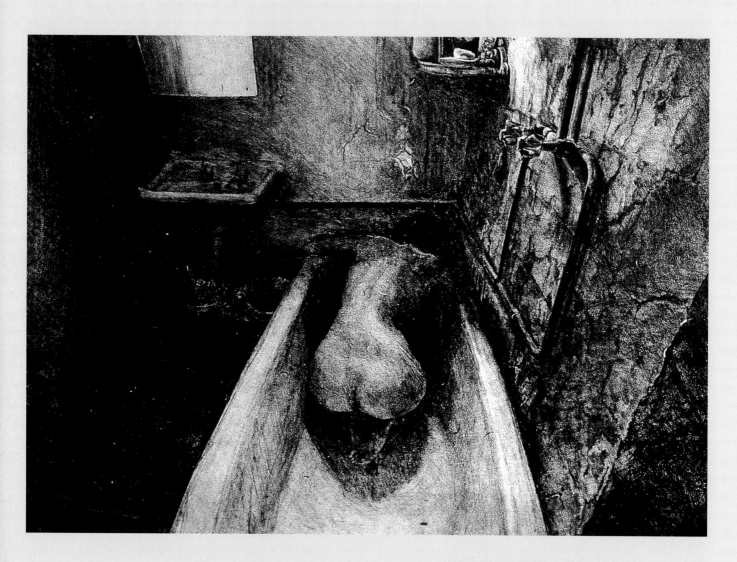

Margaret Ambridge, *Self Portrait,* **1998**
Double exposure intaglio print, 11 x 16 in (28 x 40.5 cm)
Working from a photograph, Margaret Ambridge drew
with soft pencils and lithographic crayons on True-Grain,
applying scraping techniques to vary textures and
modify tonal areas. The transparency was transferred
to a solarplate using 18 seconds for each exposure
in a commercial exposure unit.

PREPARING
AN INTAGLIO IMAGE

For an intaglio print you first create a positive transparency in which the image is composed the way it will appear in the final print. Conceptually, it is more natural to envisage a positive image, and the most common way of preparing images for intaglio solarplate is to draw or photocopy images on a transparency. This is an indirect method of working, and the transparency is then placed face to face with the plate during exposure. You can also work directly by drawing or painting or arranging found objects on the plate. In this case you compose your image in reverse. This chapter describes the best drawing and photocopying techniques for making an intaglio print.

For intaglio work you will find solarplate can capture a wide range of tones and textures from a transparency, and, especially for drawings, the materials you use and the way you apply them will strongly influence the feeling of the final print. You can start with something as basic as a soft B pencil and a sheet of drafting film, or experiment with a rich variety of inks, crayons, pencils, and pens, on textured or smooth transparent films, clear or grained glass, or painted directly on the plate. There is great freedom of expression working this way and whatever marks you make—fine, sensitive linework, richly textured crayon mark, or lucid brushstrokes of ink—with careful platemaking all can be transferred to a print. Photocopying is useful for manipulating images or collaging different kinds of material together. You can also alter the image on the transparency by drawing or using scratching techniques. There are a multitude of possibilities for creating an image for a print.

DRAWING ON FILM

There is a wide range of drawing media and there are many transparency films sold under different brand names, so it is important to test your drawing materials before engaging in serious image making. As for making relief images, you need to avoid any UV resistant transparent films and reject any drawing materials that may not dry properly or stick to the polymer during an exposure and ruin the plate.

Many printmakers experiment with drawing materials until they find a favorite way of working. One way of comparing

David Salle, *Lanterns*, 1998
Double exposure three-plate intaglio print, 16 x 11 in (40.5 x 28 cm)
Each plate was made from a drawing on frosted acetate.

Tip

Please note that platemaking techniques for making intaglio plates can vary. Both single and double exposure techniques can be used, and where relevant this has been indicated in captions.

drawing media is to make a sampler. Make a series of drawn marks on a selected transparency with, for example, a soft B pencil, a graphite pencil, pen and ink, lithographic crayon, a variety of felt tip pens, and a tusche wash applied with a brush. You could make additional samplers from a range of transparent materials, such as grained glass, clear glass, acetate, or drafting film.

As you draw or paint you need to develop an awareness of how you apply drawing media, whether it is thick and dense or very light and subtle. This has implications for platemaking: dense, opaque images block the light very effectively and can be exposed in the sun for much longer than lighter images. Once the media are dry, hold the transparency up to the light to gain a more accurate idea of their opaqueness. Some that appear black are, in fact, semi-opaque and will leave wash-like marks. Always compare the original transparency with the final printed image and examine the corresponding grooves in the solarplate. This will help you to evaluate the quality and opaqueness of different media, how they affect platemaking and the final print, and, in turn, help you to find your most favored drawing materials.

Because you are working on transparent or translucent films, another variation is to overlay films to combine images. Normally the film closest to the plate will transfer more subtle detail, while the film furthest away will transfer an image with more contrast and less detail.

TEXTURED FILM

There are many versatile textured films to work with that come in varying weights and have a multitude of names. We recommend using fairly thin films from 0.005 inches to 20.007 inches in thickness that are not too rigid so they will sit flush against the polymer surface during an exposure. True-Grain, also known as Autotex, is an example of a tough, highly transparent polyester film with a finely textured side for drawing. It is a very stable film and will not warp or expand with hot air drying.

By using pencils, graphite, charcoal, lithographic crayons, or any textured media, you can transfer fine tones, similar to aquatints or the graininess reminiscent of lithographs, to intaglio prints. To make tonal washes dilute inks with water, dissolve lithographic tusche in a small amount of water, or mix graphite dust with dilute gum arabic. Brush these particulate solutions on to the textured surface. The fine particles of pigment will become trapped in the tiny pits forming the grain, creating the wash effect. You can also experiment with overhead markers, rapidiographs, liquid opaque pens, pencils, and Finepoint pens. For more diversity or to lighten your image, you can scratch and sand the media. Some textured films, like True-Grain, are tough enough to engrave, and you can fill in lines and crevices with pigment. If you are not happy with your work, you can erase it by washing. It is possible to recycle the films at least once, and sometimes twice.

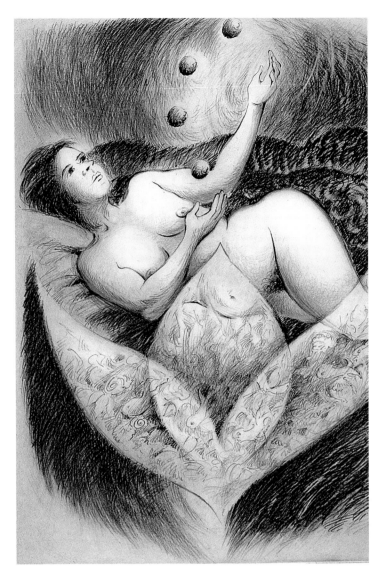

Kathleen Aird, *Possibly Maybe*, 1998
Two-plate intaglio print, 10.5 x 8 in (26.5 x 20.5 cm).
Kathleen Aird drew very delicately with pencil and used the most transparent drafting, semi-matte film, in order to pick up all the fine detail from her drawing. Each plate was made using the double exposure technique.

DRAFTING FILM

Drafting film is a frosted film available in varying weights and thicknesses from many art suppliers. It is sometimes known as architectural drafting film and is sold under many different brand names, such as Draft Rite and Clear Draft. There are two types: double matte drafting film which has a matte surface on both sides, and single matte drafting film which has a smooth side and a matte side. The opacity of double matte film is often close to delicate wash tones and solarplate will not differentiate between them, leading to the loss of up to 10 percent of the drawing in the final print. For images with light, subtle tones, use the more transparent single matte film, and for more opaque images work on double matte film.

Drafting film provides a strong, sensitive matte surface on which you can manipulate a

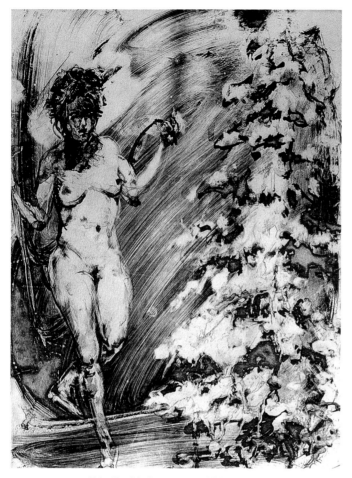

Eric Fischl, *Jumprope*, 1992
Intaglio print, 19 x 15 in (48 x 38 cm)
This painterly print was created by working with ink on acetate.

Lynda Benglis, *Hot Spots*, 1999
Double exposure intaglio print, 15 x 22 in (38 x 56 cm)
Lynda Benglis found that painting watercolor on tracing paper caused the paper to crinkle, resulting in a subtle pattern in the final print.

great range of drawing media to acquire a soft, velvet look; pencil, charcoal, crayons, ink, and a variety of felt tip pens and markers all work well. Create soft, subtle tones by smudging with a cotton swab or with paper stumps. Ink drawings are especially fragile, so always make sure the ink is completely dry before exposing. For extra protection you can dust the transparency with talc to prevent any drawing materials sticking to the plate during an exposure. But talc cannot prevent wet media sticking to the polymer; the polymer will dissolve partly and white spots and patches may appear in the final print.

You can also experiment by lightly sanding the matte surface of the film with a fine grade of sandpaper to improve its adhesion for water-soluble ink and ink washes. For more interesting textures lay textured or patterned materials, like sandpaper, underneath the transparency while you draw. The film is strong and will stand up well to gentle scratching and erasing, but is too insubstantial for engraving.

TRACING PAPER

In general, tracing paper is inexpensive, but not very sensitive to drawing media. If you want to use tracing paper always buy a good quality, such as tracing vellum, which is fairly substantial but soft and flexible. Some stiffer tracing papers crinkle easily with washes and, consequently, do not lie flat on the surface of the plate during an exposure often creating subtle radiating lines in your image.

Tip

It is a good idea to keep a notebook with test transparencies and their corresponding prints.

Drawing through wet printing ink rolled on to acetate

1. After coating the surface with ink, dust it with talc or baby powder.

2. Gently wipe the powder into the ink, and remove the excess.

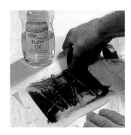

3. You can work the drawing as a monotype, using a rag.

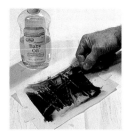

4. You can use other tools such as the blunt end of a pencil to create marks.

OTHER TRANSPARENT MATERIAL

Other types of clear material such as clear acetate, photocopy transparencies, or overhead transparencies are limited in the range of possibilities that can be achieved, and only special felt tips pens designed for drawing on plastic are suitable for such surfaces. Ink, pencil, and many other drawing media will bead on the shiny, water repellent surface. By sanding the surface some of these materials will adhere with interesting variations created by the textured surface.

Another approach is to roll or paint oil-based or water-based inks on to a piece of fairly strong, clear acetate and by wiping, adding solvents, or impressing textures and found objects, creating a variety of tonal effects. This is a similar technique to creating a negative transparency for a relief plate, but you must use a much thinner layer of ink for an intaglio print to allow the UV light to penetrate sufficiently to harden the plate. For those who love monoprinting techniques you will be in your element. Arrange found objects on the ink and lay tissue paper over the inked acetate, roll it through the press to impress textures, and as the tissue paper lifts off, it will also thin the ink. Using tissue paper this way also helps dry the ink, and leaves a fine mottled pattern, which creates an aquatint-like effect in the final image. With this process the ink is often dry enough to expose immediately. This process requires you to test exposure times, so when working you need to set up a duplicate piece of acetate and work it in the same way as your original to give accurate test readings.

Richard Mello, *Untitled*, 1997
7 x 10 in (17.5 x 25.5 cm)
This is an example of a positive transparency. Artist Richard Mello is just putting the finishing touches to a drawing on acetate, which is now ready for exposure.

USING A PHOTOCOPIER

Meredith Perrin, *Dragon Pot*, 1997
Single exposure intaglio print, 8.5 x 6 in (21.5 x 15 cm) Meredith Perrin likes to develop several versions of the same image before selecting one for exposure on a plate. To create this image, she photocopied an original drawing on to a transparency and then worked it further with felt tip pens and scratching back techniques.

Using a photocopy to make an image for solarplate printing is one of the easiest ways of working and an ideal approach for cautious newcomers to the process. Used with discrimination, photocopying has a multitude of possibilities: you can use it to make relief or intaglio prints; to enlarge or reduce an image; to collage different elements, such as text, photographs, found objects, and drawings; or to alter an image by working back into the toner with scratching and sanding techniques. You can also add more opaque marks and textures to the toner, or darken areas of the toner by rubbing drawing ink into it and wiping away the excess. It is an ideal medium for capturing the textures of very opaque found objects, such as lace, leaves, wire, or dense three-dimensional objects such as pieces of wood or chains. If laid directly on the plate these dense objects would block the light too effectively and leave no detail.

BLACK AND WHITE PHOTOCOPIERS

A standard photocopy transparency has a surface like clear acetate and normally only takes felt tip pens designed to work on plastic. Some photocopying services will allow you to copy on to drafting film, which records a greater range of mark-making and manipulations when reworking an image. Check that the heat setting process does not crinkle the film. If the drawn elements do not harmonize with the photocopied image then re-photocopy the image to create a more integrated effect. The artist, Carol Hunt, creates her images by spontaneous mark-making, photocopying, scraping, adding, re-photocopying, and constantly reworking the image until,

Carol Hunt, *Solar Etching (from a Suite of 15)*, 1993
Single exposure intaglio print, 8 x 6 in (20.5 x 15 cm) Carol Hunt uses repeated photocopying to alter and develop the image. This process also enriches the depth of the black tones.

after several generations of photocopying, she has her final transparency. There is always a marked difference between her first image placed in the copier and her final solarplate print. She discovered that this process tends to break up the photocopied look and refine the final effect.

Advances in technology mean that quality is improving rapidly, and some photocopiers produce material that is close in quality to high-resolution commercial printing. We advise avoiding older machines as some leave unwanted stripes or banding on the copy, or distribute the toner heavily, or unevenly, obscuring fine detail; any imperfections will transfer to the print. Always make some impressions on plain white paper first, and if you are not happy with the quality try another machine.

Make sure you have the appropriate transparency films that will not melt in the heat setting process; most overhead or photocopy transparencies are suitable. Photocopy transparencies come in standard sheets 8 ½ x 11 inches (21.6 x 27.9 cm), as well as some larger sizes. If you want to work with much larger images then you need to find a service with plotters or plan printers; some machines are capable of printing up to approximately 34 x 44 inches (86.4 x 111.76 cm) on drafting film or a special tracing paper provided by the service.

Photocopiers work by transmitting the image as a fine powder of toner. The most common types of machines tend to reinterpret a drawing or photograph with mid-tones appearing as mottled patches and textured effects, similar to aquatints, though many newer machines can reproduce a range of grays and transfer a more photographic look. It is important to experiment with different machines and determine the effect you want. Beware, if you use a dark setting, often a fine layer of the toner is distributed over the entire film and will be transferred to the final print.

Janet Ayliffe, *Kangarilla*, 1998
Single exposure two-plate intaglio print, 21 x 11.5 in (53.5 x 29 cm)
Janet Ayliffe tells stories through her art. To create this print she photocopied an original drawing on to a transparency and then used drawing and scraping techniques to further work the image. This transparency was used to make the key plate. The second plate was a traditional zinc etching plate. The final print was made by printing the etching plate first, then printing the key plate to give definition to the image.

Marta Romer, *Matter # 3*, 1998
Single exposure intaglio print, 7.5 x 10.5 in (19 x 26.7 cm)
Color photocopiers can vary in quality, but the newer machines have a good tonal range which can endow a print with soft, subtle qualities. Here, Marta Romer collaged a variety of images, including an original drawing, a photograph, and digital images, and printed them on to a transparency using a color photocopier set on black and white.

Always examine your transparency carefully and scratch away any excess toner before making a plate.

COLOR PHOTOCOPIERS

High quality color photocopiers scan an image digitally with a laser and tend to reproduce the character of a photograph or a drawing more closely and with a greater tonal range than a regular black-and-white copier. Consequently finer aquatint-like effects are possible with this type of photocopy. You can copy on a black-and-white setting or color for different effects. Color photocopiers can also invert images, converting a positive image into a negative image, which can then be used to make a relief plate. A word of caution: sometimes the opacity of the transparency film is insufficient for good exposures. One way around this is to sandwich two copies together or to rub drawing ink into the toner to make it more opaque; you can clean transparent areas by wiping away any excess ink with a damp cloth or cotton bud.

DRAWING ON GLASS

Drawing on the finely toothed surface of grained or sandblasted glass has great appeal for lithographers since it is very similar to working on a lithographic stone, and solarplate prints from such images resemble lithographs. However, a traditional lithograph is printed from the surface of a plate or stone, and tends to have a flattish quality, while prints from a solarplate have the additional richness of more ink deposited on the paper and an obvious embossing from printing in intaglio.

One advantage of working on glass, whether it is smooth, grained, or sandblasted, is its cheapness; once you have drawn on the glass and made a solarplate from the image you can clean off the image and rework the glass, using the glass rather like a sketch pad. Always use thick glass, preferably plateglass ¼ inch (.6 cm) thick or more, since this is less likely to break especially when graining or sandblasting the surface. Be aware that the thicker the glass the more weighty it is and it may be difficult to expose it in a vacuum frame. You can find plateglass in secondhand shops and at garage sales, or buy pieces ready cut to size from a glass supplier. If you have a glasscutter you can cut large pieces into manageable sizes, or a glazier will do it for you, although some glass is tempered and cannot be easily cut. Before drawing on glass, examine the edges first and if they are rough or sharp arrange to have them polished so you won't cut your hands.

CLEAR GLASS

Clear glass can be worked like clear acetate and can produce everything an acetate transparency can. You should only work on a completely smooth surface, so first clean off any marks and examine both sides of the plateglass for nicks and scratches. Any scratches can be removed by graining or sandblasting so you can utilize badly scratched glass this way, although eliminating deep scratches and gouges may take some time and effort. Like clear acetate, clear glass will not hold sufficient pigment from crayon, pencil, or many varieties of felt tip pens. India ink and lithographic tusche can produce some lovely effects, and felt tip pens designed for working on shiny surfaces, such as overhead markers and liquid opaque pens, work well.

GRAINED AND SANDBLASTED GLASS

Dan Welden's printmaking expertise as a stone lithographer and the influence of the glass sculptor, Harvey Littleton, gave rise to the method of working on grained glass. The surface of grained glass is identical to the texture of a lithographic stone, and the

Debra Donelson,
Untitled, 1996
Single exposure intaglio print, 30 x 22 in (76 x 56 cm) Debra Donelson created an image on clear glass by drawing with India ink and rubber stamps. The resulting plate was printed with Gamblin Portland Black, a richly pigmented ink, which added more plate tone to the final image.

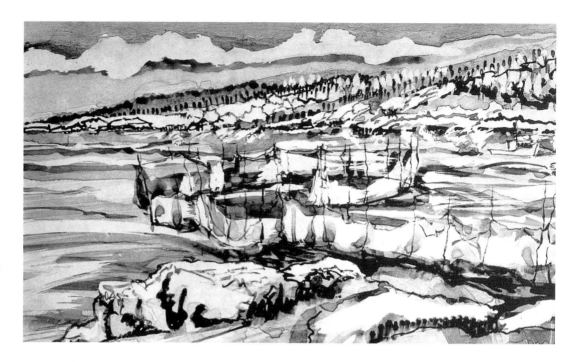

Joanna Melrose, *Fundy Shore Breeze*, 1998
Single exposure intaglio print, 15 x 20 in (38 x 51 cm) This image originated from painting lithographic tusche on grained glass to create the subtle effects captured by the plate.

pleasurable sensation of the swirling gray sludge when graining glass is very similar to the experience of graining stone. Since this method does not require a specialized lithography press, and since glass is cheaper, lighter, and easier to handle than a cumbersome seventy-five pound stone, creating lithographic images from solarplate has become a popular alternative to lithography.

Grained glass and sandblasted glass differ in the shapes of the tiny peaks and valleys that compose the abraded surface: the shapes are finer and more acute in the grained glass and more rounded in the sandblasted surface. Grained glass is more sensitive and can capture very fine marks and washes, and produce a great range of tonal effects, while sandblasted glass creates images with more contrast. Sandblasting requires special compressors and sprayers normally found at a specialist glass supplier. Graining glass is something you can do yourself, and it only takes time and good physical coordination to create a crisp pristine surface.

Three essential items are required: water, carborundum, and either a levigator, a glass muller, a small, thick piece of plateglass or a lithographic stone. A levigator is a thick, circular disk with a handle and a flat, steel base, which is traditionally used for graining lithographic stone. Suppliers of lithographic materials sell levigators, while glass mullers, sold primarily for grinding pigments, can be purchased at graphic supply houses. You can use a piece of secondhand plateglass, while lithographic stones are found in printmaking workshops where they practice lithography.

GRAINING GLASS

Many artists prefer to perform this task out of doors on a strong work table, and it is important to work at a comfortable height so you are not bending over and straining your back.

1. Soak an old towel with water and spread it on a flat working surface, making sure there are no wrinkles, and place the glass slab on the towel towards the front of the table. The towel will prevent the glass from slipping during the graining process.

2. Wet the glass slab with water and sprinkle some carborundum on the surface. The carborundum can vary from coarse, 80, to very fine, 220; the grade you choose depends on the drawn quality you are aiming for. Spread

the grit evenly over the surface carefully with your hand and place the graining tool on the glass, taking care not to make any sudden, jerky movements which will scratch or gouge the surface.

3. Grasp the handle of the graining tool and start to move it in a circular fashion, slowly rotating it with the abrasive and water, covering the entire surface as evenly as possible.

A levigator moves much like the action of an electric floor waxer and will slide around erratically if you lose control of the action. A glass muller is lighter and much safer, and, although more time consuming, it creates a beautiful crisp, finely toothed surface. If you grain with a flat stone or piece of plateglass move it in a figure eight motion.

It may take several cycles to grain the glass to a fine matte surface. Water and grits will spray from the edges and you need to wear eye goggles and some protective clothing. As you work, stop occasionally and rinse the glass with water and a brush, do not use your hand in case there are sharp edges. Examine the surface for areas you may have missed and check that scratches are disappearing. Some artists attached to a print workshop or an art school may have access to a lithographic graining area or sink, and can collect the excess carborundum, dry it, and recycle it for carborundum printing (see Reworking the plate, p.136).

DRAWING ON GLASS

When drawing on glass, first make sure the glass is clean. Glass has a distinct advantage over stone because you can place it above your drawing and redefine the image as you work. The grained surface allows an artist to work either in a free expressive manner or in a very delicate and detailed fashion.

Graining glass

1. To grain glass you need two pieces of glass, a towel, water, and carborundum.

2. Saturate the towel with water.

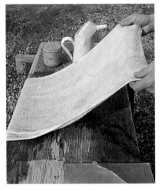

3. Lay the towel flat to act as a cushion to hold the glass.

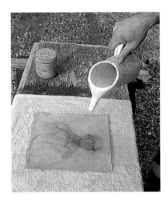

4. Pour water over the glass.

5. Sprinkle carborundum on the surface.

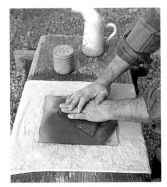

6. Grain the glass using a figure eight motion.

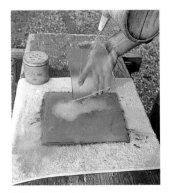

7. Rinse the glass.

8. Examine the surface.

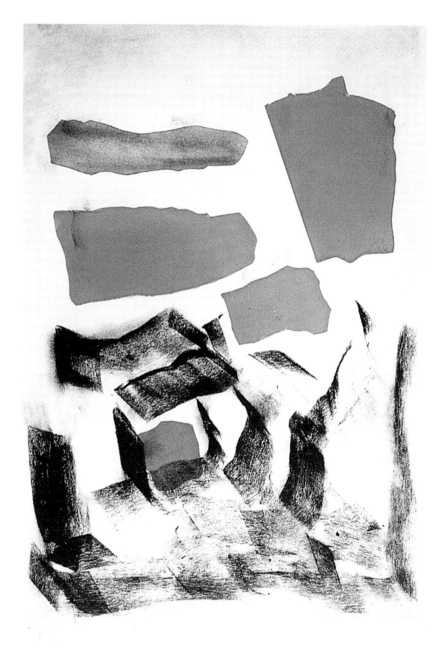

Esteban Vicente, *Untitled*, 1996
Mixed relief and intaglio print, 18 x 12 in (45.7 x 30.5 cm)
Esteban Vicente drew on grained glass with charcoal
from which a single exposure intaglio plate was made
and inked in black. Color was added to the image by
cutting interesting shapes from scrap solarplate and ink-
ing them with rollers. These small relief plates were
inked and printed separately.

We advise you test pencils and graphite sticks of varying hardness or blackness on either sandblasted or grained glass before spending a lot of time on rendering a complete image. Pencils like Stabilo 8046 and Staedler Omnicrom 108-9 are good to work with: Stabilo 8046 is a very opaque pencil which is water soluble and easily erased with a damp-ened cotton swab, while Staedler Omnicrom 108-9 pencils are less opaque but give a fine line. Due to the textured glass surface the points of graphite and pencils will constantly require sharpening. All types of charcoal work well and produce a very intense black. Black pastels, litho crayons, litho pencils, oil sticks, craypas, and many other mark-making materials also generate richly textured marks.

Just as you can roll or brush ink on to acetate to create either a negative or positive transparency, you can do the same with glass. Inscribe lines or work with brushes, adding and removing ink with a variety of tools and textured objects. Drybrush is a favorite tech-nique of some artists. If you brush lightly on the uppermost parts of the surface texture of the grained glass the final print will show a more textured quality. If you create dense applications of paint or ink the final print will show continuous areas of black. On very finely finished grained glass you can use a variety of felt tip pens and tusche or India ink washes. You can also work on glass with a technical pen, though it requires a steady hand and a compatible nib; quill-shaped nibs work best.

Both grained and sandblasted glass have an inherent problem. Once a drawing is com-pleted and exposed on a solarplate it is quite difficult to wash off the old image. Although it is possible to scrub with all kinds of cleansers, a slight ghost of the image will always remain. The best method for thorough cleaning is by lightly regraining with car-borundum and a small piece of glass. This regraining takes less than 1 minute.

WORKING DIRECTLY ON THE PLATE

Drawing directly on the plate is one of the simplest ways of working and can be used to make either a relief or an intaglio image. When Dan Welden worked on the first solarplates in the 1970s, he painted and drew this way using Abstract Expressionist techniques. You can be spontaneous and very expressive when composing an image and imaginative with the unpredictable printed effects. One advantage of working this way is you do not require a contact frame and there are no contact problems. On the

The solarplate may be drawn or painted on directly. In this instance, etching ink is applied and removed with cardboard, but brushes or small pieces of rag could be used as well.

William Negron, *Tandem,* 1998
Double exposure intaglio print, 18 x 24 in (45.7 x 61 cm)
Working directly on the plate with etching ink can yield very expressive prints and is a very spontaneous way of working. William Negron used the double exposure technique to capture as much tone as possible from his painting.

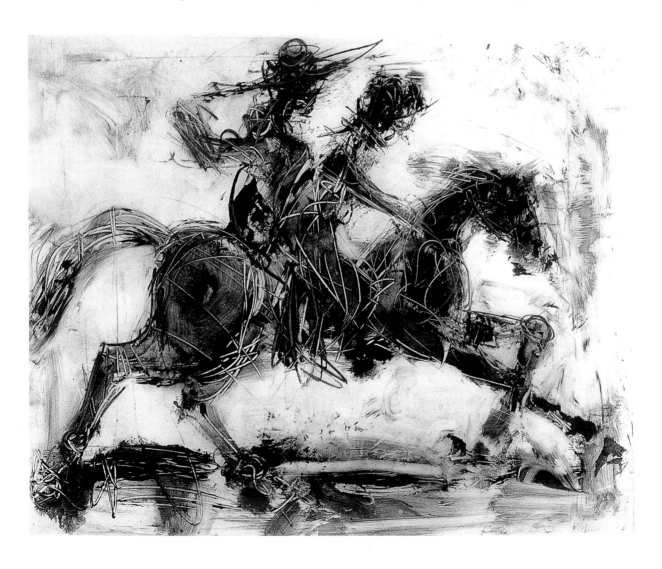

Pauline Muir, *Joy*, 1998
Single exposure intaglio print, 3 x 3.75 in (7.5 x 9.5 cm)
Pauline Muir worked the plate with etching ink, inked it in
intaglio and painted with monoprinting inks before printing.

other hand, you cannot test the image so the results are more unpredictable. As with other printmaking techniques where the printmaker works directly on a plate, like drawing into ground for etching or carving linoleum, the image must be composed in reverse.

Before beginning consider the lighting in your work room. You can draw on the plate under incandescent lighting for up to two hours, but as a precaution, keep well away from windows; it is the reflected UV light from outside, as well as the room lighting, which can harden the plate prematurely.

INK AND PAINT

The best way of working is to paint with an oil-based ink or paint. First, remove the cover film, apply the ink, and work with brushes or other mark-making tools, taking care not to scratch the surface. For special effects dilute the ink with a variety of solvents, such as oil or odorless mineral spirits, which will not damage the polymer. Remove, add, and blot the ink or impress gently with textures. If you are not happy with the result, wipe the ink off with a rag soaked in a little vegetable or baby oil and start again.

FOUND OBJECTS

Another direct method is simply arranging found objects on the solarplate, remembering to remove the cover film first. You can use found objects this way for both relief and intaglio prints. Organic objects, like leaves,

feathers, and flower petals, can be arranged on a plate, but ensure that fresh material is dried and flattened in a flower press for a few days, otherwise liquid will squeeze on to the plate and dissolve the polymer. Inorganic materials, like lace, light gauze, mesh, doilies, and cheesecloth, also create interesting effects. Collaging different papers can be interesting as they vary in opacity and many papers have textures or fibers in them. Paper can be torn into interesting shapes. Flat material should be combined and arranged to your satisfaction, and placed in a contact frame for a long exposure.

More three-dimensional objects behave differently: they cannot be held flat in a frame and do not produce a precise edge due to light refracting around the form so that the final result is unpredictable. If you want to reveal internal anatomies, like the fine network of veins in leaves and petals, choose translucent objects. For example, white petals will allow more light through than red petals, while the remaining veins of old leaves will block the light very effectively and leave their design finely etched in the plate. Dried stalks and grasses are dense and block the UV light so effectively that they form interesting silhouettes in the final image. If you want to capture the surface pattern of solid, found objects, the best way to do this is to lay the object on a photocopier and capture the details on to a transparent film.

Gary Wright, *Return to the Womb*, 1996
Three-plate relief and intaglio print, 11.5 x 5.25 in (30 x 13 cm)
Gary Wright printed two plates in intaglio, one a solarplate and one an etched metal plate. The third plate was a relief solarplate made from a photocopy of a circuit board, and was printed with silver lithographic ink to form an overlay.

Yvonne Boag, *Nowhere Road*, 1998
Double exposure intaglio print, 12 x 16.75 in
(30.5 x 42.5 cm)
Yvonne Boag created two drawings on semi-matte
drafting film with lithographic crayons and graphite
pencils. The two films were partially overlaid and taped
together, then exposed in a vacuum frame using the
double exposure technique. Inked a la poupée, this
print shows the fine marks and textures that the
double exposure technique can preserve.
Courtesy of Contemporary Access Gallery, Australia.

MAKING AND PRINTING AN INTAGLIO PLATE

Making an intaglio solarplate is very similar to making a relief plate, but the intaglio process is more sensitive and the timing of exposures can be crucial. For an intaglio solarplate you normally use two exposures. This platemaking approach is called the double exposure technique and was first developed for photopolymer printmaking by the Danish lithographer, Eli Ponsaing, and adapted by Pauline Muir for solarplate, particularly for working with drawings and paintings.

Beautiful results are achieved by using two exposures. With it you can capture much of the tonal range of a drawing or painting, and preserve the quality of drawn marks, washes, and fine brushstrokes. But there are other advantages. By careful timing and adjustments it allows you to control the depth of grooves in the polymer layer, and hence the quality of line. It also allows you to create prints with extensive areas of black as part of the image. Used with high-resolution digital images and photographic positives, the double exposure will yield stunning photogravure-like effects.

Using the double exposure you can expose all kinds of transparencies in the sun, from drawings and photocopies to photographic films. To perform a double exposure the plate is first sensitized with an aquatint screen. An aquatint screen, or random dot screen, is a high-resolution transparency film covered with a random distribution of minute, opaque dots. This screen is produced with special software that generates the random dots, often referred to as "stochastic screening," and can be found in professional reprographic services. The plate is then exposed with a positive transparency for the second exposure. The subsequent steps, developing, drying, and post-exposing the plate are almost identical to relief platemaking.

The aquatint screen, or stochastic screen, has a random pattern of dots which enables the plate to hold large areas of color.

Transparencies with massive areas of black are ideal for the double exposure technique.

Transparencies with subtle grays are also ideal.

MAKING A TEST STRIP

You will find the double exposure technique can be very sensitive to changes in the exposure time, and even a few seconds can make a difference. Accurate timing when exposing test strips and plates is essential. Initially it is preferable to keep the exposure times of the screen and the transparency the same, but in special cases you may need to adjust the ratio of the exposure times. This is described later in this chapter.

If your transparency includes extensive areas of black then with a single exposure much of the polymer would wash away beneath these areas, creating an area that will not hold ink when printed in intaglio; a phenomenon called "open bite" in traditional etching. (This would give white areas if printed in relief.) Another problem that can arise with a single exposure is deep grooves in the polymer that hold too much ink, so that the excess ink bleeds on to the paper during printing. By using an aquatint screen for the first exposure the polymer partially hardens, forming many tiny hardened areas interspersed with many tiny soluble areas. The plate is then exposed for a second time when the positive transparency is developed. Providing the exposure times are suitable, the areas of polymer beneath transparent parts of the image will completely harden, while areas of polymer beneath the solid areas of black on the transparency will be composed of many tiny cells. When inked these cells will hold sufficient ink to create continuous areas of black in the final print.

PREPARING

To prepare your test strip for a double exposure:

1. Draw on a transparency film, such as drafting film or acetate, with opaque and semi-opaque drawing media, for example, pencils, India

Dan Welden, *Sheep Tracks*, 1997
Intaglio print, 9 x 6.75 in (23 x 17 cm)
The delicate pencil-like quality of this print was achieved with three exposures. In the first exposure, Dan Welden exposed the plate without any transparency for a few seconds. In the second exposure he applied the aquatint screen for 1 minute 45 seconds, and for the third exposure he exposed his drawing on grained glass for a further 1 minute 45 seconds. All exposures were performed in the sun. Watercolor was added after printing.

ink, charcoal, and a variety of felt tip pens; draw your image the way it will appear in the final print. Create a variety of tones and hold the transparency to the light to view the results.

2. Remove the excess film by trimming the edges of the transparency once the drawing is completed.

3. With a guillotine cut some test strips and a solarplate slightly larger than the transparency for the final image, at least $^1/_4$ inch (.6 cm) larger all round.

4. For exposing the test strip cut a piece of the aquatint screen slightly smaller than the test strip. Then cut a piece of screen slightly smaller than the plate for the final image, but slightly larger than the size of the transparency film. Make it approximately $^1/_8$ inch (.3 cm) smaller than the plate so that your transparency film will be adequately covered by the screen during an exposure.

The transparency and screen must sit flush against the surface of the plate during each exposure, so cut away any warped edges on

Double exposing the plate, preparing, and inking

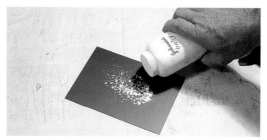

1. Dust the plate with talc.

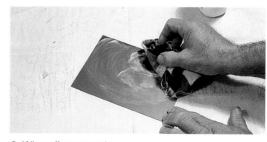

2. Wipe off excess talc.

3. Place the aquatint screen face down on the solarplate between glass and the support.

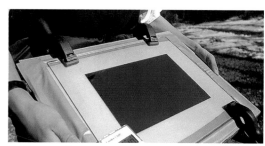

4. Clamp and expose.

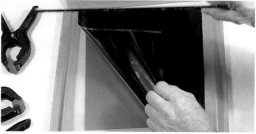

5. After removing the screen, place the transparency with the worked surface in contact with the solarplate.

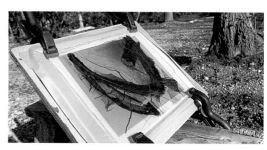

6. Clamp and expose.

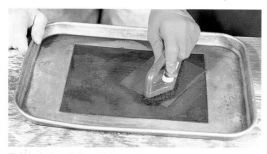

7. Wash the plate with tap water.

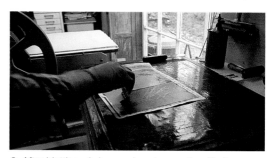

8. After blotting, drying, and post-exposing, file the corners of the plate and begin inking.

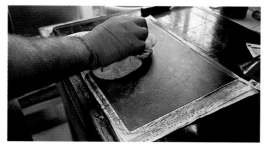

9. Wipe with tarlatan and finish with pages from a telephone book.

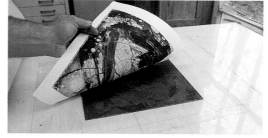

10. Print.

test strips and plate before exposing. To protect the unexposed solarplate, wrap in lightproof paper or a plastic bag until you are ready to use them.

EXPOSING

Prepare the developing tray and line it with magnetic vinyl. You will need a small jug with tepid tap water between 68–78°F. Simply adjust the temperature of the water by adding hot or cold water when needed; an oven thermometer will help you record the temperature. Keep in mind that a high water temperature can soften the polymer, while lower temperatures will not affect the rate of development.

1. Take a test strip of solarplate, remove the cover film, dust the surface with talc and place the emulsion side, which is the least shiny side of the aquatint screen, face to face with the plate.

2. Clip the plate and screen into a contact frame making sure that the spring clamps do not cover any part of the film or plate.

3. Cover the contact frame with a piece of light-proof material, such as cardboard, and go outside.

4. After removing the cardboard, expose for 1 minute 45 seconds in the midday sun in summer. So that the polymer receives the direct rays of the sun, hold the frame at right angles to the sun. Replace the cardboard and take the contact frame indoors.

5. Remove the aquatint screen, place the positive transparency on the plate with the worked surface against the plate, and clip the plate and transparency back into the frame.

6. Go back outside with the frame covered with cardboard. Remove the cardboard and expose for another 1 minute 45 seconds. Cover the frame with cardboard and go to the developing tray.

The exposure times we suggest above are for a sunny midday exposure in summer. In autumn and spring when UV light is decreasing start testing with 3 minutes for each exposure, and in winter try 3 to 10 minutes for each exposure. Much depends on the opaqueness of your image: if it is very opaque you can expose for longer, while if the image is very light you may need even shorter exposure times than 1 minute 45 seconds. In the summer sun in Australia exposure times can be as little as 30 seconds for each exposure. It is better to print the test strips and work from the troubleshooting tables to evaluate whether you need to adjust the exposure time.

DEVELOPING

If you develop the plate indoors make sure you keep well away from sunlight coming through windows. If you develop the plate outside work in a well shaded area. These precautions are to prevent sunlight from rehardening any soluble parts of the plate.

Tip

While we have not encountered any direct problems, please note that if it is very hot delicate photographic films can expand in the heat and a fuzzy or blurred image may result. Also in some parts of the world in the winter months the UV intensity is too low to achieve good results with digital transparencies and continuous tone photographic film. The alternative is to expose transparencies in a light box or a commercial exposure unit (see Exposure, pp.93–99).

The particular screen we recommend is made using a random dot pattern generated by software made by Linotype Hell. The screen is reasonably durable and can be cleaned with a little detergent and water, or isopropyl alcohol, so is ideal for printmakers' studios. Always store screens flat in a folder because they can crease if stored carelessly.

Equipment for a double exposure:

Drafting film or textured acetate

0paque and semi-opaque drawing media (pencils, India ink, charcoal, felt tip pens, etc.)

Solarplate

Aquatint screen

Lightproof paper or black plastic

Contact frame

Talc

Soft, wide brush

Cardboard

Timer

Developing tray

Magnetic vinyl

Oven thermometer

Nail brush

Lint-free towel or chamois leather

Hairdryer

Impermeable apron

Chemical splash goggles

Nitrile gloves

Equipment for printing an intaglio plate:

Good etching ink (Graphic Chemical & Ink Co Black 514 is ideal to start with)

Ink modifiers (such as Easywipe Compound or thin plate oil)

Cardboard scrapers or plastic ink applicators

Ink slab

Inking knives and spatulas

Inking board

Wad of softened tarlatan

Telephone book paper

Etching paper (such as 250g Arches cover, Somerset, or BFK Rives)

Impermeable apron

Nitrile gloves

1. Once you have removed the transparency, you can sometimes observe the ghost of the image on the polymer surface, which means that the exposure has worked. If the ghost is not visible, it does not signify that the plate will not work.

2. Wearing safety gear, place the solarplate on the magnetic vinyl in the developing tray, pour a little water on the plate and scrub gently with a soft brush as evenly as possible over the entire surface.

3. Periodically lift and examine the plate for signs of grooves forming. With an intaglio plate the grooves will be quite difficult to discern at first but with experience the plate will become easier to "read."

4. You can add more water and continue to scrub for a total of about 1 to 2 minutes. For an intaglio plate you are aiming to create shallow grooves. When printed, this plate will give a range of tones and textures reflecting the quality and application of drawing materials used for the original transparency.

5. Give the plate a final rinse before drying.

6. Arrange the plate on a clean, lint-free towel and blot the polymer surface. As you blot, constantly use a fresh part of the towel; this prevents the spread of sticky polymer to other parts of the plate.

7. Dry the surface with a hair dryer on a warm setting for about 1 minute, making sure no more water droplets are left on the plate. Always dry plates where there is little dust to minimize any particles and hairs sticking to the surface. Any particles on the plate can be washed away by rinsing or scrubbing briefly again with water. Blot and dry again with a hair dryer.

8. Post-expose for 5 to 10 minutes in the sun to harden the plate. Feel the surface of the plate, and if the polymer is tacky leave it in the sun until the polymer feels smooth. You can leave the plate on a sunny window ledge or out in the sun for up to 2 hours without damaging the plate. Now the plate is ready for printing.

Developing an intaglio plate is generally a more gentle process than developing a relief plate. Try to avoid scrubbing too vigorously as you may lose detail in the final print. However, too little pressure will make little impression on the surface of the plate.

PRINTING

We have found printing intaglio solarplate is much easier than etched metal plates: it is less time-consuming, requires no hot plate, and less press pressure when printing. Lay out clean newsprint on the bench and tear and dampen some strips of good etching paper, like BFK Rives or Lana, following the directions on p.84; newsprint will tear if you try to proof intaglio plates with it. Set up the magnetic inking board, and check that the press is clean.

1. Set up the press with etching felts, arranging the three felts in order: the sizer directly on the bed of the press, the cushion next, and the pusher on top.

2. Wind down the roller to create pressure; for experienced printmakers you will find this pressure is slightly less than the pressure needed to print etched zinc plates.

3. To test the pressure and alignment of the roller, place an uninked plate on the bed of the press, cover the plate with blotting paper, lay the blankets over the paper, and roll through the press. Lift the blotting paper off and examine the impression, which should be evenly aligned. If it is uneven wind the appropriate screw to adjust the roller. Also check that the paper has picked up enough embossed detail from the etched polymer indicating there is sufficient press pressure.

4. Put some ink on the ink slab. If it is stiff blend in some plate oil, Easywipe Compound, or Gamblin tack reducer to create consistency looser than the buttery consistency normally used in traditional intaglio printmaking. We recommend blending Graphic Chemical Black 514 with Easywipe in proportions 3 to 1, depending on temperature.

5. Place the test strip on the magnetic inking pad and apply ink to the surface of the plate

with the scraper. Completely cover the surface of the plate, making sure that ink penetrates all the fine lines and crevices in the polymer. Holding the scraper at an angle, scrape to remove the excess surface ink and put this back on the slab for the next impression. Some plates with deeper grooves or fine detail will require a dauber or tarlatan to make sure ink is thoroughly applied.

6. Continue to work the ink on the plate with a wad of softened, used tarlatan, constantly wiping the surface of the plate gently with a circular motion; this forces ink into all the grooves and crevices. At the same time, the tarlatan removes excess ink from wide or deep grooves and excess ink from the surface of the plate. Once most of the ink has been removed from the surface, you can use a cleaner, palm-sized wad of tarlatan and wipe further. Avoid using finger pressure on the plate as it has a tendency to remove ink from the intaglio lines.

7. To remove more ink from the plate surface wipe with old telephone book pages, always keeping your fingers and the palm of your hand flat against the surface of the plate. Keep wiping until the telephone paper picks up little or no more ink.

8. For the final wiping a small block of wood or a brand new lithographic sponge, wrapped in heavy paper, can serve as a wiping block and help hold the ink in the intaglio areas.

9. In preparation for printing, take a small cotton rag and clean the edges of the plate thoroughly.

At this stage you can remove your nitrile gloves to handle the strip and printing paper with clean fingers. If you don't remove your gloves, you will transfer ink to expensive and pristine paper. However, it is very difficult not get some ink on your fingers and you can avoid ink on your printing paper by dipping your fingertips in talc prior to handling the paper, or by making small folds of paper with which you can lift and position the paper. Apart from the safety factor, one of the advantages of using barrier cream on your hands is the ease with which you can wipe

ink off your fingers at this stage. (Note: some people have negative reactions to barrier cream.) Place the test strip on the bed of the press. Lay the printing paper over the plate, cover with a piece of tissue paper, lift and stretch the blankets into place, and roll through the press. You can now examine the test print. Again, the first thing to do if your print is not as you hoped is to check your inking and printing technique against the troubleshooting tables that follow.

MAKING THE FINAL PLATE

For a large intaglio plate, more than 9 x 12 inches (22.9 x 30.5 cm), use a larger brush for developing the plate. You may also need to scrub for a little longer. If you work outside, after exposing the plate at midday, you can store it in lightproof paper or in a drawer and develop it in the evening. This will avoid any rehardening of soluble parts of the polymer which result from reflected UV light in shade. Always take care to dry the plate evenly with the hair dryer.

PREPARING THE PLATE

Before proofing a plate, trim the edges of the plate to its final size with a guillotine or utility knife. Examine the plate for particles and remove any hairs or particles adhering to the surface of the plate with a pair of tweezers. File the plate to round off the corners and remove any burrs from the edges of the steel base.

MAKING A REGISTRATION SHEET

Make a registration sheet with newsprint. This is the same process as for a relief plate. First mark the outline of the printing paper with a pencil and then mark the outline of

Analyzing the test strip: Inking and printing problems

PROBLEM	CAUSE	SOLUTION
The print is too dark and has a heavy plate tone	The press pressure is too great	Loosen the screws on the press to reduce pressure
	The paper is too damp	Let the paper dry in the air for a few minutes before printing, or use less absorbent paper
	You have not wiped the surface of the plate enough	Increase wiping with tarlatan and telephone paper
	The plate is bitten too deeply	Create a new plate with a 3 second flash exposure
	The ink is heavily pigmented	Try Graphic Chemical 514 Black etching ink which is less pigmented, or add plate oil, Easywipe, or tack reducer to the ink
Ink is squeezing on to the paper	Too much press pressure	Unwind the screws to reduce pressure
	You have not wiped enough	Increase wiping with tarlatan and telephone paper
	The ink is too thin	Add heavy plate oil or mix in a little magnesium carbonate. Alternatively, start with a new batch of ink
The image prints too lightly and some details are absent	There is insufficient pressure when printing	Wind down the screws to increase the pressure, or lay more sheets of newsprint over the printing paper
	The paper is too dry	Print with damper paper
	The ink does not contain enough pigment	Try a more pigmented ink such as Gamblin or Charbonnel
The image shows a gradation from dark to light	The press is unevenly aligned	Adjust the screws of the press to align the roller evenly
	The plate may be improperly exposed	Work with a new plate

Once you have solved problems related to inking and printing but you are still obtaining unsatisfactory prints, then work through this next table to try and correct any platemaking problems.

Analyzing the test strip: Platemaking problems

PROBLEM	CAUSE	SOLUTION
The print appears faded and faint	You have overexposed the plate and insufficient polymer has washed away	Decrease exposure times or move the plate further from the light source. Repeat this cycle if necessary
	The drawing is not opaque enough	Darken your image by adding opaque marks and textures
	Poor contact between plate and image	Make sure plate is not warped. Check contact frame is properly clamped during exposure
	You have exposed with the back of the artwork face down on the plate	Arrange artwork face down on the plate and test again
The print has heavy plate tone	Due to using grained glass or textured transparency film	Polish the plate with fine carborundum, or redraw on drafting film
	Shorter exposures increase plate tone	Increase exposure time or flash expose the plate for 3 seconds
Excess ink is bleeding on to the paper during printing	You have underexposed the plate	Increase the exposure time. Ink and print and repeat the cycle if necessary
	Application of drawing materials too dense	Scratch back to lighten your drawing
	Lines and grooves are still too deep	Pre-expose plate without a transparency for 3–5 seconds, then proceed with the double exposure
	"Open bite" areas are not holding ink	Use double exposure technique

Keep adjusting these variables and developing test strips until you are happy with the result. Then expose and develop your final image with the appropriate exposure time to obtain your first intaglio solarplate.

the plate where you want the impression to sit on the paper. Then place it under the acetate on the bed of the press.

PREPARING PAPER

While your hands are still clean prepare the printing paper. Tear intaglio paper the same way you tear Japanese papers: with a blunt knife, straightedge, or by dampening the fold of a sheet with a brush. Tear the paper to size for the final plate, with some additional small pieces for printing test strips.

Always print the image on the right side of the paper. The wrong side of printing paper carries a very fine impression left by the wire mesh of the frames on which paper is dried in the papermaking process. Another way of determining the right and wrong side of paper is the watermark, which reads correctly on the right side of the paper. With a medium pencil mark the wrong side with a small cross in one corner; this way you will make no errors when printing.

Intaglio papers work best if they are dampened; this makes them more receptive to ink and flexible enough to be forced into the grooves of plates to pick up ink during printing. For proofing you can dampen intaglio papers by brushing one side of each sheet with a wet brush. Stack the damp sheets of paper on top of one another and wrap in a plastic bag. After a few hours the paper should be evenly damp. Take a sheet out and check to make sure there is no shiny surface moisture. Normally it is better to use paper which is only slightly damp: the damper the paper the more plate tone will appear in the print.

Another way to dampen paper is to soak a few sheets in a tray of water for 5 to 15 minutes. When you are ready to print, take out a sheet at a time and blot it dry between blotters or towels. Alternatively, you can very briefly run a sheet through the water, blot and print. The shorter the time the crisper the image. Soaking in water disperses the sizing making the paper very receptive to ink, and depending on the amount of size, different papers require more or less time soaking. Paper like Lana has little size and requires much less soaking than a paper with more size, like BFK Rives. Through experimentation you will learn to judge how much to soak paper.

The traditional way of drying paper is between blotters. Place the dampened paper between blotters and pat with your hand, or roll a rolling pin across the blotter. In the shared space of access workshops participants frequently encounter the frustration of ink-stained, uneven and pilled blotting paper, but it is possible with care and good organization to make a set of blotters last many years.

An alternative is to substitute lint-free towels; this saves trees and cuts costs considerably. Spread out a towel on a flat bench, take a sheet of paper out of the tray and hold it to let excess water drip back into the tray. Lay the sheet on the towel and place another towel on top. Smooth and pat with clean hands. Upon removing the top towel, examine the paper and remove any particles or swipe a draftsman's brush across the surface to remove any shiny wet spots.

For editioning you can prepare paper the day before. Soak half of the sheets in a tray of water and stack them by interleaving a wet sheet with a dry sheet. Wrap in plastic and cover with a board and weights to keep the paper flat. By the next day the sheets are evenly damp and ready for printing. In dry, cool climates dampened paper will last like this for several days, but in a humid, hot atmosphere mold will grow and ruin the paper. After a printing session it is better to remove any remaining sheets from the plastic to let them dry out, and redampen them when you are next ready to print.

PRINTING THE PLATE

Place the inked plate on the bed of the press in the plate outline of the registration sheet,

align the etching paper on top of the plate using the paper outline of the registration sheet and gently cover the plate with etching paper. Cover with a sheet of newsprint or tissue paper, stretch and lower the blankets carefully on to the paper and roll through the press. Lift the paper off the plate and examine your completed intaglio image.

As you continue to print it is important to flatten prints as they dry so they do not twist. Use a set of boards or blotters as described in the relief printing section above.

EXPERIMENTING

It is important to experiment with printing intaglio plates to obtain different aesthetic effects. Vary the dampness of your paper and the consistency of the ink. One of the striking characteristics of intaglio prints is an attractive light plate tone, and by skillful inking and wiping you can modify plate tone and generate sensitive and atmospheric prints. We also recommend experimenting with platemaking to explore the impact on the printed image. You can expose the positive transparency without using the aquatint screen to create "open bite" which can add vitality to an image, or create plates with many levels ideal for color printing techniques, such as viscosity printing or relief intaglio. Delicate prints can be created by exposing the plate as many as three times, while varying exposure times can influence the tonal range of a print. Refining printing and platemaking techniques can take time, but combined with the many ways of creating positive transparencies, experimentation offers great flexibility and exciting possibilities.

MODIFYING PLATE TONE

There are many ways to enhance or reduce plate tone according to your aesthetic preference. With your first intaglio plate experiment with minimal wiping to leave a

Beth Rundquist, *Untitled*, 1997
Intaglio print, 11 x 7.5 in (28 x 19 cm)
Beth Rundquist worked directly on the plate with etching ink and processed the plate using the double exposure technique to create a painterly effect.

lot of plate tone on the plate. Then make another impression by wiping the plate as clean as possible to minimize plate tone. The type of ink affects plate tone: inks made by Charbonnel and Gamblin are richly pigmented and enhance plate tone, while 514 Black made by Graphic Chemical & Ink Co contains less pigment and leaves less plate tone. Thinning inks with varying amounts of plate oil, Easywipe Compound, Setswell Compound, or tack reducers also reduces plate tone.

If the printing paper is very damp it will pick up more ink from the surface of the plate increasing plate tone, while slightly damp paper will reduce it. Dry paper picks up very little ink from the surface, but you may lose some details of your image. Another manipulation is to rework the plate by polishing with jeweler's rouge and other fine abrasives to introduce highlights or reduce plate tone (see Reworking the Plate, on p. 17).

The type of transparency you use affects plate tone. Textured films, like True Grain, and sandblasted and grained glass tend to increase plate tone, while more transparent media, like clear acetate and drafting film, minimize the effect.

One trick for reducing plate tone in platemaking is to give the entire plate a post-exposure flash of 1 to 5 seconds in the sun after completing a double exposure and removing the positive transparency. This is a third exposure. The length of the flash depends on the intensity of the UV light. Experiment with shorter times in summer

Working with the printing plate

	ENHANCING	REDUCING
Enhancing and reducing plate tone	Less wiping of the plate	More wiping
	Use richly pigmented inks like Charbonnel, Gamblin	Use less pigmented inks like Graphic Chemical & Ink Co 514 Black
	More press pressure	Less press pressure
	Well dampened paper	Dry or slightly damp paper
	Do not modiify inks	Thin inks with plate oil, Easywipe, extender, or Setswell Compound. Add magnesium carbonate and plate oil to ink
		Polishing the plate with jewelers rouge, fine carborundum, or metal polish
Abrasives	Use grained or sandblasted glass, or textured acetate as the transparency	Use clear acetate or clear glass
	Using papers with little sizing	Using papers with heavy sizing

Ford Robbins, *Untitled*,
1998
Intaglio print, 1 x 15 in
(28 x 38 cm)
This image began as a very
light laser transparency and
using equal times for the
double exposure technique
gave poor results. By
increasing the screen time,
1 minute 45 seconds,
relative to the positive
transparency time,
10 seconds, Ford Robbins
achieved strong blacks
in the final print.

and longer for winter. For delicate images test the effect of the flash carefully with test strips to make sure it does not harden the plate too much and eliminate subtle detail.

WORKING DIRECTLY ON THE PLATE

When painting or drawing directly on the plate you can pre-sensitize the plate with the aquatint screen and then apply ink and other media directly to the polymer. For denser found objects or opaque etching ink the print will retain more tone and extensive areas of black.

ALTERING THE EXPOSURE TIME

In general, with the double exposure technique the best results are obtained by using equal times for both exposures, but you can manipulate the relative times of each expo-

sure to influence the final impression. If you increase the exposure time of the screen relative to the positive, say 2 minutes 15 seconds for the screen and 1 minute 15 seconds for the transparency, lighter tones are strengthened, while some darker tones will become darker. The overall effect is to darken the image and is a useful approach for very light transparencies. For example, in one workshop a participant brought along a very light laser transparency which only gave a good result when the screen was exposed for 1 minute 45 seconds and the transparency for 10 seconds.

You can also do the converse and decrease the time of the screen relative to the positive, say, 30 seconds for the screen and 1 minute 30 seconds for the transparency. With this type of exposure you may gain a better range of midtones, but lose some lighter tones. The overall effect is to lighten an image. Deep grooves and areas of open bite can form, and, by fine-

Rita Dibert, *Forbidden Fruits*, 1999
Photopolymer gravure print, 16 x 12 in (40.7 x 30.5 cm)
This is a variation of working directly on the plate. First
the plate was pre-sensitized with an aquatint screen,
then a continuous tone positive was arranged in the
center of the plate and the artist painted directly on to
the plate around the edges of the transparency and
exposed again.

tuning the relative times of each exposure,
you can control the extent of open bite.

HYBRIDIZING IMAGES

Another interesting experiment is to expose
one transparency, remove it, and then expose
a second transparency using equal times for
each exposure. The result is not the same as
overlaying transparencies where two com-
plete images are transferred to the plate, but
there is a blending or hybridization of the
two images and is comparable to a double
exposure effect used in photography.

This technique is a good way of adding
text or additional elements to create a collage
effect. It works well with digital transparen-
cies, which are very opaque and have
extensive areas of black, and often exposing a
negative transparency first then a positive
transparency second works well. You can also
pre-sensitize the plate with an aquatint screen
and expose two transparencies subsequently
for a different effect.

USING A PRE-EXPOSURE FLASH

A 3 to 5 second flash prior to exposing the
aquatint screen and positive transparency
makes a total of three separate exposures on
one plate. Since the polymer always hardens
from the base up, a flash exposure will
harden the lower part of the polymer layer,
while the upper part remains soluble. Then if
you expose the screen and follow with the
positive transparency as for a normal double-
exposure it is impossible for deep grooves
to form. This approach will yield images
with a delicate quality as if drawn with
pencil. Another variation is to flash the
plate then expose the positive transparency
only.

The time of the pre-exposure will vary
according to the intensity of solar or artificial
UV light, and initially should be estimated
with a test strip. The best way to do this is to

Terry Elkins, *Shipwreck*, 1999
Single exposure intaglio print, 14.75 x 17 in (37.5 x 43 cm)
Drawn with soft pencils on grained glass.

take a strip of solarplate, remove the cover film, dust with talc, and expose by sliding a piece of cardboard along the strip for varying times, for example, 1, 2, 3, 4, 5, 6, and 7 seconds. Process the strip following the standard procedure. By examining this strip you can observe a stepwise structure of hardening and determine the time you want. Once you have estimated the time, take a test strip, pre-expose it, remove it from the light source, expose the screen for 1 minute 45 seconds and then the positive transparency for 1 minute 45 seconds. Develop, dry, and post-expose following standard techniques and print. Once you have printed a successful test strip make a full-size plate.

This approach tends to suit printmakers who are more methodical in their approach to printmaking and like measuring times accurately. If you prefer a more unpredictable to approach to platemaking, then this method may not suit you.

USING SINGLE EXPOSURES

Some transparencies can be exposed without pre-sensitizing the plate. Drawings on acetate and grained or sandblasted glass often work well with a single exposure because the drawing media has been broken up into many small dots by the textured surface of the glass or plastic. This kind of image allows light to penetrate and harden the polymer sufficiently to prevent the polymer washing away. Experiment with summer exposure times of 1 minute 30 seconds for light drawings, and up to five minutes for more opaque drawings. If drawings have extensive areas of black, then it is advisable to use the double exposure technique.

Many standard photocopies made up of many tiny dots of toner have little tone and produce good results with a single exposure. Experiment with exposures of three to five minutes in the summer sun. However, for

Exposing, processing, preparing, and inking a single exposure plate

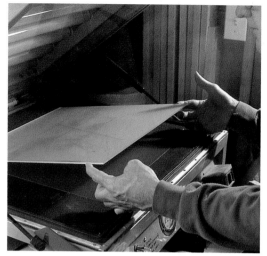

1. The drawing is placed face to face with the solarplate and exposed.

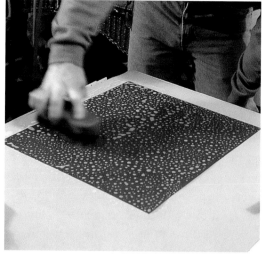

2. Scrubbing the plate.

3. Post-exposing.

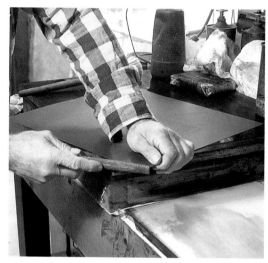

4. Filing the sharp corners of the plate.

5. After inking the plate, wipe the surface of the plate with tarlatan to remove excess ink.

6. Using phone book pages for wiping away more ink.

photocopies that have been darkened with ink or have heavy applications of toner, you will need to use the double exposure to prevent the polymer washing away.

There are, in fact, no hard and fast rules about platemaking; the final result is what is important. For those who prefer a more spontaneous, unpredictable approach you can purposely generate an image with very opaque marks and expose the transparency for a single exposure. This will lead to a plate where the polymer partly washes away to create "open bite." Open bite can add vitality to an image. Using a single exposure is also useful for creating plates with different levels for viscosity printing. Experiment by drawing an image with media of different opacities, expose this for a single exposure of 1 minute 30 seconds, and, by controlling the washout process, grooves of varying depths will form. Applying the double exposure technique to the same image will lead to a very different printed effect.

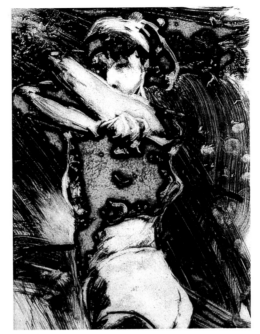

Eric Fischl, *Woman with Blouse*, 1992
Single exposure intaglio print , 7.75 x 5.75 in (19.7 x 14.5 cm)
Created with ink on acetate, the transparency was exposed once, developing areas of open bite. When inked and printed, the open bite added to the expressive quality of the print.

Comparison of double exposure and single exposure techniques for intaglio images

DOUBLE EXPOSURE	SINGLE EXPOSURE
Requires shorter washout	Requires longer washout
Shallow lines and grooves in the polymer	Variable depth of lines and grooves
Quality of line preserved	Line work may be sketchy and broken up
Increased tonal range	Images have more contrast
Extensive areas of black preserved	More likely to have areas of open bite
Increased plate tone	Less plate tone
Minimal embossment	Use for blind embossing

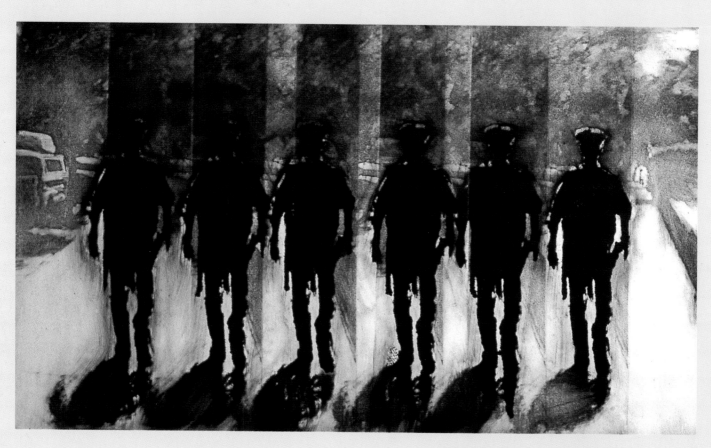

Peter Lambert, *Law and Order*, 1997
Single exposure intaglio print, 6.5 x 11.25 in
(16.5 x 28.5 cm)
Peter Lambert photocopied an original drawing and
transferred it to a small strip of solarplate by exposing
in the sun. This was printed several times on the same
sheet of paper to create this dramatic image.

EXPOSURE

In an age of solar powered technology and energy conservation, exposing solarplates in the sun is free and practical and provides an enjoyment you cannot experience with many other forms of printmaking. This chapter describes the range of seasonal and weather conditions that are most suitable for solar exposures. If you want to take a more scientific approach, you can also measure UV light indirectly with a step wedge. By recording these measurements you can develop a reliable guide for exposing plates throughout the year.

Using the sun will be inconvenient for many printmakers, and an alternative is to use an exposure unit with an artificial UV light source, such as a sunlamp, blacklight fluorescent strips, a mercury vapor lamp or a metal halide light. In this chapter there are directions for constructing a versatile and reliable UV light box with blacklight fluorescent strips. Another alternative is to use a commercial metal halide exposure unit. These are often found in tertiary institutions and some print workshops, although it is becoming easier to buy a secondhand one. Currently there is a revolution going on in the commercial printing industry as many printers are turning to computerized printing, eliminating the need for exposure units to transfer text and images to printing plates. As a result, exposure units are being sold off at a fraction of their original cost, along with other equipment, such as process cameras and vacuum frames. This kind of equipment is very useful for solarplate printmaking.

EXPOSING IN THE SUN

The sun gives out a wide range of UV light, which passes straight through the ozone layer, filters through any cloud cover and is present in varying amounts at ground level all year round. While there are some limitations, it is easy to expose solarplates in different seasons and in varying weather conditions. Although it can be very pleasant to work outside, always take precautions against overexposure to UV light (see Safety and the Working Environment, pp. 129–137).

SENSITIVITY TO UV LIGHT

Solarplates are most sensitive to a range of UV light varying between a wavelength of 350 nanometers (nm) and 370 nm, at a peak of 360 nm. (UV light is measured in nanometers, which is a unit of measurement called wavelength.) This falls within the range of natural UV light from the sun.

Trudi Last, *Thrush's Nest*, 1999
Single exposure intaglio print, 9.75 x 6.5 in (24.5 x 16.5 cm)
Sun exposure.

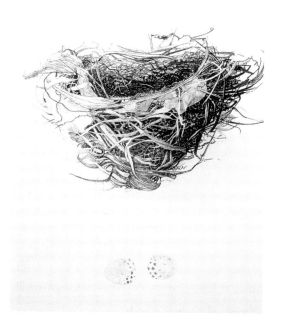

In addition, solarplate has a special property which industrial platemakers call "a wide latitude of exposure." This means that the polymer is insensitive to small variations in the intensity of UV light. For example, if a light cloud passes over the sun while you are exposing test strips or a plate, the slight decrease in UV light will not affect your results. On the other hand, if you expose a test strip in the sun and then a dark, thick bank of cloud completely obscures the sun while you are exposing a plate, you may find the plate underexposed. It is always best to survey the skies before testing and making plates.

SOLAR EXPOSURES

It is best to expose on sunny days or on days when the cloud cover is relatively constant and casts an even intensity of light. Expose from late morning to mid-afternoon when the UV intensity is least variable and you have more control. In the early morning or late afternoon the intensity is increasing or decreasing rapidly and it is more difficult to estimate exposure times. By the time you have made and printed a test strip, the intensity of UV light will have changed.

In practice you can expose solarplates in all kinds of weather, all year round and in many different geographical locations; Dan Welden has even given a successful workshop in the pouring rain. Take care in very hot weather: the polymer can become sticky and you may need to dust both the plate and the transparency with talc. On one occasion we found that at over 100°F the polymer completely hardened without any image forming. With experience you can learn to estimate solar exposure times accurately despite the variable intensity of UV light with daily and seasonal cycles.

As the earth tilts and creates the seasons so the intensity of UV light varies through-out the year, with the greatest intensity in

midsummer and the lowest in midwinter. Exposure times can range from as little as 30 seconds at the height of summer, to 30 minutes in midwinter, depending on where you live. The authors live in different parts of the world, one in New York near the 40°N line of latitude and the other in Adelaide, South Australia, which lies on the 35°S line of latitude, and both authors have found that exposing plates all year round is practical. In the southern part of Australia, as a rule of thumb for the double exposure technique, you can expose for 1 minute for each exposure in summer, 3 minutes in spring or autumn, and up to 15 minutes in the winter months. It is really important when working in the sun to use test strips to determine exposure times before making the final plate.

THE STOUFFER WEDGE

A Stouffer Wedge is a small grayscale transparency available from photographic suppliers, which provides an inexpensive way of measuring UV light indirectly. There are several different kinds, but they are all generally known as step wedges and work in a similar way. Commercial platemakers use a step wedge to estimate the optimal exposure time for photographic film. It is not an essential item for solarplate printmaking since you can rely on test strips to determine optimum exposure times, but it is a useful "tool" if you wish to learn more about fluctuations in solar UV light or need to test the intensity of UV light in exposure units. We used a 21 Step Stouffer Wedge, which consists of a strip of continuous tone film with a range of grays arranged in blocks of increasing opaqueness from very pale gray to very black. Each step varies by 0.1 in density from the adjacent step, and each step is numbered from the lightest step, number 2, to the darkest step, number 21.

To obtain a reading in the sun, cut a small strip of solarplate slightly larger than the grayscale, remove the cover film and dust the strip with talc. Then just as if you were exposing a transparency, expose the grayscale on the test strip in the sun for a given time, say 2 1/2 minutes. A good tip is to expose with the shiny non-emulsion surface of the grayscale face to face with the polymer; this makes no difference to the readings and will protect the film's delicate emulsion. Always develop for a fixed time, say 3 minutes, dry, and examine the strip to take a reading. There is no need to post-expose or print the strip.

Under the most opaque blocks or steps of the scale the polymer will completely wash away; under the lightest steps the polymer will harden; while several steps in the middle will be only partially washed away. Observe that the numbers 2 to 21 form in relief and this is the scale you can refer to. (Keep in mind these numbers will appear back to front if you expose the scale with the emulsion side upwards.) For a reading, all hardened or partially hardened steps are counted as "solid" and the highest numbered step that remains solid provides the reading. For example, if you find that steps 2 to 9 are solid, steps 10 and 11 are partially washed away, and steps 12 to 21 have completely washed away, then the reading is 11. As you become experienced with a grayscale, you can judge roughly what a reading is likely to be and economize by cutting very small pieces of solarplate to cover the relevant part of the scale.

Taking readings in the sun at different times of the day and year will give you an understanding of daily and seasonal UV fluctuations in your part of the world. Keeping records will give you a guide to when to expose your transparencies and for how long. We have found that the best results for drawings and photocopies is a range of between 9 and 11, while more opaque film, such as laser and photographic transparencies will work well in a range of 12 to 14.

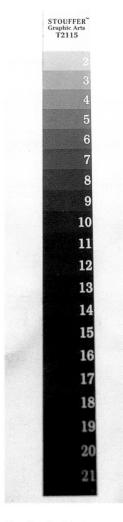

The Stouffer 21 step sensitivity guide is a quality control scale that helps the user determine and standardize the proper exposure and processing of photo sensitive materials.

EXPOSING INDOORS

Having a permanent light box in your studio allows you to work at any time of the day or night. You can make a light box with a sunlamp, blacklight UV fluorescent strips, or buy a secondhand exposure unit or platemaking machine with a metal halide lamp. All these light sources emit UV-A light of 360 nm, which is optimal for solarplate.

MAKING A UV LIGHT BOX

While a sunlamp gives out the correct wavelength of UV light for solarplate and is a cheap option as a UV light source, it has some disadvantages: the lamp tends to get very hot, and, because it is globe shaped, it casts an uneven distribution of light. Plates can be overexposed in the center and underexposed at the edges and print very unevenly, though it is useful for exposing small plates.

You can make a more reliable unit by securing a bank of UV blacklight fluorescent strips to a board. Blacklights give off a cooler light that is much safer for studios and classrooms, and, providing the strips are tightly packed together, they will cast an even distribution of light. The completed light box should cost no more than US$100.00 to make.

For exposing 12 x 16 inch (30.5 x 40.6 cm) plates, assemble the following materials: a 14 x 18 inch (35.5 x 45.7 cm) board $^3/_4$ inch (1.9 cm) thick, six 24-inch (61 cm) standard strip light fittings, six 20-watt blacklight UV fluorescent lights, screws, a switch, and blackout lining fabric. Blacklights look like ordinary white fluorescent lights and give off a soft purple light when lit; you can locate them through a specialist lighting supplier. Order those with a wavelength of 360 nm, as the UV wavelength may vary with different types of blacklights.

1. Place the six light fittings in the center of the board and stack them together lengthways. Pack them together reasonably firmly.

2. Remove each of the coverings protecting the condenser and other internal wiring and make sure the fittings are all oriented the same way; if they are all aligned the same way then an electrician can wire them all together from the same end.

3. Screw the fittings to the board and bolt the coverings back in place.

4. Take the board to an electrician for wiring and attachment of a switch.

5. Insert the lights.

You can balance the board on two sets of wooden blocks or bricks, one set supporting either end. We have found an ideal height, measured from the plate to the lights, is eight inches. Arrange a sheet of blackout lining fabric over the entire ensemble, which will protect your eyes and skin from the damaging effects of UV light. Alternatively, build a wooden box to house the lights. You must take care to properly shield the UV lights to protect your eyes.

This light board is very versatile; it is easily moved and can be stored away neatly if necessary. Pauline Muir takes it into the country regions of South Australia for workshops in case of rain. In this setup 1 minute for the screen and 1 minute for the trans-

A homemade exposure unit made with plywood base and pine sides. Holes have been drilled in the sides to prevent overheating.

Blacklight fluorescent bulbs mounted in the fixtures of the box. Note that the box may be lowered over a contact frame or inverted with thick glass to support the artwork from the top.

parency are good starting times for the double exposure technique; the corresponding grayscale reading is 11. You can vary the intensity of the light reaching the plate by removing or adding blocks, thereby altering the distance of the lights from the plate. Artificial lights lose power after many hours of use, so increase exposure times or lower the light board as the lights age; eventually you will need to replace them.

PROBLEM SOLVING

Whether you are exposing in the sun or in a light box, it is likely you will be using a contact frame. One of the most frequent problems encountered with a contact frame is incomplete contact between the transparency film and the plate, resulting in prints that are frequently patchy and faded. The problem arises mainly from poor technique in cutting steel-backed plates: if there is any warping, the film will not sit flush against the surface of the polymer. Check that your plate is cut absolutely flat and review the section on cutting plates (p.18) if it is a recurring problem.

Another detail to check is the construction of your contact frame. If the foam is too thin or the glass does not have enough weight, the transparency will not sit flush against the plate. If you use bubblewrap as a cushion on the wooden base of the frame, it can work loose, so it needs to be stretched tightly across the base and taped down securely with strong electrical or duct tape. Check that your spring clips are the same style or brand; if they are of unequal strength they may cause contact problems also.

You are more likely to encounter contact problems if you use a rigid medium as a transparency, such as sandblasted glass or thick acetate. Similar problems arise from wrinkled transparency film or films with dense applications of drawing media, which will not sit flush against the plate. One way of checking for good contact is to hold the contact frame

Dieter Engler, *Vineyard Landscape II*, 1999
Two-plate double exposure intaglio print, 9 x 7.25 in (23 x 18.5 cm)
Transparencies for this print image were exposed in a homemade UV light box.

at eye level and view it from the side. By slowly rotating the frame, you can determine to some extent how well the film sits against the plate. In addition, if a transparency is cut larger than the plate, it will overhang the plate and not sit flush against the edges of the polymer creating faded strips along the edges of intaglio prints.

There is a limit to the size of the plate suitable for exposing in a contact frame and we recommend starting with small plates about 4 x 6 inches (10 x 15.25 cm) in size and working up

to larger plates no more than 16 x 20 inches (40.6 x 50.8 cm). The larger the plate the more likely you are to encounter contact problems. The most common problem with a large frame is the cover glass, which can bow and lift up at the center when the spring clamps are put in place. We found that we could solve the problem by either using fairly weak spring clamps or removing them altogether and simply allowing the weight of the plate glass to keep the transparency against the polymer. But you need to take care to hold the glass firmly since it could slip.

EXPOSING IN A COMMERCIAL UNIT

There are many different kinds of commercial exposure units with different kinds of UV light, and often with a vacuum frame built into the machine. Some may be sophisticated machines with circuit boards, while others may have manual timers. Do not be put off by the age of a machine; older machines frequently work just as well as newer models.

BUYING A METAL HALIDE EXPOSURE UNIT

Many art schools and universities have metal halide units, which are suitable for exposing all kinds of transparencies. They are particularly appropriate for exposing transparencies larger than 16 x 20 inches (40.6 x 50.8 cm) and delicate photographic films.

A good exposure unit will incorporate a metal halide lamp and a vacuum frame and may take plates as large as 24 x 36 inches (61 x 91.44 cm). The vacuum seal ensures complete contact between the polymer and the transparency, while the lamp, combined with a reflector, emits an even distribution of light over a wide area. Some sophisticated units have a piece of frosted glass or diffuser, which sits over the lamp and randomizes the light rays during an exposure. The disadvantage of metal halide lamps is their high cost and fragility: they are easily damaged and should only be handled with a cloth. Never touch the lamp with your fingers, and if you are relocating the machine, always remove the lamp from the machine and transport it separately.

Before buying a unit, test it thoroughly to make sure the lamp and the vacuum are functioning properly. There are specialist technicians who can help you check a prospective machine. Take along some solarplate, a grayscale, and some transparencies; the grayscale is a quick and convenient way to test the intensity and the spread of light in any unit, as well as estimate likely exposure times. Take some readings and make some test plates and print them. You need a machine that will give readings in the range 9 to 14 and, therefore, allow you to expose most types of transparencies.

A secondhand machine may contain an old lamp with little power, but you can remedy the problem by replacing the lamp with a new one. Check the vacuum pressure, which should reach 90 percent; a lower pressure may be due to a blanket which is old and stiff. Keep in mind that many machines have circuit boards and other parts which are very expensive to replace; sometimes the older and simpler the machine the easier it is to maintain.

If you cannot buy a unit you may be lucky enough to find a commercial printer or platemaker who is willing to let you use his/her unit. South Australian artist, Janet Ayliffe, exposes her large drawings in a Printon CDL 2000 owned by a local platemaker. To test exposure times, Ayliffe takes a very small, mobile press, and prints her test strips before exposing a transparency on a large solarplate.

USING A COMMERCIAL UNIT

The procedure is identical for exposing any positive transparency in the sun, and it is still

very important to use test strips. The difference is you will have to learn to use a sophisticated piece of machinery, but once you have learned to press the right buttons, it is usually very straightforward.

Most machines measure the exposure in light units rather than minutes and seconds, but often the number of light units corresponds to the number of seconds. For example, an exposure of fifteen light units is often equivalent to an exposure of about 15 seconds. We have found exposure times may vary depending on the machine, from as little as 15 seconds up to 8 minutes for each exposure of the double exposure technique.

PROBLEM SOLVING

Occasionally plates developed in a vacuum frame will develop faded patches due to contact problems. This can be due to a leaking vacuum. Check the vacuum pressure gauge as you expose a plate and, if this is low, inspect the rubber seal along the edges of the vacuum blanket. You may need to replace it.

Contact problems are also caused by air bubbles or grit which become trapped between the transparency and the plate. Take care to remove any particles of grit before you arrange the transparency over the plate. Air bubbles are most likely to form when it is humid, and you can avoid them by dusting the plate with talc. The fine particles of talc provide a buffer zone between the transparency and the plate; as the vacuum is turned on and the pressure increases, tiny air bubbles can escape between the particles of talc. Another solution to this problem is to use pressure to remove the air bubbles. Some units already do this automatically with rollers inserted behind the blanket, which run across the plate as the vacuum is activated. You can also do this manually by laying the transparency on the plate and rolling a relief roller across the back of the transparency several times before exposing. This often solves the problem.

Louisa Chase, *Baby Baby*, 1997
Three-plate double exposure intaglio print, 12 x 9 in (30.5 x 23 cm)
This image was made by exposing transparencies in a commercial exposure unit.
Courtesy of Goya Girl Press.

Dennis Olsen, *Archive*, **1997**
Photopolymer gravure print, 7.5 x 9.75 in (19 x 25 cm)
This image was printed as a random dot on to a transparency at a graphic service bureau. It was exposed once, and because of the fineness and random nature of the dot, the print resembles photogravure.

DIGITAL IMAGES
AND PHOTOGRAVURE

You can work in a sophisticated way with solarplate by using digital transparencies and continuous tone photographic positives. You need computer equipment and graphic software to create digital imagery, while access to a dark room is a necessity for producing photographic positives. This chapter provides basic guidelines for preparing these kinds of transparencies. Attending courses in digital imaging or photography will expand your knowledge and expertise.

In recent years there has been an explosion of interest among artists in computers and the astounding possibilities they offer for artwork and design. Most of the artwork you can do by hand can be simulated on the computer using artist-friendly graphic software programs, such as Photoshop. But the greatest advantage is that you have many choices: you can create an image, store it, copy it, and change it further, producing many different versions of one original image. You can then add an intriguing dimension by transferring a digital image to a solarplate and printing on a manual press to create a permanent print with the earthy qualities of traditional printmaking. While, with careful platemaking, prints from high-resolution digital transparencies can resemble traditional photogravure.

Another approach is to make continuous tone photographic positives from photographic negatives in the dark room and transfer the image to a solarplate. The resulting print can possess a rich tonal range and the exquisite, velvet quality characteristic of traditional photogravure. To distinguish them from the older technique, these prints have come to be known as photopolymer gravure.

DIGITAL IMAGES

Many artists have invested in the equipment required for making digital images, but artists new to computing find the prospect of learning a new and complicated skill overwhelming. This feeling is justified considering the highly sophisticated nature of modern computer technology, the obscure and complex jargon used to describe it, and the cost of computers, peripheral devices, and software programs, although these costs are constantly coming down.

Digital images are printed on to transparencies as halftone images before transferring to a solarplate. Just as you can compose a drawing as a negative or positive transparency, so you can format a digital image as a negative or positive image to create either a relief or an intaglio print. There are several ways to output a transparency: by using a printer attached to a personal computer, such as a laser printer or an inkjet printer; by printing an image as high resolution film on

an imagesetter at a graphic design house; or another cheaper alternative is by printing from color photocopiers attached to computers, a service now offered by some photocopy centers.

HALFTONES

Most commercial printed material, such as magazines, brochures, and newspapers, is printed from halftone plates. A halftone picture is made up of a series of dots of equal opaqueness; if you examine any brochure or newspaper image with a magnifying glass, you can see the myriad of tiny dots arranged in lines or rows to form a regular grid-like pattern. The darker tones of the picture are made up of many dots clustered together, while the lighter tones consist of a sparser distribution of dots.

TERMINOLOGY

It is a good idea to become familiar with the terminology used to describe halftone images. The clarity and definition of a halftone image is called the resolution. The resolution is measured by the number of dots in an inch (dpi), or the number of lines of dots per inch (lpi). Lpi is also called the screen ruling or frequency of a film or image. In general, the smaller the dot, the higher the resolution, the higher the screen ruling and the finer the reproduction; conversely with a larger dot, the resolution and screen ruling are lower and the reproduction much coarser.

In commercial printing the resolution is usually described in terms of lpi. For example, newspaper images are printed at 85–100 lpi, while high quality magazines usually have a screen ruling between 150–175 lpi. The resolution of printers attached to personal computers is frequently described in dpi and can vary between 300–1440 dpi. In contrast, conventional photographs comprise microscopic dots, which together form a continuous tone image with many shades of gray, from deepest black through to pure white.

Anthea Boesenberg,
Dark City, **1998**
Intaglio print, 10.5 x 7.5 in
(26.5 x 19 cm)
Anthea Boesenberg used
a computer much like
a photocopier, collaging
newspaper images and text
and printing the final image
on to a transparency with
an inkjet. The plate, made
with a single exposure, was
printed with the relief intaglio
method.

COMPUTER TECHNOLOGY

There is a great variety of computer hardware and software on the market. Our description is confined to the main principles and features of current hardware and software components, since it is beyond the scope of this book to cover this topic in detail. However, whether you choose an Apple Macintosh, an IBM PC, or one of their many clones, creating a digital image on a personal computer and printing it on to transparency film is a function that most types of computer systems can perform.

MEMORY

There are some basic requirements for graphic work since you will be working with images requiring large amounts of memory. It is important to have a powerful computer with plenty of random access memory (RAM), and a high capacity hard disk. Random access memory allows you to manipulate images and perform other activities on the screen.

A simple black-and-white image 9 x 12 inches (22.9 x 30.5 cm) is likely to require about 10 megabytes (MB) of RAM. By comparison, text takes up much less memory; for

Roy Nicholson, *Aconite*, 2000
Photopolymer gravure print, 7 x 7 in (18 x 18 cm)
Roy Nicholson scanned a photograph of one of his paintings, a drawing on tracing paper and some Aconite flowers. He merged the three images using Photoshop, drew with the graphics tablet, and printed the final image with an inkjet. The plate was made with the double exposure technique.

example, the text for this book is about 450 KB (1024 KB are equivalent to 1 MB). As a rough guide, if you are working in grayscale for manipulations you need twice as much RAM as the size of your image for manipulations, and three times as much if you are working in color. Therefore, considering a 10 MB image as an example, you need at least 20 MB of RAM for a grayscale image, and 30 MB of RAM for a color image. These are minimum amounts and to maintain a reasonable speed 48 MB of RAM is a good starting amount. If possible install more. 100 MB will give you much more flexibility. Computers always come with a certain amount of RAM already installed, but your local supplier can add more if your computer is suitable.

Information from RAM is saved in the form of storage memory on a hard disk, and, because of the large size of digital files required for artwork, a substantial hard disk is desirable. 500 MB capacity would be a mini-

Author's note

We urge aspiring computer artists to dispel their fears by enrolling in a course that will teach them how to manipulate some of the excellent graphic software programs available. If you do not own a computer, you can hire a computer system or use the facilities at open access studios at very reasonable hourly rates.

mum requirement; the latest personal computers are now capable of storing up to several gigabytes of data (1 Gigabyte is equivalent to 1024 MB).

SOFTWARE

There are some very exciting graphic software programs designed for manipulating artwork. Adobe Photoshop, often abbreviated to "Photoshop," is a very popular program among graphic designers and artists. It is very versatile and provides powerful "tools," options and filters for manipulating images. Another expressive program is Fractile Painter: originally designed for illustrators it has a wide range of tools for more painterly effects, and artists often use it in conjunction with Photoshop to increase the variety of imagery.

Both these programs are artist friendly and include excellent manuals and tutorials to teach you how to use the many tools, like pencils, brushes, and erasers. There is also a "layers" option, so you can work in Photoshop in a very similar way to overlaying transparencies for collaged images, or when working with transparencies for multiple plate printing.

PERIPHERAL DEVICES

If you do not have a hard disk with lots of memory, you can attach a peripheral device called a removable storage device, more commonly known as a zip drive, to your computer, which will expand your storage capacity. These machines take cartridges of varying capacity from 50 MB up to 250 MB, and some can even store 1 GB of data. Some external hard disks store huge amounts of data in Terabytes (1 Terabyte is equivalent to 1000 GB). Cartridges are very useful for storing backup copies of valuable files, taking an overflow of extra data, and transporting large files to and from a graphic design house.

There are a number of other peripheral devices, such as a scanner, a graphics tablet,

Jimmy Staples, *Mechanics*, 1996
Intaglio print, 27.5 x 22 in (70 x 56 cm)
This is an innovative way of using X-rays. Jimmy Staples scanned X-rays of his broken leg and used them for the basis of this print.

Luci Harrison, *Untitled*, 1998
Photopolymer gravure print, 7 x 10 in (18 x 25.5 cm)
This image started out as a color photograph, and was
photocopied and printed from an inkjet printer. By using
the double exposure technique, the image acquired a
gravure-like quality.

and a digital camera, which give the artist
much greater freedom and flexibility in
working with digital images. A scanner is like
a digital photocopier that allows you to scan
and digitize original drawings, photographs,
found objects, and textures. These can then be
collaged, altered, and manipulated in part or
whole. If you do not have access to a scanner,
take drawings and photographs to a graphic
design house and they will scan material on
to a disk or cartridge for you. A digital
camera works like a regular photographic
camera but it does not use photographic film.
A digital camera has a memory card that
records the images, and the images can be
read and printed from your computer.

The mouse is a standard attachment for
manipulating software, but as a drawing tool
it is awkward and cumbersome. A graphics
tablet comprising a special pad and pen allows
a more natural way of drawing. The pad is
attached to the computer, and as you draw on
the pad with the pen, you can control soft-
ware commands or draw shapes and marks
that are digitized and appear on the screen
instantaneously. This is one of the best devices
for manipulating digital images. In general,
the more expensive the equipment is, the
more sensitive and versatile the pen.

PRINTERS

Most printers designed for personal comput-
ers are either laser printers or inkjet printers.
Laser printers output good quality images up
to a resolution of 1200 dpi. They are expen-
sive machines, especially color laser printers,
but cheap to run in the long term. They work
like color photocopiers by attracting a black
toner to an image on a drum that has been
electrostatically charged by a laser. The image
is then transferred to paper and set by heat.
Inkjet printers are more expensive to operate,
but have the advantage of printing in color,
and so are useful for proofing color digital
images. The image is printed by propelling
tiny droplets of ink on to paper. If the jets
become blocked and the image prints
imperfectly, take the cartridge out and give it
a single shake to unblock the jets. Many
older models of inkjet printers output at a
resolution of 300 dpi, but manufacturers are
constantly upgrading and releasing new
printers on to the market, and some inkjets,
like the latest Epson models, print at resolu-
tions of up to 1440 dpi. Many of the digital
images in this chapter have been printed from
high quality inkjet printers. When an intaglio
print is made using the standard double

Russ Young, *Artifact*, 1999
Photopolymer gravure print, 7 x 9.5 in (18 x 24 cm)
Russ Young scanned a photograph, printed it on an
Epson inkjet printer, and exposed it with the solarplate
using the double exposure technique. He found that
tthe smooth coated transparencies made by Epson for
inkjets gave very good results.

exposure technique very finely grained images resembling traditional photogravure are possible.

Just like photocopiers, lasers and inkjets vary in the quality of the image they output. If you are buying a secondhand printer reject any that create banding patterns or other defects. Always use the transparency film supplied by the manufacturer which has been specifically designed for your machine; you cannot use just any kind of transparency film for personal printers.

HIGH RESOLUTION FILM

The main limitation encountered when using a personal printer is size, as most print no larger than 8 ½ x 11 inches (21.6 x 27.9cm). To transfer larger images to a transparency, store the image on disk and take it to a graphic design house where you can have it printed to a larger size. In our experience the largest imagesetters can output transparencies up to approximately 36 x 48 inches (91.4 x 121.9 cm).

Graphic design houses output images on imagesetters that transfer an image by passing a digitally controlled laser beam across a photosensitive film. Although it is a laser printer, it differs from a personal laser printer because it produces a photographic image rather than an image composed of toner. Depending on the type of machine, the resolution of film can vary from 1200 dpi up to 3600 dpi, with screen rulings varying between 29 and 425 lpi. This is a much finer resolution than most personal printers and often the dot structure is difficult to see.

COLOR PHOTOCOPIERS

Some photocopying centers have computers and can output your image on a color photocopier. This is less expensive than high resolution film and still gives good results. Copy on a black and white setting and test the film for opaqueness with a test strip of solarplate before exposing an entire image.

PREPARING A DIGITAL IMAGE FOR A RELIEF PRINT

f you are aiming to produce a relief print, then you require a negative halftone film. Both Photoshop and Painter have an invert option, so after designing a positive image, you can invert it and view it as a negative image.

SCANNING IMAGES

Decide beforehand what resolution of film you are going to expose on a solarplate because this determines the resolution for scanning drawings and other material. There is a simple mathematical equation that graphic designers apply to work this out: the scanning resolution in dpi should be double the final output resolution measured in lpi.

Donald Furst, *Lazarus II*, 1996
Relief print, 4.75 x 3.75 in (12 x 9.5 cm)
Donald Furst scanned one of his sculptures and created a negative transparency to make a digital relief print.

For example, for a film of 100 lpi the scanning resolution should be no less than 200 dpi. In practice most artists use a minimum of 300 dpi for scanning. Scan drawings, photographs, found objects, or any other material and work on your image until you are happy with it.

PRINTING FILM

Especially with low resolution digital relief images printed from a personal printer, the grid of halftone dots from the original film is transferred to the final print. Some artists will find the dot structure can interfere with the artistic quality of the image, but you can minimize this effect. The effect is not so apparent when using high resolution film from a graphic design bureau.

PERSONAL PRINTERS: You can minimize the dot effect by always using the highest resolution possible when printing from a personal printer; 600 dpi or more is preferable. Scratching and sanding toner, darkening the image with inks, or applying solvents will introduce more interesting effects and also minimize the dot structure.

IMAGESETTERS: If you order high resolution film from a graphic design bureau an ideal screen ruling for relief images is 100 or 110 lpi. This is a measure routinely used by commercial platemakers. You also need to understand the terms Right-Reading Emulsion Up (RREU) and Right-Reading Emulsion Down (RRED). Just as the worked surface of a drawn image is placed face down on a solarplate for an exposure, the emulsion side of halftone film is arranged face down in the same manner. When viewing your halftone image from the emulsion side it must appear the way you composed it. This is called Right-Reading Emulsion Up (RREU) (or sometimes Wrong-Reading Emulsion Down WRED), and when ordering film you need to specify RREU along with the desired lpi and the image dimensions.

Rosemary Aliukonis, *Before Babelí ñ Economic Indicator,* 1998
Mixed media, 33.5 x 43.5 x 2 in (85 x 110 x 5 cm)
Rosemary Aliukonis makes a powerful statement by using the plate as a piece of artwork. She created a relief surface of text and applied gold leaf and a gold metallic finish to the surface. The attached a pendulum cut from solarplate which swings by means of a quartz movement.
Photographed by Michael Kluvanek

MAKING AND PRINTING A PLATE

Making a relief digital plate is very similar to other relief plates, but requires extra care in development and printing. Because of the very fine dot structure of the plate you have to wash away the residue very thoroughly without dislodging any small printing elements.

When printing, apply ink in very thin layers with a good quality medium roller in order to avoid filling in the tiny cells in the polymer. Plates made with film with a screen ruling higher than 110 lpi become increasingly difficult to print since the plate fills in with ink often after only one or two impressions. Manual presses and rollers are not sensitive enough for such fine plates.

Martha Macks, *Wong*, 1997
Three-plate intaglio print, 12 x 9 in (30.5 x 23 cm)
Martha Macks combined drawings and halftone
images to make three intaglio plates that she printed
a la poupée. The dots from the halftone image are
visible in the final print.

Maria Hanley, *Untitled*, 1999
Photopolymer gravure print, 1 x 10 in (28 x 25.5 cm)
Hanley scanned an original photograph on to a trans-
parency and used the double exposure technique to
create this photopolymer gravure print.

PREPARING A DIGITAL IMAGE FOR AN INTAGLIO PRINT

For an intaglio print you require a positive halftone film. Scanning, manipulating imagery, and printing are very similar operations to preparing a negative film for a relief print.

SCANNING IMAGES

In our experimental work we found that the mathematical equation graphic designers use for determining the scanning resolution does not need be applied so strictly. The scanning resolution of imagery can be 300 dpi and the screen ruling 200 to 300 lpi to give good results.

PRINTING FILM

You can achieve high quality intaglio digital prints whether you use a personal printer or an imagesetter at a graphic design bureau to print film.

PERSONAL PRINTERS: For the best results always print out images on a personal printer at 600 dpi or at the highest resolution available. You can also rework the image like a photocopy by scratching and sanding the toner, by drawing, and by adding solvents.

IMAGESETTERS: The resolution of film for intaglio images is not limited by the printing method, and you can order film from a graphic design bureau at resolutions of up to 300 lpi. However, due to the limits of the resolving power of the human eye we cannot distinguish between high resolution images: a 200 lpi image will look very similar to one of 300 lpi. At lower resolutions the difference is more obvious and an image at 85 lpi will look coarser than one at 100 lpi. You can use your discretion, but 200 to 300 lpi will yield good results for intaglio images. You also need to specify the dimensions of the film and that it

should be Right-Reading Emulsion Up (RREU).

RANDOM DOT FILM: Some graphic design houses have software that generates the image as a random distribution of halftone dots rather than the grid-like structure of dots of conventional halftone film. The process is frequently referred to as *stochastic screening* where stochastic means random. This is the same type of software involved in producing the aquatint screen used in the double exposure technique. You would not use this type of film for making relief prints because the dot structure is too fine; you would only use it for making intaglio prints. One advantage of a random dot film is, unlike conventional film, the scanning resolution is less critical and material can be scanned at quite low resolutions to achieve high quality images.

You need to make inquiries about the software since there are different kinds. The size and shape of the dots vary: there are round, elliptical, and square dots, and Linotype Hell software produces a diamond dot. You can also request a particular dot size for your film. Our initial research suggests that to retain good blacks in the final image you should choose a minimum dot size of 40 microns (a micron is 1/1000th of a millimeter); at lower dot sizes blacks in prints tend to lose their intensity and appear dark gray.

PRINTING A PLATE

Making and printing an intaglio digital plate is the same as for other intaglio plates. You can use either the single exposure or double exposure technique for making plates, but the double exposure technique will minimize the dot structure for images printed from a personal printer. When printing, experiment with different inks, the consistency of ink, and the dampness of paper, as for any intaglio plate. In general, digital intaglio images print darker than the original screen image and you can compensate for this by reducing the darkness of the original by up to 10 percent, but you may need to do a number of tests to reach the desired effect.

Kathryn Brimberry, *Personal Effects*, 1999
Intaglio print, 6 x 6 in (15 x 15 cm)

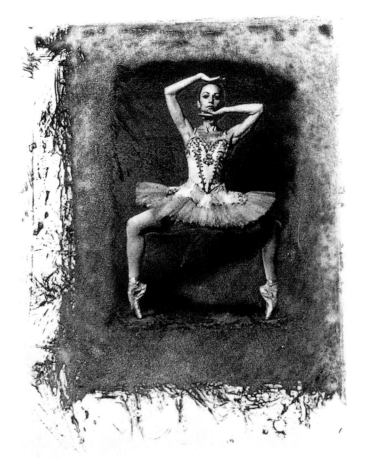

Will Ryan, *Tantric Tu Tu*, 1999
Intaglio print, 15 x 22 in (38 x 56 cm)
Will Ryan painted around the edges of these digital transparencies. The plates were exposed once and the polymer partially washed away around the edges. The resulting blurred and ragged borders created an atmospheric surround for the central figures in the final prints.

Jacques Charoux, *Self*, 1996
Two-plate intaglio print, 30 x 22 in (76 x 56 cm)
One plate was made from a photocopy transparency,
and the second plate was made from photographs
transferred to lith film at a graphics service bureau.
Photocopy transfers of color photographs were pasted
on to the print afterwards.

Ibram Lassaw, *Untitled*, 1996
Three-plate relief print, 12 x 18 in (30.5 x 46 cm)
Ibram Lassaw prepared a transparency for each
plate by drawing a positive image and inverting it
using a process camera.

PREPARING A DIGITAL IMAGE FOR A MULTIPLE-PLATE COLOR PRINT

If you are planning to make multiple-plate color images, you have to consider the screen angle. The screen angle is the angle at which the grid of dots on a conventional halftone film is printed. For a single black-and-white image the grid is aligned at 45 degrees to the horizontal. If you are making a two-plate print the second transparency must have a different screen angle to avoid generating moiré patterns that superimpose and interfere with the final printed image. For example, for a two-plate print, the grid of dots of the film representing one color is printed at a 45 degree angle, while for the second color, the grid is printed at a 15 degree angle. A graphic design house will automatically print film work at different screen angles, whether it is for a two-plate image or a more ambitious project involving four-color separation work to create a full color image. If you are using random dot halftones the screen angle restriction does not apply.

Tip

Some graphic design houses and platemakers keep halftone film at a variety of screen rulings from 85 lpi, 100 lpi, 133 lpi, up to 150 lpi. For relief plates use a screen ruling of 100 lpi, and for intaglio use from 100 to 150 lpi. Depending on the process camera, operators can photograph drawings from small sizes of less than 9 x 12 inches (22.9 x 30.5 cm) up to 60 x 84 inches (152.4 x 213.4 cm).

THE PROCESS CAMERA

Using a process camera is not a method of generating images digitally, but it is included in this section because it involves the use of halftone film. A process camera is a specialized type of camera for photographing a piece of artwork and transferring it as a halftone image on to lithographic film, commonly referred to as "lith film," or the more recent rapid access high contrast film. You can convert a drawing, photograph, or collage to a halftone transparency preserving tonal qualities lost with other transfer methods, like some types of photocopying. Many platemakers, graphic design houses, universities, colleges, and some print workshops have process cameras for this kind of work.

Process cameras can enlarge or reduce artwork and, by using different kinds of film, a negative image can be converted to a positive image and vice versa. One other advantage of this method is that the emulsion side of the transparency is matte and clings well to the solarplate during an exposure, minimizing contact problems.

PHOTOPOLYMER GRAVURE

By Bernice Ficek-Swenson

Historians attribute the invention of the traditional photogravure process to the Viennese printer, Karl Klic, in 1878, who later adapted it for commercial work. His process was a modification of a photogravure process developed by the English photographer, Henry Fox Talbot, in 1858, who wanted to make photographic

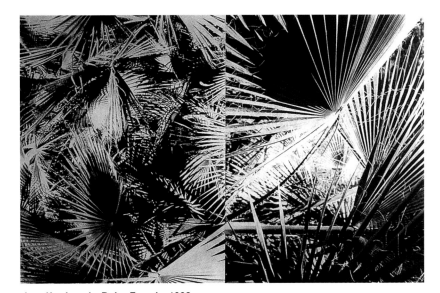

Jennifer Lynch, *Palm Fronds*, 1998
Photopolymer gravure print, 12 x 18 in (30.5 x 46 cm)
This print was made from a continuous tone
photographic positive transferred to solarplate
using the double exposure technique.

images more permanent by printing them with ink on paper. Prints made by this process have rich tones and a beautiful surface and became very popular among graphic and illustrative photographers at the end of the nineteenth century.

Traditional photogravure is a long and delicate technique requiring great expertise, and is more commonly practiced today by art photographers rather than printmakers. An alternative to the current traditional photogravure technique is to use solarplates. This technique has come to be known as photopolymer gravure.

MAKING A FILM POSITIVE
Artists using photography as the basis for their solarplates can achieve a finely detailed, finely grained image by creating a transparent continuous tone film positive from a photographic negative in a darkroom. A film positive developed in the darkroom can be manipulated to achieve maximum delicacy of tonality (density) in the highlight regions and details in the shadow regions.

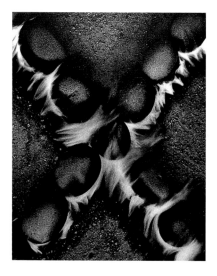

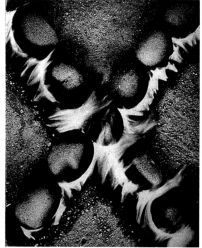

left
Bernice Ficek-Swenson,
Putting Out Ashes XII,
1998
copper plate gravure

right
Bernice Ficek-Swenson,
Putting Out Ashes XII,
2000
Photopolymer gravure print,
18 x 15 in (46 x 38 cm)
Ficek-Swenson's photo-
graphic work captures still-
lives of ashes, stones, and
cremated bones. She uses
fire both as a drawing tool
and because of its inherent
ritualistic meanings.
To compare gravure
processes, Ficek-Swenson
used the same photo-
graphic positive to make
a copper plate gravure and
a photopolymer gravure.
Both images were printed
on Arches 88 with a Gampi
silk tissue chine collé.

A continuous-tone film positive is usually more opaque than a digital or copy machine transparency and allows the film to withstand a longer exposure time to UV light. It also eliminates undercutting, the problem of UV light diffusing under the opaque film, which results in a lighter image and/or softer edges, and appears in prints when using "thinner" or less opaque trans-parencies. With a continuous-tone film positive the final print often has more detail and a much finer grain.

Normal darkroom equipment and regular photographic chemicals such as developer, stop bath, fix with hardener, and a Photo-Flo bath, are used to create a film positive.

There are several brands of fine ortho-chromatic films on the market of varying sizes and costs manufactured by Agfa, Arista, and Kodak. One of the most commonly used films is Arista Premium-APH film, sold by Freestyle in Los Angeles, California. APH film is rela-tively inexpensive, comes in several sheet sizes and in 200 foot rolls.

Film developers play an important role in creating a true continuous tonal range. When using a developer, three factors can affect the tonal/density ranges: the type of developer used, the strength of the developer, and the amount of development time.

Two commonly used developers for making continuous tone film positives are Dektol and HC 110. As a rule of thumb developers used for filmwork need to create a fine grain and a lower contrast positive. This is often referred to as a "soft" developer.

The strength of the developer is deter-mined by the density and contrast of the negative and can be increased or decreased according to your needs. For example, a higher contrast negative can be controlled by using a weaker developer, thus slowing the development time of the image and allowing the tonality ranges in the positive to develop more slowly, becoming richer. When using a "harsher" developer such as Dektol (normally mixed in a 1 to 1 ratio) it is necessary to weaken the solution in order to avoid a "contrasty" image. A common formula is 4 parts water to 1 part developer for use with filmwork. However, a very con-trasty negative may necessitate a still weaker developer. In such a case, Dektol can be diluted up to a 9 to 1 ratio. The original working solution of HC 110 can be extended from a 9 to 1 ratio (9 parts water to 1 part developer) to an 18 to 1 ratio. HC 110 is a recommended developer for a higher contrast negative.

Development time can also have a large impact on the amount of detail and the con-trast range of the image. A longer develop-ment time expands the tonality range, a shorter development compresses the tonality. Development in a Dektol bath can be extended to 3 minutes, in a HC 110 bath up to 4 minutes.

It is important to remember that as you use the developer it becomes weaker and the development bath will need to be replenished occasionally (approximately every three to five film positives). A film positive developed in a "spent" working solution will have a noticeable lack of richness throughout the image.

CREATING A FILM POSITIVE

All darkroom processes need to be kept at 68–70°F. Exposure, development, and fixing processes must be done with a 1A red safelight (the orthochromatic sheet film used will fog in yellow safelight conditions).

1. First expose a negative to the film positive, with the non-glossy emulsion side of the film positive face up.

2. Move the exposed film positive into developer quickly and evenly to avoid uneven, streaky development. Agitate briskly for 1 minute, then slowly agitate with a gentle, constant rolling motion for 1 minute. Adjust the development time according to the needs of your negative.

3. Place the film in a stop bath for between 30 seconds and 1 minute, and agitate evenly.

4. Place the film in a bath of fix with hardener for 3 to 5 minutes and agitate evenly.

5. Rinse the film in a constant flow of water for 3 to 5 minutes. Remove from the wash bath, squeegee the film against a firm glass surface, and dry with a hair dryer before checking the tonal and density ranges. The film positive will be slightly darker when dry.

6. Put the film in a Photo-Flo solution for 1 minute and agitate lightly. One-quarter cap of Photo-Flo in a pan of water will help avoid streaks forming and achieve a smoother, more even film.

7. Remove the film positive from the Photo-Flo bath and allow the excess water to drip before placing the film in a drying room or heat cabinet. Alternatively drip-dry the film in a dust-free environment. Once the positive is made it can be exposed on a solarplate.

MAKING AND PRINTING A SOLARPLATE

Solarplates by their very nature tend to create an image with a higher contrast than a traditional copperplate gravure. You can manipulate the development of the film positive to maximize the tonal range. This will minimize a high contrast image on the solarplate.

Another consideration is the density (how opaque or transparent) of your film positive which determines the exposure time of a solarplate: the less opaque the positive, the less exposure time required. The density can be measured with a transmission densitometer, and film positives need to be in a range of .55, to achieve greatest details in highlights, and 1.40, to retain shadow detail.

Make a solarplate using the double exposure technique, and do test exposures for each film positive, since each positive will have a varying degree of opacity. For example, test exposure times for *Putting Out Ashes XII* varyied by as little as 10 seconds and made a substantial difference to the highlights and shadow regions of the image.

Proofing and editioning a photopolymer gravure plate is a more delicate operation than printing other intaglio solarplates. To capture maximum detail and tone only use printing papers with a fine texture and smooth surface. Soak sheets for a minimum of 25 minutes for even hydration and flexibility, and print when the paper is fairly damp. Experiment with the opacity of the ink by adding transparent base, and add #1 lithographic varnish to loosen the ink. When working with tarlatan and newsprint, always wipe from light regions toward the darkest areas. If necessary, hand-wipe to define details and brighten the image. For printing use three blankets, but you may find with an additional sizing catcher and greater pressure you can capture the finest detail.

Karen Fizgerald, *Wave, Mountain, Amber*, 1998
Intaglio print, 7 x 7 in (18 x 18 cm)
After exposing and developing the plate, the artist carefully cut a circular shaped plate with scissors making many small snips. A large cutting action can warp the edges of the plate. If this happens, roll the plate through a press under high pressure to flatten the wavy edges before printing.

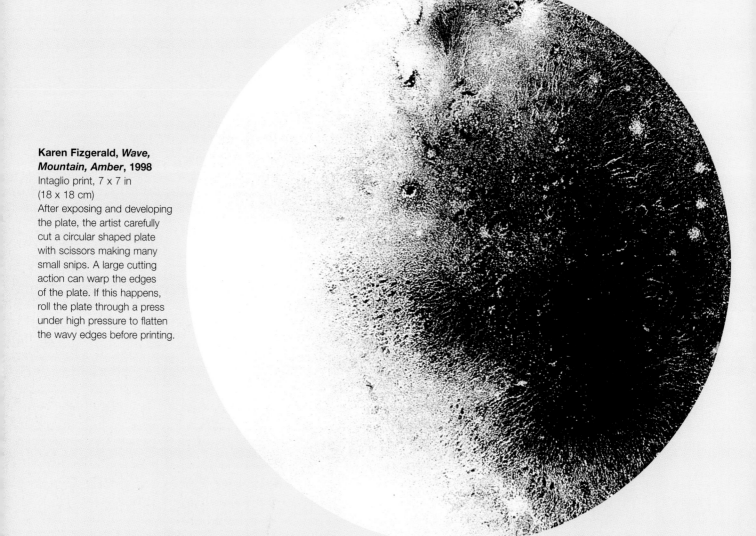

COLOR PRINTING

Printing in color is an absorbing and exciting experience. There are many techniques and, therefore, many possibilities. The most traditional technique is multiple plate printing, in which each color is printed from a separate plate. Other techniques, such as la poupée and combinations of relief and intaglio methods, allow you to apply two or more colors to one plate, which is then printed as a single impression. Many printmakers prefer more painterly techniques, inking the plate then painting directly on the plate with oil paints, or water-based monoprinting inks and crayons, to create variable impressions, each of which is called a monoprint. Yet another alternative is to hand color the print with pencils, crayons, or watercolors. None of these techniques are exclusive, and you can combine two or more inking methods in various ways to print one image.

PROOFING

Before printing an edition, the important work of proofing must be done. These "trial proofs" may vary a great deal, as this is the stage when the artist determines which inks and papers to use, tests the pressure of the press, and adjusts the consistency of the ink with modifiers. If you do not achieve what you hoped for with your initial impression, manipulating the opaqueness of inks can save you from reworking an image and making another plate. You can blend ink with varying amounts of transparent white or extender to increase the transparency of inks and create more subtle tones in an image that was formerly too dark or had too much contrast. You can also blend inks with white opaque to increase the opaqueness of inks. Becoming adept at controlling plate tone is also important for color work (consult the table, p.86 which outlines the various methods for enhancing or reducing plate tone).

If modifying inking techniques do not go far enough in solving problems, you can rework the plate by polishing, sanding, or carving. Another option is to make a second or third plate to create a multiple plate print, or rework the original drawing and make a new plate. Rembrandt might have enjoyed working with solarplate, erasing parts of his original drawing, redrawing elements, and

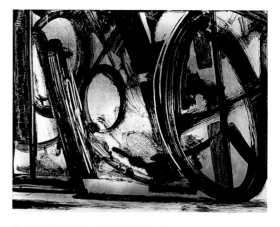

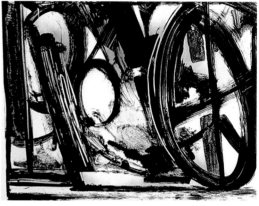

Denise Kasof, *Om*, 1999
29 x 31 in (73.5 x 79 cm)
This print was made from a drawing on glass. The plate was proofed before and after polishing with fine carborundum in baby oil. These comparative prints show how polishing introduces highlights and changes the look of the image.

making a new plate. In fact he took considerable time to rework his etchings, scraping and burnishing parts of the etched copper, applying more ground and stop out, scribing the new drawing, and re-etching the plate.

Reworking the plate

1. Metal polish, automobile rubbing compound, and putz are among the polishes one can use.

2. Making your own polish may be done with a variety of abrasives including pumice or fine carborundum.

3. Mixing with baby oil.

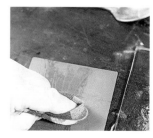

4. Polishing the plate.

REWORKING THE PLATE

When reworking the plate we recommend a gentle approach: only work on the plate after it is processed.

POLISHING AND SANDING

Plate tone is an inherent characteristic of an intaglio solarplate print due to the very fine film on the polymer surface that tends to retain ink. Besides varying the type and consistency of ink, you can also reduce plate tone or create highlights by polishing the plate with any one of a number of mild abrasives: automotive car polish, putz pomade, or a fine grade of carborundum all work well. Always use a small amount of oil with the abrasives to reduce scratching. For more delicate areas, try Rolite, jewelers rouge, or ordinary household cleansers like Bon Ami. Polish with a soft, clean, cotton cloth without seams, and use very light pressure since abrasives vary in coarseness and excessive pressure can remove elements of the image. Brush off any excess abrasive with a soft brush and clean the surface with baby oil or vegetable oil. Wipe away the excess oil before printing.

You can also polish with very fine sandpaper like emery paper, as coarser sandpaper will create linear or tonal effects on the polymer surface much like a series of parallel lines.

USING A DRYPOINT NEEDLE

A drypoint needle is a steel instrument about the size of a pencil with a sharp steel or diamond point. It is usually wrapped with tape to give the artist a better grip. Drypoint is traditionally practiced by incising lines in metal, usually copper or zinc, to create a burr on either side of the line giving a characteristic soft, velvet line, which is quite distinct

Scribing into the plate

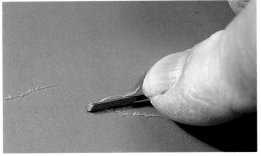

Using an engraver's burin to cut into the plate.

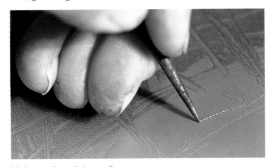

Using a drypoint needle.

from a line from a plate etched in acid. You can create a similar effect by incising solarplate, but only a few impressions will retain this soft, velvet line before the burrs start to wear away.

Scribing with varying degrees of pressure into the polymer surface will create deep grooves which hold more ink and produce darker lines in the final print, while shallow grooves hold less ink and produce lighter lines. Experiment with crosshatching and other mark-making in the polymer to introduce more tone. In areas that have partially washed away and do not retain quite enough ink, you can roughen the polymer so that these areas will print completely black.

If the polymer completely washes away in some parts of the plate, you can incise the exposed steel support so it will hold ink and print black. By exerting more pressure you can engrave the steel with a series of crosshatched or stippled marks and lines, or use an electric engraving tool for larger areas.

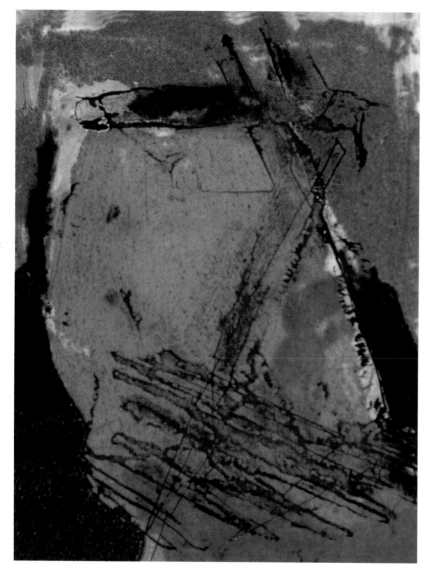

Dan Welden, *Traverse*, 1998
Three-plate intaglio print, 8.75 x 6.75 in (22 x 17 cm)
Each plate was developed from an original drawing on
acetate. After a single exposure in the sun each plate
developed open bite areas. Dan Welden pasted a mix-
ture of carborundum and acrylic medium into the open
bite areas to preserve continuous surfaces for printing
more extensive areas of color.

LINO AND WOOD-CUTTING TOOLS

The polymer surface is reasonably soft and you can carve and score the surface with a variety of lino and woodcutting tools. Carve only thin, shallow grooves for intaglio print-ing, and deeper grooves for relief printing.

CARBORUNDUM PRINTING

Henri Goetz first developed carborundum printing in France thirty years ago. He pre-pared a mixture of fine carborundum and a binding agent and applied it to a variety of supports. In the same way you can blend various grades of carborundum with acrylic polymer medium to make a creamy mix-ture and paint it on to the plate or fill in areas of open bite. When it is dry and inked up in intaglio these textural areas will print a rich black. Experimenting with different grades of carborundum will give a range of blacks.

SHAPING PLATES

For curved or rounded shapes use a jewelers saw, a scroll saw, or scissors to cut the plate. Take care not to leave scratch marks in the polymer which will then take up ink and print, and always wear goggles to protect your eyes when cutting steel. Any resulting rough or burred edges should be filed down to leave smooth edges for good presentation in printing.

Use a utility knife and tin snips to shape a plate with angular rather than curved edges. First draw the cutting lines on the polymer. Then with a metal ruler and a utility knife with a fresh blade, slice along the marked lines several times. Then take the tin snips and cut without using the full length of the blades, cutting just near where the blades join; many small cuts performed carefully will minimize the tendency of the steel back-ing to warp.

MULTIPLE-PLATE PRINTING

There are many ways of using color in printmaking. The traditional way of working when editioning is with multiple plates where each plate is inked with a separate color and printed in combination to create a final impression.

Printing multiple plates is easily applied to plates made from drawings, photocopies, and low-resolution halftone images. However, printing this "multiple drop" technique using plates made from high-resolution film is difficult and not for the faint hearted, and only the most adept and adventurous of printmakers should tackle more than one plate since it requires great skill in registration.

PLANNING A PRINT

You can use any number of plates for this technique and apply it to either relief or intaglio prints. Each plate is inked individually and printed directly one after the other on the same piece of paper for one impression. Then the inking and order of printing is repeated for each impression for the entire edition. It is not uncommon to work with many color separations, but also incorporate other techniques and apply more than one color to individual plates. You can also explore the effects of overprinting colors and change the order of printing to vary the final effect. Working this way requires concentration and it is crucial to register plates precisely, and to follow a discipline of inking and printing to ensure a consistent edition.

To develop a color image you will need a separate piece of artwork on a transparency for each plate representing a color. Lay the transparency films over one another and tape them down at the top. Keep applying media to different layers and lay the films flat every

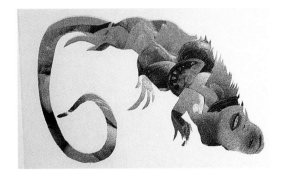

Kate Leavitt, *Tomato*, 1997
Four-plate intaglio print, 11 x 15 in (28 x 38 cm) Color separations sequentially created on separate plates, printed individually and together.

Printing a three-plate color print

1. In preparation for printing a three-plate intaglio solarplate, a new litho sponge is wrapped securely with heavy-duty paper.

2. The block is then wrapped in pages from a phone book which is used to give the plate a final quick wipe.

3. The first inked plate is placed precisely on the registration area and the paper is lowered carefully.

4. After rolling through the press, one edge of the paper is secured firmly beneath the roller, and the paper is flipped back.

5. The first plate is removed, the second inked plate is carefully put in its place, and the procedure is repeated.

6. The second plate is removed, the third plate is carefully put in its place, and the print is completed.

now and then to view the evolving image. Registration is relatively easy with transparencies.

It is common to print darker colors over lighter colors, so when planning an image, first consider the colors in order from the lightest to the darkest. It is better to apply tones and textures to the underlying transparencies and use these transparency films to make the plates that will be printed first. If you draw lines on these underlying transparencies, the inked lines from these plates would be flattened because the paper will travel back and forth under the roller several times. So apply fine line work and some tex-

ture to the uppermost transparency film, and use this to produce the key plate. This plate, inked with the darkest color to give strong outlines to a print, should be printed last.

An alternative method of color printing works in reverse where the darkest colors are printed first. The ensuing colors should be very transparent and, in turn, enhance the darker color. With experimentation the two approaches to color can be varied in any way.

Once you have finalized each transparency, process solarplates from each transparency film, making sure you trim plates very precisely so they are all exactly the same size. Then proceed to printing.

REGISTERING PLATES

For accurate registration as well as a registration sheet you need a method for holding the printing paper firmly in place as each plate is printed. There are several methods depending on the size and type of printing paper. For registering large sheets of paper:

1. First tear and dampen paper ready for proofing, and prepare the inks, arranging each color on separate ink slabs so there is no risk of cross contamination.

2. Make a registration sheet by cutting a sheet of colored paper to the size of your printing paper.

3. Place a solarplate on the registration sheet in the place where you would like the image to sit on the printing paper and draw a line around the solarplate to make a plate outline.

4. Place the registration sheet on the bed of the press and under the protective plastic.

5. Adjust the pressure of the press and ink up all the plates. If the printing paper is large enough, you can roll a plate through the press leaving one edge of the paper trapped under the roller; this will hold the paper in place and allow you to take away each plate as it is printed and replace it with the next plate.

6. Carefully place a sheet of dampened printing paper over the registration sheet and turn the press until the paper is trapped just under the roller.

7. Flip the blankets and printing paper over the top roller, and place the first inked solarplate exactly in the plate outline.

8. Lower the paper and blankets and run the first plate through, but leave the end of the paper trapped under the roller.

9. Flip the blankets and paper over the roller, remove the plate, wipe the protective plastic clean, and replace it with the second plate in the plate outline, exactly aligned and with the same orientation as the first plate.

10. Repeat the process with subsequent plates in the order you planned.

Dieter Engler, *Andere Platze I (Mit Schiene)*, 1998
Four-plate intaglio print, 4 x 4 in (10 x 10 cm)
Dieter Engler printed more than one edition of this image by varying the colors of the four plates. In this print, he inked the first plate in yellow, the second in red, the third in black, and the fourth in light green.

It is most important when working in this fashion to know your order and sense of direction, to have clean hands and good eyes. Paper expands with moisture and contracts as it dries out and to avoid problems with registration, work quickly and keep your stack of paper damp by sealing in a plastic bag.

For printing smaller plates with smaller printing paper:

1. Cut short pieces of tape and tape down the leading edge of the paper, that is, the edge of the paper closest to the roller of the press.

2. Position the first plate within the plate outline of the registration sheet.

3. Roll through the press, lift back the paper, and remove the plate.

4. Clean the bed of the press, position the second inked plate within the plate outline, and lay the paper over it.

5. Tape the new leading edge before removing the first pieces of tape and print.

6. As prints come off the press, cover with newsprint, and lay between blotters or boards to dry.

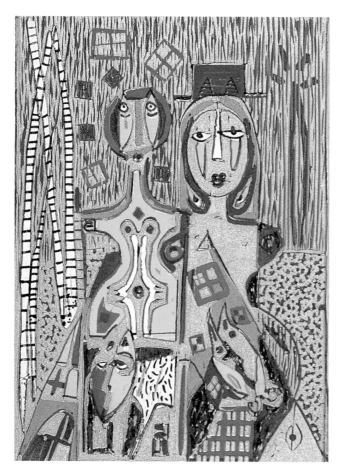

Henry Szen, *A Perfect Pair,* 1999
5.5 x 4 in (14 x 10 cm)
Henry Szen made relief plates from worked photocopies
and created this colorful print resembling a woodcut.

The tape peels off easily since the paper is damp, leaving only small marks on the back of the paper.

Another method of registration, especially for relief printing with Japanese papers, is to use a metal bar to hold the paper in place after each plate is printed and a new plate is put in place. These methods of registration are suitable for printing intaglio solarplates one after another, described as wet on wet printing. You can also print multiple relief solarplates this way, although in traditional printmaking when printing multiple linoleum blocks normally each color is allowed to dry on paper before printing the next color. Making multiple solarplate prints is rapid and proofing is much more exciting.

RELIEF INTAGLIO

One of the simplest approaches is to ink both the surface and the grooves of a single solarplate to obtain a two-color print. This technique works well for intaglio plates with a shallow relief structure. Ink it up as for intaglio printing, and apply a thin layer of relief ink to the surface of the plate with a roller. It is usual to dilute the relief ink with extender to produce a fine transparent layer of color in the print. As the roller moves across the plate, the relief and intaglio inks blend slightly and both colors influence one another. Use dampened intaglio paper and print under pressure as for an intaglio plate.

The resulting print can be most attractive, but there is a disadvantage: both the roller and the plate pick up ink from each other and need to be cleaned after every impression to ensure consistency between prints of an edition. An alternative is to use separate intaglio and relief plates thus avoiding contamination of the inking slab and roller. Make a registration sheet and using one of the registration methods described above, print the relief plate first and the intaglio plate second to preserve fine raised ink lines.

VISCOSITY PRINTING

When printmakers experiment with viscosity printing, they can discover a whole new aspect of printmaking that leads to a true adventure in playing with color. Viscosity printing, which involves applying multiple layers of different colored inks to one plate, was developed in Stanley William Hayter's Atelier 17 in Paris and was later popularized in the United States by Krishna Reddy. Established in 1926, Atelier 17 is renowned for inventing relief and intaglio

printing techniques and had a profound and long-lasting impact on printmaking.

You can alter the viscosity of the inks by mixing ink with magnesium carbonate to make it stiffer and more viscous, or by adding plate oil to make a "lean" or low viscosity ink. If you roll high viscosity ink over low viscosity ink they will repel one another. You can compare this to the peanut butter and jelly principle, where if you try to spread a layer of peanut butter on to a jellied piece of bread, the peanut butter will not mix with the jelly. For a relief intaglio image you can make the relief ink more viscous than the intaglio ink, and, as it travels across the solarplate, it repels the less viscous intaglio ink. As a result the two colors do not blend and very little intaglio ink is transferred to the roller. For a different effect you can do the converse, making a stiffer, more viscous intaglio ink and a looser, less viscous relief ink.

For applying three layers of ink, choose a plate with many facets and extensive areas of open bite. This is usually a plate that has been made using a single exposure rather then pre-sensitizing the plate with a screen. To prevent the colors merging, inks are prepared with different viscosities in order to repel one another. You can increase the complexity of the process by using rollers of varying durometers. First ink up the plate in intaglio and wipe the surface clean, then use a roller with a hard durometer, such as 60, to roll low viscosity ink on to the uppermost portions of the plate. Finally the softer roller with the tackier, high viscosity ink is rolled on the same plate. The low viscosity ink repels the high viscosity ink and the softer roller penetrates into the deeper areas of the plate. Remember to use rollers with sufficient circumference and width to cover the entire plate in a single roll and print under pressure with dampened intaglio paper. Exploring color by reversing the order or changing the colors can lead to an exciting array of work from the same plate.

Isabelle Geiger, *Proof II*, 1998
Intaglio print, 12 x 9 in (30.5 x 23 cm)
Isabelle Geiger made this image using the viscosity technique.

RELIEF PLATE HAND PAINTED WITH INTAGLIO

Try this technique with a relief plate that has a deeper relief structure than an intaglio plate. Paint oil-based ink diluted with solvent into the grooves and lines with a brush, and apply a relief roll of ink to the surface of the plate. Print on dampened intaglio paper under pressure as for an intaglio plate. The technique is better classified as monoprinting because each print will vary due to the hand painting. You can experiment further by altering the pressure of the

Edinah Jewett, *Friends*, 1992
Intaglio print, 12 x 9 in (30.5 x 23 cm)
A plate was made from a photocopy transparency and inked with the a la poupée method.

Seraphina Martin, *A Taste of Life*, 1998
Intaglio print with hand coloring, 19.5 x 26 in (49.5 x 66 cm)
The plate was inked in intaglio with an oil-based ink, painted with Createx monoprinting inks and printed. The print was also hand-colored with watercolor.

Stephanie Reit, *Mapping my Life Logos*, 1996
Intaglio print with hand coloring, 6 x 5 in (15 x 12.7 cm)
This intaglio print was painted with watercolors.

press to increase or decrease the amount of ink the paper picks up from the grooves and, hence, develop different printed effects. Because you are using solvents make sure you work with a local exhaust system to remove any harmful vapors.

A LA POUPÉE

From the French "poupée" meaning "doll," a la poupée is a method of inking a single plate with many colors. However, you need to choose a plate with a loose design requiring broad areas of color. This kind of plate is easier to tackle than one with a very fine design that would be too difficult to ink this way. Make the dolls by rolling up small pieces of felt or make padded cotton dabbers, small pieces of cotton filled with cotton wool and secured with string, and dab color directly into grooves and local areas of the plate. Wipe carefully with a different piece of tarlatan for each color, and print under pressure on dampened intaglio paper. Many printmakers apply oil paint rather than etching ink due to the greater range of colors and practicality of the tubes.

HAND COLORING

At the turn of the eighteenth century William Blake, the great British painter, poet, and printmaker, took a revolutionary step in printmaking when he hand painted his prints with watercolor. Later, Degas who had little interest in producing a large number of identical impressions, experimented with intaglio wiping and created the painterly print by working with pastels over printed images. In the early twentieth century, the commercial lithographs of Currior and

Ives were printed mostly in black, and later hand colored in watercolor by women working in crowded factory style conditions. This mass production of prints discouraged most printmakers from adopting this technique until the resurgence of printmaking in the 1970s, when artists began to create individual works from their edition pieces. Today, many artists use hand coloring to enhance or complete their pieces. Watercolors, crayons, chalks, pencils, or drawing inks can be used. June Kluglein's *Summer* (p.128), printed in both a black and white and a hand-colored version, illustrates clearly the impact of color.

MONOPRINTING

An expressive way of working is to ink up an intaglio plate, then apply water-based crayons and paints directly to the plate. When the plate is printed under pressure the water-based media are transferred along with the oil-based etching ink to dampened paper. The Swiss made Caran D'Ache aquarelle crayons transfer very well, and the crayons can be diluted with water or Createx monoprint base to create wash effects.

For a more painterly technique paint the plate with Createx monoprinting inks only. The approach is simple: ink the plate in the normal intaglio manner, wiping the surface as clean as possible, and apply Createx monoprint inks with a brush. Because the monoprint colors are intense and richly pigmented, it is important to apply the pigments thinly, diluting them with the monoprint base, otherwise they can obscure the intaglio image. Thinning inks also prevents color from spreading to unwanted areas. Print plates while the ink is still damp. We have found dampened BFK Rives or Somerset etching paper works well for this technique. Be aware that continued use of water-based materials on a solarplate may

Christine Dufresne, *Leda and the Swan*, 1997
Intaglio print, 15 x 13.5 in (38 x 34 cm)
Christine Dufresne made this print by inking the plate in intaglio with an oil-based etching ink, painting directly on the relief surface of the plate with Createx mono-printing inks, and then printing the plate. Oil-based and water-based inks transfer well to paper when printed together.

cause the polymer to break down and rehardening the plate in the sun periodically will help to prolong the life of the plate.

For more variation apply inks and crayons to a piece of plastic cut to the same size as the intaglio plate and print this before printing the intaglio plate. For accurate registration make a registration sheet and use one of the registration methods described in the section on multiple-plate printing. Small scraps of newsprint laid on the plastic plate will act as stencils and transfer interesting shapes to the final impression. You can then work further on the print with inks and crayons elaborating and enriching the image. Dan Welden frequently reworks a print until very little of the initial print remains. This mixed-media approach can create a successful piece of art, and the multiple impressions printed from one solarplate allow artists to explore an entire series of work from a single image.

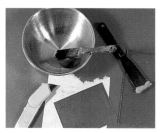

1. Simple preparation for working in chine collé includes paste, water, paper, and a knife.

2. Cut the paper that is going to be glued to the backing paper.

3. Mix a batch of paste.

4. Apply the paste evenly to the back of the paper with a brush.

5. After inking the plate, wipe the edges clean.

6. Place the plate on the press.

7. Place the paper on the plate, paste side up.

8. Print the image.

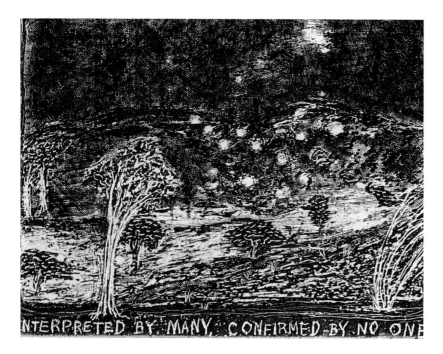

Anna Marie Pavlik, *Marfa Lights,* 1998
Intaglio print, 5 x 6.5 in (12.7 x 16.5 cm)
Anna Marie Pavlik created a drawing with lithocrayon and India ink on acetate, also using scraping to modify the image. Before printing the plate, she added watercolor to the Oriental paper and printed it on to a support paper using chine collé.

CHINE COLLÉ

You can introduce color and texture to an impression using the collage technique of chine collé. This employs delicate Oriental papers that are laminated to a support of stronger intaglio paper. "Collé" means glue or paste in French. Traditionally, rice flour paste was applied. Today, printmakers often use methyl cellulose, PVA glue, or "yes" paste.

Oriental papers vary in color and texture, and selecting the appropriate papers can add a new dimension to an impression. First tear the Oriental paper to the size required for the image. Ink the intaglio plate and place it on a registration sheet on the bed of the press. Brush glue or powdered methyl cellulose on to the back of the Oriental paper and arrange the glued sheet on the inked plate with the glued surface face up. Lay the dampened intaglio paper over the Oriental paper, cover with extra sheets of newsprint to prevent glue leaking on to the blankets, and run the whole ensemble through the press. The image will transfer to the Oriental paper and, in turn, should adhere securely to the support paper.

MIXED PRINT TECHNIQUES

There are a great many possibilities for combining solarplates with other materials and different printmaking methods, such as lithography, screen printing, etching, or other forms of intaglio print-making. We have described using plastic plates with a single solarplate, but you can use cardboard, particle board, etched zinc plates, the reverse side of solarplates, and many other materials, which can make the production of prints simpler and cheaper. Combining solarplate with other print media can provide an exciting range of thought-provoking images and could take a book in itself.

EDITIONING

Once you have proofed your image you are ready to edition. Prepare the paper and make up enough ink for an edition. Estimating the amount of ink required will come with practice, but it is important to note down exactly how you made up the inks. This is especially important if you print an entire edition in two or three sessions, or if you have mixed colors or added modifiers, since you may not be able to achieve the same balance if you run out of ink part way through editioning. Consistency of technique and materials is important and all the prints should be as similar as possible within the limits of manual printmaking.

An edition can be as large as you wish, but the number is limited by the durability of the plate. Faded areas will start to appear in impressions as the polymer starts to wear with the rolling action of the press. Because the plate is so durable and has been designed to print thousands of impressions in relief you are almost unlimited in the size of a relief edition. In our experience the maximum number of impressions printed from an intaglio plate is 125, but in most cases it is 40 to 80. This variation is due to wiping techniques, so the gentler the technique the more impressions you will obtain.

Normally, each print is numbered by the artist with a medium pencil under the left hand corner of the impression. For an edition of fifty the first impression is labeled 1/50, the second 2/50, and so on to 50/50. There is a title centered beneath the impression and the artist's signature and the year of printing under the right hand corner of the impression. These are normally the prints released for sale. Another ten or 10 percent of the edition number are printed as Artist's Proofs and each is identified with an AP or A/P. They are presented to the artist by the publisher or printer to do with as he or she wishes.

Judith O'Rourke,
Atmospheric Creatures,
1996
Vitreograph/intaglio print,
24 x 24 in (61 x 61 cm)
Judith O'Rourke etched and inked a piece of glass, then placed many small inked intaglio solarplates on top of the glass and printed them together.
Courtesy Littleton Studios.

June Kluglein, *Summer,* **1998**
Intaglio print with hand coloring, 15 x 20 in (38 x 51 cm)
The original image for this print was drawn on grained
glass. June Kluglein inked the plate with an oil-based ink
and then hand-colored the print with colored pencils.

SAFETY AND THE WORKING ENVIRONMENT

The potentially hazardous qualities of art materials were first astutely observed and recorded by Bernardino Ramazzini, the "Father of Occupational Medicine." In his book, *Diseases of Workers*, published in 1713, Ramazzini described the atrocious working conditions and related illnesses of many different workers, including printers, compositors, and painters. Of printers and compositors he wrote: "Besides diseases of the eyes (they) incur other serious maladies, such as continuous fevers, pleurisy, pneumonia, and other diseases of the chest." He observed that painters suffered, "palsy of the limbs, cachexy, blackened teeth, unhealthy complexions, melancholia, and the loss of the sense of smell." (Cachexy, or cachexia, is the general breakdown of health associated with chronic illness.)

Fortunately, today the working conditions of artists are changing for the better, even though many of the hazardous chemicals used in Ramazzini's day are still found in modern art materials. Artists working today have ready access to information about hazardous chemicals and appropriate safety measures, available in books, on the Internet, and from health and safety organizations. Combined with government safety regulations, this knowledge has led many artists and art institutions to implement safer work practices. While we cannot cover all the new information and precautions required, this chapter, co-written with a health and safety expert, is designed to help you understand the safety issues related to practicing solarplate printmaking, and guide you in establishing a safer working environment.

WORKING SAFELY

t is important for every artist to work in a safe environment. You can achieve this by eliminating harmful chemicals from your art practice, substituting less hazardous substances, and practicing safer techniques. Wearing protective gear and installing equipment, such as exhaust ventilation systems, will make your work place safer.

Harmful art materials are frequently described as "hazardous." This is a fairly loose term which includes a wide range of substances from irritants, carcinogens, mutagens, teratogens, sensitizers to chemicals of varying toxicity, and it is almost inevitable that as an artist you will encounter such materials at some time in your work.

SAFETY RESOURCES

Bernardino Ramazzini believed that the minerals in paints and inks caused many of the disorders he observed, and today we know he was right. Pigments used in Ramazzini's day were based on lead, cadmium, and other toxic metals that are still common in modern paints and inks. In addition, some paints and inks contain new organic chemical pigments, each with its own unique hazards. Exposure to many of these pigments and solvents can cause damage to the nervous system, kidneys and liver, skin diseases, allergies, and other occupational diseases, while several recent studies show that professional artists and printmakers are at increased risk of developing certain cancers.

Although all this sounds grim, the future looks promising, and there are a number of actions you can take to improve your working conditions:

1. If you are a teacher or employed to work with art materials, make sure your employer is meeting the requirements of the "right-to-know" laws. These laws require employers to provide formal training, access to material safety data sheets (MSDSs), and all the ventilation and safety equipment needed to work safely. If you are self-employed you do not come under these laws, so it is important to obtain the MSDSs from the manufacturers yourself and start a program of self-education.

2. Support reputable art material companies by only purchasing products from those that provide MSDSs, safety literature, and specify the ingredients in their products. Conscientious manufacturers identify the pigments, solvents, and other substances in their chemicals by accurate chemical names so that you can research them further on your own.

3. Build up a safety reference library and use it. Two good sources are the books *Danger! Artists at Work* by Monona Rossol and Ben Bartlett, and *Making Art Safely* by Merle Spandorfer et al. These and similar books present technical information about ventilation systems, respiratory protection, tables listing technical data on pigments, solvents, and other hazardous chemicals, and much more. There are many useful Internet addresses, and we list some in Resources: Safety and the Working Environment (p.137) along with the names of health and safety organizations you can contact for further information.

SAFETY CONCEPTS

If you receive good right-to-know training, you will be given a number of concepts to guide you when using art materials. While it is not possible to present all this information here, there are a few facts to keep in mind.

Substances can only harm you if they get into your body. They enter your body in three ways: by skin contact, by inhalation, and by ingestion. This means you are probably not at risk if you avoid getting materials all over your hands, if you control airborne dusts, vapors, and gases with proper ventilation, and if you never eat, smoke, or drink in the studio without washing up carefully first.

While all this is common sense, there are a few ways materials can get into your body of which you are unaware. For example, some gases and vapors have no odor and you do not know you are inhaling them. And some solvents are rapidly absorbed through even thick chemical gloves without changing the appearance of the gloves, and can then be absorbed through the skin. It is important to get detailed information about the chemicals in the products you use to be certain that you are not being exposed to harmful substances unknowingly.

TERMINOLOGY

You cannot rely on label terminology. This is especially true of the term "non-toxic." The reason is that the only tests mandated by the consumer protection laws are tests that cause acute (sudden onset) effects. These are tests which expose laboratory animals to a single dose or period of exposure by skin or eye contact, inhalation, and ingestion.

To illustrate the inadequacy of these tests, take the example of a group of laboratory animals. If they are exposed to asbestos over a two-week period, they will appear perfectly healthy at the end of the test period. This could result in the asbestos being labeled non-toxic. However, asbestos is known to cause cancer after many months or years of exposure. While manufacturers are unlikely to label a known carcinogen non-toxic, they regularly label untested chemicals non-toxic. Keep in mind that the vast majority of chemicals to which you will be exposed in printmaking have never ever been tested for cancer or other long-term effects.

As long as untested chemicals are labeled non-toxic by default, it is important to treat all chemicals as potentially toxic. For each stage of making a solarplate, from drawing an image to the final cleaning up and disposal of waste, there are hazards to consider.

PREPARING IMAGES

You are likely to spend considerable time, even many hours, drawing, photo-copying, or preparing digital images. So it is worthwhile selecting the safest drawing materials, and to take care not to work inappropriately with a photocopier or a computer. If you plan to make photographic positives, there are definite hazards from chemicals in the dark room and good ventilation is essential.

DRAWING MATERIALS

To create images you will mainly use black drawing materials and many of these do not

Ellen Peckham, *Self-Portrait*, 1997
Single exposure intaglio print, 24 x 18 in (61 x 46 cm)
This image was made from a drawing on acetate.

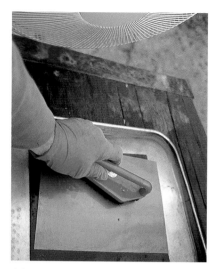

A fan, strategically located while washing out plates, disperses fumes away from the printmaker.

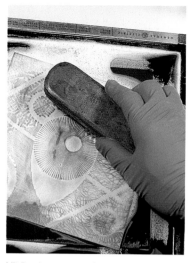

Nitrile gloves are resistant to many types of chemicals, thus making them the best choice for the printmaker.

Barbara Wilson, *Carrie in Flight*, 1999
Photopolymer gravure print, 15 x 11 in (38 x 28 cm)
The photograph for this print was taken with a pinhole camera, and the negative was turned into a photographic positive. It was transferred to solarplate using the double exposure technique.

present a significant health hazard if used appropriately. Pencils, graphite sticks, good quality charcoal, oil sticks, lithocrayons, and India ink are the safest materials to use. When creating tones it is a good idea not to use fingers but substitute paper stumps or cotton swabs. If you start to draw vigorously and generate a lot of dust with dry media, like charcoal or graphite sticks, or if you add talc or iron oxide to images to make them more opaque, then you may require a dust mask and gloves. If you like painting with tusche it is preferable to dilute it with water rather than solvent, and ask for an MSDS since some types of tusche contain a small amount of solvent.

Water-based drawing inks, some types of gouache, and water-based acrylic paints can contain formaldehyde or ammonia. Both these chemicals are irritants, while formaldehyde is also a sensitizer and ammonia is corrosive, so for sensitive individuals applying a barrier cream or wearing gloves is a sound precaution. If you use permanent inks, which contain pigment, shellac, borax in water, or organic solvent, work with good ventilation. Water-based markers and felt tip pens are normally safer than permanent ones. Some permanent markers contain xylene, toluene, glycol ethers, and other toxic solvents and should be used with a local exhaust system. Try to use those with the less toxic solvents, ethyl alcohol or acetone. If you decide to paint with oil-based inks and solvents or use denatured alcohol with water-based inks, wear nitrile gloves and work in a well-ventilated space with a local exhaust system.

PHOTOCOPIERS

Photocopiers should always be located in well ventilated areas where gases, like ozone or ammonia generated by the heat setting process, cannot cause harmful effects. Toners vary in composition, but normally they consist of a dry powder composed of carbon

black, inert mineral powders like silica, and plastic resin mixed with various dispersants. Safety consultants advise us that today toners are more refined and less likely to be hazardous than older types of toner, but there have been recent reports of disabling lung diseases contracted from inhaling the iron and silica in toner dust.

When scratching toner, wear a dust mask and use a gentle technique to minimize airborne particles.

COMPUTERS

Working with a computer limits your exposure to chemicals, although laser and inkjet transparencies, like photocopies, are likely to be hazardous when scratched and sanded and require similar precautions to working with photocopies. However, sitting at a computer in a fixed position for many hours can lead to other work related illnesses: eyestrain, headaches, backache, dizziness, nausea, inexplicable skin rashes, and more debilitating conditions like repetitive strain injury. It is important to take frequent breaks, and to relieve eyestrain and stiff muscles with appropriate exercises.

PHOTOGRAVURE

The initial stages of photogravure involve making photographic negatives and positives with toners, developers, and fixers in the darkroom. Photographic chemicals release gases and vapors which are a significant health hazard and a local exhaust system is essential. Always wear protective clothing and appropriate gloves when mixing chemicals: neoprene gloves for handling acids and alkalis, and nitrile gloves for most organic solvents. If your main interest in solarplate is photogravure then we recommend Overexposure: Health Hazards in Photography by Susan Shaw and Monona Rossol which gives comprehensive recommendations for work in the dark room.

WORKING WITH SOLARPLATE

One of the advantages of solarplate is the speed of the process. You are likely to spend considerable time in creating an image, using drawing media that usually do not present a significant health hazard and only a short time in platemaking. Unlike the long involved processes of etching and lithography, making a solarplate takes only a few minutes so the artist is exposed to polymer chemicals very briefly.

ULTRAVIOLET LIGHT

If you live in a sunny part of the world, using the sun as a light source will be highly convenient, but you need to take precautions. Overexposure to UV light from the sun or artificial UV light sources can cause skin cancer and cataracts. Countries like Australia, have the highest incidence of skin cancer in the world due to overexposure to the sun.

To avoid damaging your skin and eyes do not stand out in the sun when exposing a solarplate. Simply place the contact frame in the sun and retreat to the shade with your timer. As a precaution, apply an effective sunscreen, and wear a broad brimmed hat and clothing to protect your arms and legs.

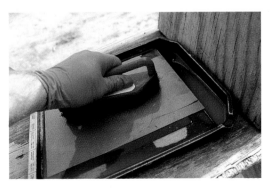

You can wash small plates outdoors in the shade, but it should be done quickly otherwise the UV light can harden the plate prematurely.

Precautions also apply when using an artificial UV light source and the unit must be properly shielded to protect both your eyes and skin. UV light goggles will give additional protection.

CHEMICALS

Solarplate complies with the American Society for Testing and Materials (ASTM) Standard of Practice for Labeling Art Materials for Chronic Health Hazards. It is classified ASTM-D4236. Under this classification knowledge about chronic health hazards is incomplete. Health and safety experts advise us that some chemicals in solarplate are not identified by the manufacturer on their MSDS. In addition, the MSDS shows there have been no long-term tests for cancer, birth defects, and other chronic hazards done on the ingredients or on the product as a whole. In our experience some individuals can develop dermatitis, especially if they develop plates without wearing gloves and on one rare occasion a workshop participant developed a headache when working with solarplate in an unvented room. These effects were not necessarily caused by solarplate, but since so little information is available, we recommend treating the product as if it were very toxic. This means that inhalation, ingestion, and exposure to skin and eyes should be avoided as completely as possible.

There is no simple way to know if a product is harmful. Odor can be deceiving and is not a reliable guide to toxicity. Some nasty smelling chemicals are not toxic, while other chemicals with pleasant odors or no odor at all are deadly. One good approach is to listen to your body and if you develop symptoms of allergy or illness see your doctor. Remember that allergy is not related to acute toxicity. Many non-toxic and natural substances, such as peanuts, shellfish, and the proteins in natural rubber latex, can cause life-threatening allergies in people who are sensitized to them. Many synthetic substances like dyes and plastic monomers also cause serious allergies.

The best way to reduce your chances of developing an allergy or a toxic reaction to solarplate is to avoid exposure. To do this, the following simple precautions should be followed:

1. Dispose of the cover film even though it is suitable for drawing, since unprocessed chemicals can adhere to the film and transfer to your hands.

2. When developing the plates always work in a well-ventilated workroom with a local exhaust system such as a spray booth, chemical fume hood, or in front of a window exhaust fan. If local exhaust ventilation is not available, exposure can be reduced by working outside, providing there is sufficient shade to prevent the polymer rehardening. A fan will disperse the odor.

3. When developing the plate wear nitrile gloves, a waterproof apron or other protective clothing, and a face shield or goggles that are rated for protection against chemical splash.

4. If any residue splashes on the skin during development, the manufacturers recommend washing the area immediately with soap and water. Health and safety experts concur with this.

5. Should any participant experience adverse allergic or toxic reactions, then he or she should seek medical attention as soon as possible.

6. Do not eat, drink, apply cosmetics, or do any hygiene tasks while platemaking or printmaking.

7. Always wash your hands thoroughly every time you leave the studio.

Author's note

Since only the classes of chemicals making up solarplate are identified on the MSDS and not the specific chemicals, experts cannot be 100 percent certain that nitrile gloves will resist the various ingredients in solarplate.

PRINTING

There are so many different makes of inks and paints with varying compositions that it is up to the individual printmaker to obtain a MSDS for every ink he or she buys, and to follow the recommendations laid down by the manufacturers. There are also excellent charts in safety books that will give you valuable information about inks, their composition, and hazards.

WORKING WITH INKS

Water-soluble inks are normally safer to use than oil-based inks, but some may contain water-miscible solvents and preservatives. Some water-soluble inks contain glycol ethers and may be more toxic than oil-based inks. Oil-based inks contain pigment, burnt linseed oil, and a number of additives. Burnt linseed oil is not a known hazardous substance, but the pigments that give inks their wonderful colors can be harmful.

Inks and related products contain inorganic pigments, organic pigments, or dyes (solarplate contains a dye). Inorganic pigments are based on metal compounds and/or minerals and range in toxicity from extremely low to high. For example, ultramarine blue is a synthetic mineral composed of sodium, aluminum, and silica, and is of extremely low toxicity, while pigments containing metals such as cadmium, chrome, nickel, and cobalt are highly toxic.

Organic pigments and dyes are natural or synthetic complex hydrocarbons, which can be divided into various chemical classes such as anthraquinone, benzidine, and aniline. Many are toxic, and it is not by accident that there are over 2000 organic chemical dyes and pigments and only six are approved for use in food.

There are also additives in ink which include stabilizers, driers, and plasticizers. Little is known about their effects, but Spandorfer et al. recommend using inks which contain the drier cobalt linoleate, rather than driers which contain lead, manganese, or cobalt naphthenate. But all these driers should be considered toxic and inhalation or excessive skin contact avoided.

The same rules apply for the safe use of oil-based inks as for many other toxic chemicals:

1. Whenever possible, purchase inks where the manufacturers have identified the pigments and other chemicals by their Chemical Abstract Service Numbers (CAS). Once you know the CAS number of the pigment you can find out its exact identity and the correct precautions to take by consulting safety publications, Web pages, or health and safety experts (See Resources: Safety and the Working Environment, p.137).

2. Always work with good ventilation, preferably with a local exhaust system and wear an impermeable apron and solvent resistant nitrile gloves or barrier cream when handling inks.

3. Do not work with powdered pigments, sand work, or airbrush inks since airborne particles are easily inhaled.

4. Do not handwipe intaglio plates.

5. Do not eat or drink in the studio.

6. Do not use a hot plate for inking up the plate or heat the plate to high temperatures.

7. Always keep containers of ink closed as much as possible.

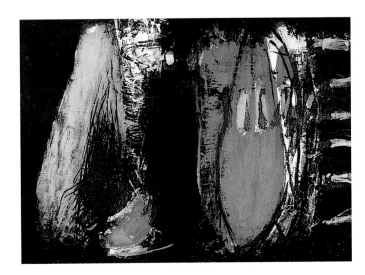

Wendy Stokes, *Night Tide,* 1995
Intaglio print, 7.5 x 10 in (19 x 25.5 cm)
Intaglio image printed with oil-based etching and monoprinting inks.

8. Printmakers frequently apply talc, sometimes known as French chalk, to rollers after cleaning with odorless mineral spirits. French chalk may be contaminated with asbestos that is carcinogenic; safer substitutes are baby talc or cosmetic talc.

9. For cleaning up ink use vegetable oil or baby oil as a safe alternative to toxic solvents. Baby oil is less greasy, but any vegetable oil will serve this purpose. Some rubber rollers may degrade if cleaned with vegetable oil, so use odorless mineral spirits to clean rollers. Please note that you can use vegetable oil to clean up solvent-based inks when practicing any other printmaking techniques.

USING SOLVENTS

If you need to use a solvent, health and safety experts recommend using odorless mineral spirits, also called varnish makers' and painters' naphtha (VM & P Naphtha) (CAS 64475-85-0), because the more toxic aromatic hydrocarbons have been removed. There are other types of odorless mineral spirits available in Australia: Archival odorless solvent (CAS 64742-48-9), and Langridge's odorless solvent (CAS 64741-65-7). Do not use citrus turpentine (CAS 5989-27-5), also known as D-limonene and many other names, which is highly toxic. Avoid inhaling solvent vapor by working with a local exhaust fan, or work outside. Always wear nitrile gloves since odorless mineral spirits will easily pass through other kinds of rubber gloves and be absorbed directly through the skin. At the end of a printing session, seal all newspapers, gloves, and rags soaked with ink, oil, and solvents in plastic bags and dispose of promptly. Bag contaminated clothing and launder it separately from other clothing. Clean surfaces with a wet mop and a damp cloth, and only use a specialized vacuum cleaner with a high-efficiency particulate-air (HEPA) filter to remove dust. Never sweep in the studio, this can throw up clouds of harmful particles which are then inhaled.

REWORKING THE PLATE

We do not know the consequences of reworking the plate but have not experienced nor heard of any ill effects. When polishing with abrasives such as jeweler's rouge, or sanding or carving the polymer use very gentle pressure. Jewelers rouge is iron oxide and silica and a known respiratory irritant. Health and safety experts advise us that a vigorous action may break down the polymer and abrasives releasing airborne particles and hazardous chemicals, which can then be inhaled. Always work with good ventilation, preferably with a local exhaust system.

ENVIRONMENTAL DATA

Health and safety experts state that the waste residue is rather like soluble plastic film which, if poured down the drain, will clog up the waterways and damage aquatic life. There is some scientific evidence to suggest that the residue is eventually partially degraded by bacteria in water, however, if you want to reduce the amount of pollutants going into our oceans and rivers, there is a simple technique to recover the residue. In practice this method is a little unpredictable, and seems to work best in warmer weather.

Make sure you are wearing protective clothing. Add a good handful of salt to the tray containing the residue, and in about ten to fifteen minutes the plastics should start to precipitate out. If nothing appears you can try warming the water by leaving it in the sun or adding more salt. Scoop the precipitate out with a kitchen sieve or filter it through a sieve lined with cotton. It will harden in the sun, and can be either recycled, disposed of in the household garbage, or taken to an incineration depot. The remaining wastewater can be poured down the drain.

RESOURCES: SAFETY AND
THE WORKING ENVIRONMENT

This section provides a list of books, Web pages and safety organizations that you can contact to help you understand and find solutions to problems associated with working with harmful art materials. Some books may be out of print, such as *Danger! Artists at Work*, but many can still be found in libraries.

Books

Lewis, Richard J. *Hazardous Chemicals Desk Reference*. New York: Van Nostrand Reinhold, 1996.

Rossol, Monona. *The Artist's Complete Health and Safety Guide*. New York: Allworth Press, 1994.

_____, and Ben Bartlett. *Danger! Artists at Work*. Port Melbourne: Thorpe, 1991.

_____, and Susan Shaw. *Overexposure: Health Hazards in Photography*. New York: Allworth Press, 1994.

Spandorfer, Merle, Deborah Curtiss, and Jack Snyder. *Making Art Safely*. New York: Van Nostrand Reinhold, 1993.

Web pages

There is an enormous amount of safety information available on the Internet. You can download MSDSs and consult chemical data bases listed on many Web pages, which are, in turn, linked to many other relevant Internet sites. Used in conjunction with books, it is easy to become familiar with and well informed about health and safety issues. We offer three Web addresses that will provide a starting point for exploring this kind of information. If you cannot interpret the information you should consult health and safety experts.

http://dir.yahoo.com/Health/Workplace/Material Safety Data Sheets/MSDSs

http://www.ACTS@CaseWeb.Com

http://www.nwfsc.noaa.gov/msds.html

Health and safety organizations

The US-based Arts, Crafts, and Theater Safety (ACTS) extend their services world wide by offering free information by phone, mail, and e-mail. Their health and safety experts can give you advice about professional safety and industrial hygiene, copies of educational materials, access to research materials, and referrals to doctors and other sources of help. For a reasonable fee they also provide speakers for lectures, workshops, and courses; US Occupational Safety and Health Administration (OHSA) compliance training sessions and inspections; and technical assistance for building planning, renovation, and ventilation projects.

Arts, Crafts and Theater Safety also publish a monthly newsletter called ACTS FACTS which updates health and safety regulations and research affecting the arts. This is available from ACTS for a subscription of US$15 a year for 12 issues. If you live in Australia there is an additional fee of US$6.00 for postage.

Arts, Crafts, and Theater Safety (ACTS)
181 Thompson Street, #23
New York, NY 10012-2586
Telephone: (212) 777-0062

In Australia you can contact national and state government departments responsible for providing health and safety information and many other services. Another very good source of information is companies selling safety equipment. For example, they can provide items such as leaflets listing many types of safety gloves and which types of gloves are appropriate for handling specific chemicals.

For government departments at the national level contact:

Worksafe Australia
National Occupational Health and Safety Commission
92 Parramatta Road
CAMPERDOWN, New South Wales
Telephone: (02) 9577 9555

At the state level, WorkCover offices are found in most state capitals and country regions. They have specialists who can give you information about hazardous chemicals and advice about their proper use. We have listed the central offices for NSW, Victoria, and South Australia, but many more are listed in the White Pages.

WorkCover New South Wales
400 Kent Street City
SYDNEY, New South Wales
Telephone: (02) 9375 5000
WorkCover Advisory Service Victoria
Telephone: (03) 9641 1444
WorkCover Corporation
100 Waymouth Street
ADELAIDE, South Australia
Telephone: (08) 8233 2222
WorkCover Corporation
100 Waymouth Street
ADELAIDE, South Australia
Telephone: (08) 8233 2222

GLOSSARY

Acid-free: Most printing papers have a neutral pH of about 7.0. The pH scale indicates the acidity or alkalinity of a substance: substances with a pH of less than 7.0 are acids and those with a pH of more than 7.0 are alkaline.

Adobe Photoshop: A graphic software program created for a variety of computer users, such as photographers, artists, desktop publishers, scientists, and medical professionals. The program allows users to achieve results only attained previously by the printing industry.

Aquatint: Porous ground made of rosin powder dusted on to metal plates and fused to the surface by heat. Immersion in acid creates many tiny crevices in the surface of the plate which, when inked, print as tones and textures. The aquatint method was invented in the eighteenth century and is used in etching, often combined with line work.

Artist's proof: These are additional prints over and above the number of prints in an edition, that remain the property of the artist. They are identical to the edition prints and usually consist of 10 percent of the edition.

Blankets: Also called felts. They are made of woven or felted wool and, during printing, lie between the roller and the bed of the press. When printed under pressure the blankets force dampened paper into inked grooves and lines and, hence, assist the transfer of ink to paper.

Bleeding: An error that appears as excess ink in a print. It occurs in intaglio methods when a solarplate or etched metal plate has a deep relief structure; the grooves hold too much ink, which squeezes out on to the paper under the pressure of printing.

Brayer: Another term for a roller. See Roller.

Cartridge: A hard disk in a casing rather like a floppy disk, which is inserted into a peripheral storage device and is capable of transporting large amounts of data between a personal computer and a graphic design house. They are available in a variety of different storage capacities, for example, 50 MB, 100 MB, 250 MB, and 1 Gb.

Collage: A form of artwork where different materials, such as photographs, found objects, papers, and line drawings, are combined and glued to a backing. Also refers to a combination of different kinds of images on to transparency film.

Continuous tone: Refers to the quality of a photograph or illustration where the image is composed of shades of gray from white through to black without showing any discontinuities.

Deckle: Mostly used to describe the edges of handmade paper; as handmade paper dries the sheet loses fibers from the edges and leaves thin wavy edges called deckles. The wooden frame covered with a fine wire mesh in which handmade paper is dried is called a deckle or mold. It also refers to a device in papermaking machines which limits the size of the sheet.

Density: The degree of opaqueness of an image: the darker the image the greater the density of color.

Digital image: An image generated and stored in electronic form.

Digitize: The process of converting images into an electronic form using peripheral devices, such as a graphics tablet, keyboard, mouse, or scanner.

Disk: A flat, circular object coated with a magnetic material that stores computer data. Floppy disks are called "floppy" because the magnetic material inside the disk is flexible. They can be inserted into the computer and used to transport small amounts of data. Most floppies carry either 800 KB or 1.4 MB of data. See Cartridge and Hard disk.

dpi: Abbreviation for dots per inch. This can be a measure of the resolution of printers, imagesetters, and other output devices. High quality reproductions are likely to have a high dpi and a fine resolution. See ppi.

Drypoint: Graphic technique whereby a printmaker draws directly into the surface of the plate with a tool tipped with a sharp steel or diamond point. The action creates a burr on each side of the incised line, which holds ink and gives a velvet quality to the printed image.

Edition: The total number of prints printed from a plate or block. It does not include artist's proofs or working proofs.

Embossing: When a plate or block has a deep relief structure or deeply etched lines and is printed under strong pressure to create a raised design in the print. The plate or block can be inked in relief. Alternatively, if it is not inked, the process is called blind embossing.

Emulsion: In photography it refers to a suspension of silver compounds in a gelatin coating applied to films and plates.

Engraving: A graphic technique using mainly wood or metal which is incised with tools, such as a burin or a graver: the plate or block can then be printed as a relief or as an intaglio print. Also refers to the print pulled from an engraved plate or block.

Etching: Graphic technique whereby a metal plate is coated with ground, then drawn into with an etching needle and other tools, and immersed in acid. The ground acts as a resist and the acid etches into the uncoated metal, creating lines and crevices. The plate can then be printed in intaglio. See Intaglio.

Extenders: Substances blended with inks to create a more transparent quality in prints.

File: In computing, a collection of data with a filename stored on a disk.

Found objects: Any organic material, such as leaves, feathers, and shells, or inorganic materials, such as wood, rubber, and meshes. In traditional printmaking these items are inked and printed directly on to paper or combined in collage artwork.

Frequency: See Screen ruling.

Gigabyte: Abbreviated to Gb. Measure of memory storage where 1 Gb is equal to 1024 megabytes. See Megabyte and Kilobyte.

Graphic design house: Also called a service bureau. A graphics business that offers a number of services to platemakers, graphic artists, desktop publishers, and users of personal computers. A graphic design house can print high-resolution bromides and lith film on imagesetters from files supplied on disk; they have high quality scanners for digitizing photographs, artwork, transparencies, and photographic negatives.

Graphics tablet: Also called a digitizer or digitizing pad. This is a peripheral input device that allows a natural drawing style with a special pen and pad. The pressure of simulated strokes and marks activates the pad and converts these into electronic information.

Grayscale: Tonal scale of grays from white through increasingly darker grays to black. Often used as a standard to monitor the quality of photographic reproductions.

Gum arabic: Gum from the acacia tree. Constituent of water-based inks, lift ground, and gum etch in lithography. Watercolor artists add it to paint to enhance color.

Halftone image: An image produced by photographic or electronic means, composed of a series of dots arranged in lines that simulate a continuous tone.

Hard disk: Part of the computer forming a permanent magnetic memory. Consists of several plates for storing data.

Hardware: The parts of a computing system consisting of the equipment, such as peripheral devices, the monitor, central processing unit, and hard disk which together comprise the computer. See Peripheral device.

Imagesetter: An output device that prints high-resolution images from a file on a disk on to bromide or film as film negatives or film positives. The early imagesetters worked by projecting light though tiny negatives on to photosensitive bromide film. Modern imagesetters incorporate a computer called a raster imaging processor (RIP) which converts image and text on a file into a computer language, usually Postscript. Printing is digitally controlled and performed by a laser beam which "rakes" across photosensitive film.

Impression: Print on paper from an inked block or plate. Also the indentation in the paper left by the plate or block during the printing process.

Intaglio: Refers to many graphic printing methods including drypoint, etching, aquatint, mezzotint, and engraving. Incised lines in etched metal plates or carved blocks are inked, the surface is wiped, and the image transferred to paper under pressure. See Drypoint, Etching, Aquatint, Mezzotint, and Engraving.

Kilobyte: Abbreviated to KB. A unit of memory describing the amount of data stored in a computer or on a disk. 1 KB is equal to 1024 bytes and equivalent to approximately seventy words. See Megabyte and Gigabyte.

Laser printer: Output device often attached to personal computers whereby the image is transferred to paper by means of a laser.

Letterpress printing: Term usually applied to commercial relief printing processes whereby the raised surface of metal type, a block, or plate is inked and the image transferred to paper under pressure. See Relief printing.

Lithography: Planographic technique invented by Aloys Senefelder in 1798. The principle of the technique is based on the repulsion of grease and water. An image is created on stone or metal using a greasy medium, the stone is dampened, and when ink is applied it only adheres to the greasy drawing, which is then transferred to paper under pressure.

lpi: Abbreviation of lines per inch. Refers to the screen ruling or frequency of halftone film. It is a unit of measurement describing the dots on halftone film which form regular lines. It is related to but independent of the dpi. See Halftone image, Screen ruling, or dpi.

Megabyte: Abbreviated to MB. Unit describing the amount of data stored in a computer or on a disk. 1 MB is equal to 1024 kilobytes, and equivalent to approximately 175,000 words.

Memory: The capacity of a computer to recall and remember information. Read only memory (ROM) is memory which stores information for running the computer. Random access memory (RAM) is the memory available for any screen activities and is only available when the computer is on. A third form of memory is permanent memory or storage memory where information from RAM is saved to the hard disk.

Mezzotint: An intaglio process whereby a metal plate is first worked with a tool called a rocker creating a surface that will retain ink. Then parts of the roughened surface are worked with scrapers to create lighter areas and so form the image.

Moiré: Pattern superimposed on a color image as a result of using halftone films with the dots set at the same angles. Dots should always be printed on film at different angles.

Monomer: A small molecule that links with others to form a long molecule or polymer. See Polymer and Polymerisation.

Monoprint: Refers to a print created from a matrix, such as an intaglio plate, which has been inked to create an individual piece of artwork rather than an edition.

Nanometer: Abbreviated to nm. A unit of length equal to one billionth of a meter. The wavelength of white light, UV light, and other forms of short wave electromagnetic radiation is measured in nanometers.

Negative film: Film in which the image is formed by transparent or translucent lines and the background is opaque. A film negative can be produced by creating an inverse of a film positive using Photoshop, a laser printer, or a color photocopier at a graphic design house, or by a platemaker using a process camera.

Open bite: In printmaking it describes large areas on metal plates which are etched away by acid and cannot retain ink.

Output device: A hardware device that displays data in a visual form; the monitor, printers, and imagesetters are all output devices.

Peripheral device: Any hardware device or computing equipment attached to the computer. Input devices are the keyboard, scanner, and mouse; output devices are printers and imagesetters.

Personal computer: A computer that is a self-contained unit and not attached to a central computing unit as in universities and other institutions. The abbreviation

PC stands for "personal computer," but also refers to IBM and IBM compatible computers.

Photogravure: Also called gravure. Industrial intaglio printing process invented by Fox Talbot in the mid-nineteenth century to reproduce images with continuous tones. The image is etched into a cylinder creating many tiny cells, the tone of the printed image is determined by the depth and size of the cells. It is used for high quality printing of postage stamps and bank notes. More recently it describes a printmaking technique developed by Eli Ponsaing using photopolymer plates to obtain a continuous tone print which is called photopolymer gravure or polymer photogravure.

Photopolymer: A chemical made up of long interlinked molecules that have formed from smaller molecular subunits in the presence of light.

Photopolymer plates: Relief printing plates with a photopolymer layer sensitive to UV light. Used extensively in the printing industry in letterpress and flexographic printing applications to print on a great range of advertising materials, such as cardboard boxes, paper, plastic, and metal.

Pixel: Abbreviation for picture element. Pixels are dots of light on a computer screen which when illuminated represents the image. The higher the number of pixels the better the definition of the image.

Planographic: Normally applies to lithography where the image and the non-image areas of a printing surface are on the same plane.

Platemaker: A professional working in the printing industry who converts artwork into printing plates using photographic processes.

Plate tone: The background tone of prints produced in intaglio techniques imparted by the ink left on the surface of the plate after wiping.

Polymer: Chemicals of natural and synthetic origin made of long molecules, each composed of smaller molecular subunits.

Polymerisation: The process of small molecular subunits linking to create long molecules to form a polymer.

Positive film: Film where opaque lines form the image and the background is transparent or translucent.

ppi: Abbreviation for pixels per inch. A measure of the resolution of a computer screen or scanned image. Most Apple Macintosh computers have a resolution of 72 ppi. See Pixel.

Proofing: Term used in printmaking when a printmaker prints from a plate or block while still developing the plate or block. Also the stage in printing prior to editioning when a printmaker is experimenting with different papers and inks. These prints are called working proofs or trial proofs

RAM: See Memory.

Registration: Process of positioning paper accurately on a plate or block for printing. Important in color work when using more than one plate.

Relief printing: Any printing method where the raised surface of a plate is inked and the inked image is transferred to paper under light pressure. The method dates back to 167 BC in China.

Resolution: Applied to digital images where the clarity and definition of an image is measured in dots per inch (dpi). The higher the dpi, the better the resolution. See dpi.

RGB: Abbreviation for red, green, and blue. In computing this is the color system normally used for displaying color images on the monitor.

Right Reading Emulsion Down: Abbreviated to RRED. High-resolution film where the image appears the right way round when viewed from the shiny side. Used in making plates for offset applications.

Right Reading Emulsion Up: Abbreviated to RREU. High-resolution film where the image appears the right way round when viewed from the matte emulsion side. Used in making plates for letterpress and solarplate printing.

Roller: Also called a brayer. A tool with a cylinder of rubber, polyurethane, or neoprene that is used to apply ink to plates for relief printing. The cylinder of rubber is also called a roller.

Scanner: Peripheral input device for transforming photographs, drawings, and found objects into an electronic form.

Screen: A halftone or continuous tone film covered with dots to produce flat shades of gray. Also called a tint. Sometimes used as an abbreviation for screen ruling.

Screen angle: This describes the angle from the horizontal at which the dots on a halftone film are printed.

Screen ruling: Also called the frequency. Term applied to halftone film where the dots on the film are arranged in lines and measured in lines per inch. Common screen rulings are 85 lpi, 100 lpi, 133 lpi, and 150 lpi. See lpi and Halftone image.

Shore hardness: The compressibility or sponginess of the surface of the photopolymer layer. It is measured by compressing a layer of photopolymer at least 6mm in thickness.

Software: Term applied to the extensive specialized data that is organized to instruct the computer in its tasks.

Stouffer Wedge: Also called the 21 Step Stouffer Wedge, or the 21 Step Sensitivity Guide. This is a continuous tone film arranged in blocks of increasing density from very pale gray to solid black. In photopolymer platemaking it can provide an indirect measure of the amount of UV light required to harden a polymer.

Tarlatan: Starched cheesecloth used in intaglio printmaking techniques for wiping the surface of plates during inking.

True-Grain drafting film: A transparent textured film also known as Autotex. Manufactured by Autotype and developed by them in conjunction with Curwen Chilford Prints in Cambridge, UK, specifically for transferring fine tones in screen printing.

Ultraviolet radiation: Electromagnetic radiation with wavelengths of 4–400 nanometers.

Wavelength: Unit for measuring light and other forms of electromagnetic radiation. Light travels in the form of waves and the wavelength is the distance in meters between the peak of one wave and the peak of the next wave. See Nanometer.

SELECTED READING

Allen, Lynne and Phyllis McGibbon(selectors). *The Best of Printmaking*. Gloucester: Quarry Books, 1997.

Ayres, Julia. *Printmaking Techniques*. New York: Watson-Guptill Publications, 1993.

_____, Monotype: *Mediums and Methods for Painterly Printmaking*. New York: Watson-Guptill Publications, 1993.

Burkholder, Dan. *Making Digital Negatives for Contact Printing*. San Antonio: Bladed Iris Press, 1999.

Campbell, Alistair. *The Macdesigner's Handbook*. NSW, Australia: Angus and Robertson, 1992.

Crawford, William. *The Keepers of Light: A History and Working Guide to Early Photographic Processes*. Dobbs Ferry, New York: Morgan & Morgan, 1979.

Emmett, Dr. Anthony. *Your Skin and the Sun. Australia*: Simon and Schuster, 1990.

Grishin, Sasha. *Contemporary Australian Printmaking: An Interpretative History*. NSW, Australia: Craftsman House, 1994.

Heller, Jules. *Paper-making*. New York: Watson-Guptill Publications, 1997.

Leaf, Ruth. *Etching, Engraving and Other Intaglio Printmaking Techniques*. New York: Dover Publications, 1984.

Martin, Judy. *The Encyclopedia of Printmaking Techniques*. Sydney: Simon and Schuster, 1993.

Pipes, Alan. *Production for Graphic Designers*. Singapore: Laurence King, 1992.

Ponsaing, Eli. "Photopolymer Printing Plates." *Printmaking Today*, Vol 4 No 2 (1995).

Ponsaing, Eli. *Photopolymergravure: A New Method*. Copenhagen Valby: Borgens Forlag, 1995.

Reddy, Krishna N. *Intaglio Simultaneous Color Printmaking: Significance of Materials and Processes*. Albany: State University of New York Press, 1988.

Saff, D. and D. Sacilotto. *Printmaking: History and Processes*. New York: Holt, Rinehart & Winston, 1978.

Simmons, Rosemary & Clemson, Katie. *The Complete Manual of Relief Printmaking*. Sydney: William Collins, 1988.

Stainton, Elaine M., ed. *Printmaking in America: Collaborative Prints and Presses 1960–1990*. New York: Harry N. Abrams, 1995.

Tallman, Susan. *The Contemporary Print: From Pre-Pop to Postmodern*. London: Thames and Hudson, 1996.

Toale, Bernard. *Basic Printmaking Techniques*. Worcester: Davis Publications, 1992.

Torelief Technical News (No. 2). *Waste Wash-out Solution of W and W-T Plate* (Revised).

Turner, Silvie. *Which Paper: A Review of Fine Papers for Artists, Craftspeople & Designers*. estamp (1991).

Welden, Daniel and Lorna Logan. *Understanding Prints*. New York: The Long Island Printmakers Society, 1980.

SUPPLIERS

Suppliers in the US

Solarplate and solarplate aquatint screens
Hampton Editions, Ltd.
P.0. Box 520
Sag Harbor, NY 11963
631-725-3990
solarplate@aol.com
www.solarplate.com

Solarplate and printmaking supplies
Daniel Smith
4050 1st Ave. South
Seattle, Washington
1-800-426-7923
206-223-9599
dsartmtrl@aol.com
Renaissance Graphic Arts
69 Steamwhistle Dr.
Ivyland, Pennsylvania 18974
888-833-3398
215-357-5705
pat@printmakingmaterials.com
www.printmaking-materials.com
Freestyle Sales
5124 Sunset Boulevard
Los Angeles, California 90027
1-800-292-6137
323-660-3460
ksmith@freestylesalesco.com
Rembrandt Graphic Arts
P.O. Box 130 , Rosemont
New Jersey 08556-0130
1-800-622-1887
1-609-397-0068
sales@rembrandtgraphicarts.com
www.rembrandtgraphicarts.com
Graphic Chemical and Ink Co.
728 North Yale Ave
P.O. Box 7027, Villa Park
Illinois 60181-7027
800-465-7382
630-832-6004
Fax: 630-832-6064
Graphchem@aol.com
www.graphicchemical.com
Ateliers, Inc.
418 Montezuma
Santa Fe, NM 87501
www.whelanpress.com

Paper trimmers
Kutrimmer, MBM Corporation,
3134 Industry Drive, N.
Charlston, South Carolina 29418
800-223-2508
wendym@mbmcorp.com
www.mbmcorp.com

Water-based monoprinting colors
Color Craft
14 Airport Park Roa
East Granby, CT 06026
800-243-2712
860-653-5505
Fax: 860-653-0643
createx@aol.com
www.createxcolors.com
Rostow & Jung
219 E. 4th St. suite 3B
New York, NY 10009

Miscellaneous supplies
Stones Crayons
1525 Overhulse Rd. N.W.
Olympia Washington, 98502
360-866-2605
fax 360-866-0138
craig@stonescrayons.com
www.stonescrayons.com
Gamblin Artists Colors Co.
PO Box 625
Portland, Oregon 97207
503-235-1945
fax 503-235-1946
email info@gamblincolors.com
www.gamblincolors.com

Archival supplies and packaging
Light Impressions
P.O. Box 940
Rochester, New York 14603-0940
800-828-6216
714-441-4500
www.lightimpressionsdirect.com
Masterpak
145 East 57th Street
N Y 10022
800-922-5522
mpak@webspan.net
www.masterpak-usa.com

Presses
Conrad Machine
1525-CI-South Warner
Whitehall, Michigan 49461
231-893-7455
www.imox.com/conrad
Takach Press Corporation
3207 Morningside NE
Albuquerque, New Mexico
87110 800-248-3460
505-242-7674
fax: 505-888-6988
info@takachpress.com
www.takachpress.com

Papers
Atlantic Papers, 1800 Mearns Road,
Suite P, Ivyland, PA 18974
1-800-367-8547
atlpapers@aol.com
Twinrocker Handmade Paper, Inc.
P.O. Box 413
Brookston, Indiana 47923
800-757-8946
765-563-3119
twinrock@twinrocker.com
www.twinrocker.com
Savoir-Faire
40 Leveroni Court
Novato, CA 94949
415-884-8090
800-332-4660.
info@savoir-faire.com
www.savoir-faire.com
Legion Paper Corp.
11 Madison Ave
NY 10010
800-278-4478
212-683-6990
ginsm@legionpaper.com
www.legionpaper.com
Legion Paper West, Inc.
6333 Chalet Drive, LA
California, 90040
800-727-3716
562-928-5600
Stephen Kinsella, Inc Fine Art Papers
PO Box 32420
Olivette, MO 63132
800-445-8865
314-991-0141
sue@kinsellaartpapers.com

Hiromi Paper International, Inc.
 2525 Michigan Ave.
 Bergamot Station G9
 Santa Monica, CA 90404
 310-998-0098
 Fax: 310-998-0028
 email:hiromipaper@earthlink.net
 website:www.hiromipaper.com
White Crow Paper
 186 Lake Road
 Fleetwood, PA 19522
 610-944-9061
 www.napconn.org

Eastern Arts Connection, inc.
Yue Mei Hand Made Papers
 1033 Farmington Ave.,
 Farmington, CT. 06032
 860-674-0128
 fax 860-674-0538
 yuemei@yuemei.net
 www.yuemei.net

Far East Art Imports
 P.O. Box 4281 Boise
 Idaho 83711
 208-658-9968
 Fax 208-888-9851
 email:rsorenson@mci.net

Palm press, Semenoff roller system, toner chalks
Nik Semenoff
 102 Wilson Crescent
 Saskatoon, SK, S7J2L5 Canada
 http//dukeusask.ca/~semenoff
 semenoff@skyway.usask.ca
 306-931-7198

Toner liquids
Si-Lith
 525 Jersey Ave.
 Jersey City, NJ 07302
 201-435-5409

Suppliers in Australia
Contact Graphic Machinery & Supplies in Victoria for suppliers of solarplate in all states.
Graphic Machinery & Supplie
 274 Ferntree Gully Rd
 Notting Hill, Victoria 3168
 03 9542 7820
Graphic Machinery & Supplies
 18 Galloway St
 North Parramatta, NSW 2151
 02 9890 7707
Henley Graphics (SA & NT)
 36A Welland Ave
 Welland, South Australia 5007
 08 8340 0607
Lithographics
 107 Westminster St
 East Victoria Park, W.A. 6101
 08 9362 4533

Paper trimmers
Jasco Business Machines Pty Ltd
 66 North Tce
 Kent Town, South Australia 5067
 08 8363 0522
 1800 676 155
 www.jasco.com.au

Drawing films
True-Grain drawing film
Cadillac Plastics
 537 Pittwater Rd
 Brookvale, NSW 2100
 02 9938 1944

Single matt drafting film
Aarque Systems Pty Ltd
 1 Eden Street
 Crows Nest, NSW 2065
 02 9957 1279

Printmaking supplies
Melbourne Etching Supplies,
 33A St David Street
 Fitzroy, Victoria 3065
 03 9419 5666
Neil Wallace Printmaking Supplies
 44-46 Greeves Street
 Fitzroy, Victoria 3065
 03 9419 5949

Eckersley's Arts, Crafts and Imagination
 1300 65 77 66 for all branches
 93 York St
 North Sydney, New South Wales
 88 Walker St
 St Leonards, New South Wales
 2-8 Phillip St
 Parramatta, New South Wales
 51 Parry St
 Newcastle, New South Wales
 116-126 Commercial Rd
 Prahran, Melbourne
 21-27 Frome St, Adelaide
 South Australia
 91-93 Edward St
 Brisbane, Queensland

Createx monoprinting inks
Judy Bourke
 10 Mt Gilead Rd
 Thirroul, NSW 2515
 02 4267 2697
 judib@hotkey.net.au
 http://www.hotkey.net.au/~judib

Presses
Artequip
 Factory 5
 18 Powlett Street
 Moorabin, Victoria 3189
 03 9555 8644

Etching Press
 4 George Street
 Beverley, South Australia 5009
 08 8445 8617

Papers
Magnani Papers
 53 Smith Street,
 Fitzroy, Victoria 3065
 03 9417 3736
Quire Handmade Paper
 PO Box 248
 Belair, South Australia 5052
 08 8295 2966

Suppliers in New Zealand
Solarplate
National Art Supplies
 41 Nielsen Street
 Onehunga, Auckland
 9 634 0325
Aslin Graphics Ltd
 2/16AView Roa
 Henderson, Auckland 7
 9 837 5890

Suppliers in the UK and Europe
Solarplate
Toray Europe Ltd.
 3rd Floor, 7 Old Park Lane
 London W1Y 4AD

True-Grain drawing film
John Purcell Paper
 15 Rumsey Road
 London SW9 OTR
 071 737 5199

Printmaking supplies
Intaglio Printmaker
 62 Southwark Bridge Road
 London SE1 OAS
 0171 928 2633
T N Lawrence & Son Ltd
 117 - 119 Clerkenwell Road
 London EC1
 0171 242 3534

INDEX